DATE DUE

Demco, Inc. 38-293

Boat Design

CLASSIC AND NEW MOTORBOATS

Paolo Tumminelli

Editor in chief: Paolo Tumminelli
Art Director: Heike Sieber

Published by teNeues Publishing Group

teNeues Publishing Company
16 West 22nd Street, New York, NY 100010, USA
Tel.: 001-212-627-9090, Fax: 001-212-627-9511

teNeues Book Division
Kaistraße 18
40221 Düsseldorf, Germany
Tel.: 0049-211-994597-0, Fax: 0049-211-994597-40

teNeues Publishing UK Ltd.
P.O. Box 402
West Byfleet
KT14 7ZF, Great Britain
Tel.: 0044-1932-403509, Fax: 0044-1932-403514

teNeues France S.A.R.L.
4, rue de Valence, 75005 Paris, France
Tel.: 0033-1-55766205, Fax: 0033-1-55766419

teNeues Iberica S.L.
Pso. Juan de la Encina 2–48, Urb. Club de Campo
28700 S.S.R.R. Madrid, Spain
Tel./Fax: 0034-91-65 95 876

www.teneues.com

ISBN-10: 3-8327-9054-3
ISBN-13: 978-3-8327-9054-7

Editorial Project: © 2004 goodbrands GmbH

Goodbrands GmbH Beratung | consulting: design + marketing + media
Weissenburgstraße 35, 50670 Cologne, Germany
Tel.: 0049-221-17933-775, Fax: 0049-221-17933-776
e-mail: mail@goodbrands.org, www.goodbrands.org

Printed in Italy
Cover photo: Riva Ariston, Collezione Gervasoni ©30

Bibliographic information published by Die Deutsche Bibliothek. Die Deutsche Bibliothek lists this publication in the Deutsche Nationalbibliografie; detailed bibliographic data is available in the Internet at http://dnb.dbb.de

8 introduction
26 technology
38 power
46 design
54 types
116 show
332 people
396 editor
398 thanks
399 copyright

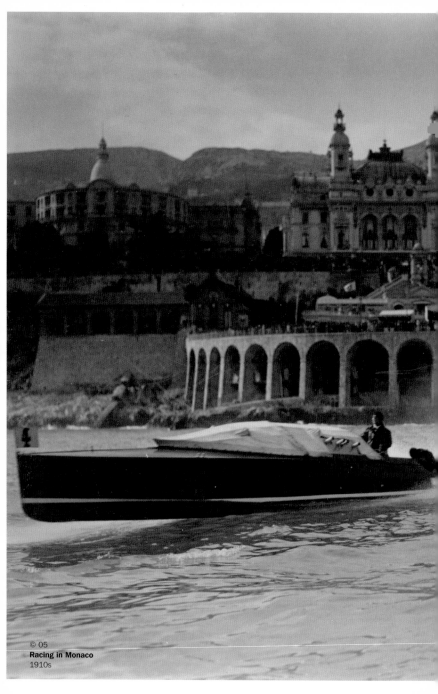

© 05
Racing in Monaco
1910s

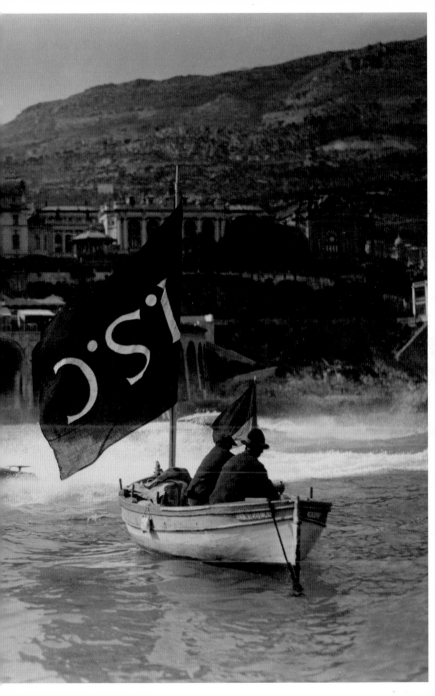

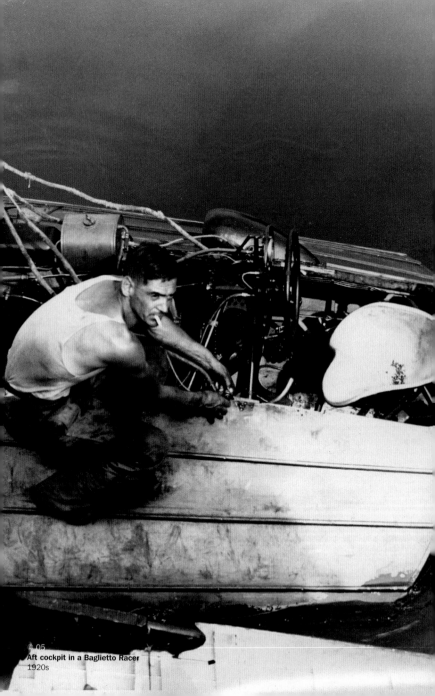

© 05
Aft cockpit in a Baglietto Racer
1920s

Introduction

One may see fast motorboats as the choice of rich and mostly uncultivated
people with an innate drive to exhibitionism. I do not share this opinion.
Boats of all kinds have been the first man-made vehicle and have always
maintained their legacy: rescue, discovery, fascination. It is true that, while
sailing boats keep on with a millenary tradition, motorboats were the
byproduct of dirty modern times. As soon as the combustion engine and the
propeller were invented, a new generation of "watercars" was designed for
futuristic speed. The first official races being held on the river Seine near
Paris in 1900, the motorboat fever soon reached the Unites States with the
legendary 1904 Gold Cup. This race paved 1922 the way to the develop-
ment of the gentlemen's runabout and with it to—so to say—of popular lei-
sure motor boating.

The plastic revolution in the 50s finally marked a new design and con-
sumption paradigma. The motorboats' high design integration is what
makes them so fascinating: with their flowing shapes and often beautiful
detailing, early wooden racers and runabouts were masterpieces of crafts-
manship and conceptual work of art at the same time. Less praised fiber-
glass boats often deserve the same respect: Over the years they developed
into a plethora of typologies and styles, often in obvious analogy with car
design, and happen to have been used for cruising, camping, sunbathing,
waterskiing, racing, even smuggling, or just to show-off in places-to-be.
Unquestionably they remain adult toys.

Although they finally became very popular, only a few thousands motor
boats are being made each year by hundreds of shipyards. Although much
has been designed, there is little knowledge about the subject and a lot to
be discovered yet. Like a mixed-antipasti platter, this book offers a quick
and easy overview. Only original images from archives, press or sales
literature have been used, with the aim to portray the genuine lifestyle of
times gone by. They help to see the evolution of motorboat design within its
cultural and social frame rather than as purely technical development.

Like our society, motorboats have grown up larger, faster and more diverse.
Since the early wooden runabouts a bit of human touch may have gone
lost, still I believe it is time to tribute all motorboats a higher cultural value
and a better place in our consumer world.

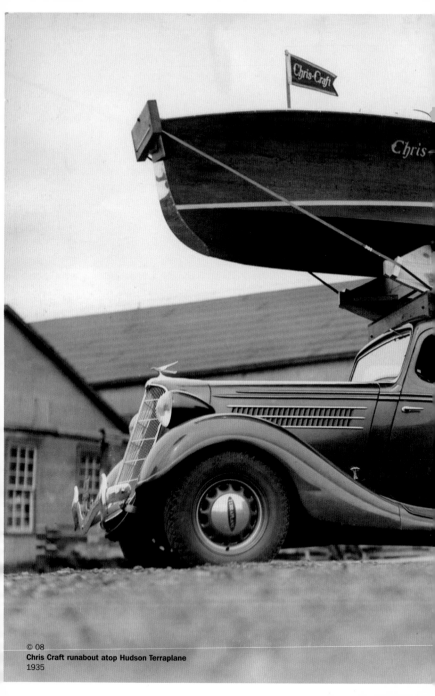

Chris Craft runabout atop Hudson Terraplane
1935

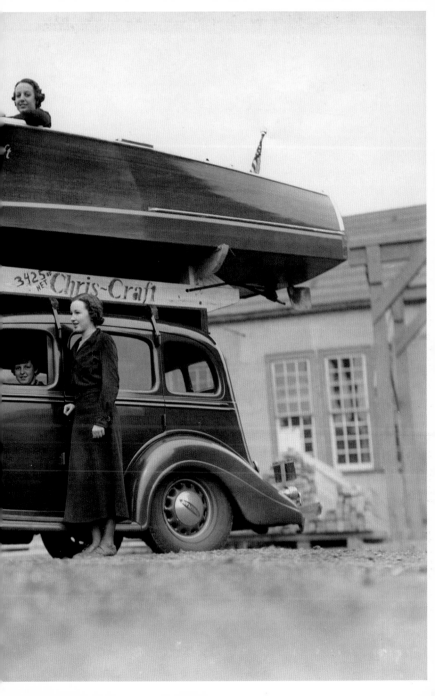

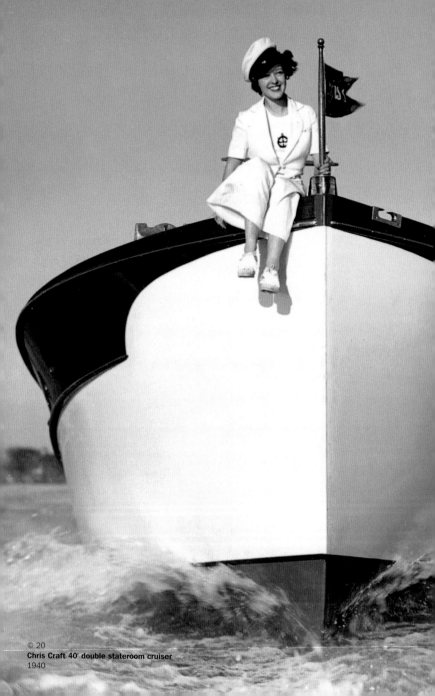

Chris Craft 40' double stateroom cruiser
1940

Einleitung

Schnelle Motorboote mag man als Angelegenheit reicher, unkultivierter und von Hause aus exhibitionistischer Leute ansehen. Ich teile diese Meinung nicht. Boote waren die ersten von Menschenhand gemachten Fahrzeuge, deren Vermächtnis wir noch heute bewahren, retten, entdecken, und uns weiterhin fasziniert. Wahr ist, dass das Motorboot der Moderne entstammt, denn sobald der Verbrennungsmotor und der Propeller erfunden waren, wurde auch eine neue Generation von „Wasserautos" für die Geschwindigkeit der Zukunft erschaffen. Nach den ersten offiziellen Rennen an der Seine im Jahr 1900 erreichte das Motorboot-Fieber die USA mit dem legendären Gold Cup 1904. Dieses Rennen ebnete 1922 schließlich den Weg für die Entwicklung des Runabouts für den feineren Herren, der seine Freizeit nun auf dem Wasser verstreichen lassen konnte.

Die Plastik-Revolution in den 50ern brachte komplett neue Design- und Konsumparadigmen. Die Faszination geht vom Design aus; mit fließenden Formen und wunderschönen Details waren die ersten aus Holz gefertigten Racer und Runabouts wieder Meisterwerke des Handwerks und der Konzeptkunst zugleich. Weniger gelobte Boote aus Fiberglas verdienen mittlerweile den gleichen Respekt, denn im Laufe der Jahre haben sich vielfältige Typologien und Stile herausgebildet. Genutzt hingegen wurden die Boote zum Herumfahren, Sonnenbaden, Camping, Wasserski, Rennen, sogar Schmuggeln – oder bloß als aufschneiderisches Vorzeigeobjekt. Zweifellos ein Spielzeug für Erwachsene.

Obwohl jährlich nur einige tausend Boote hergestellt werden, ist das Design vielfältig. Es mangelt nur an Wissen zu einem Thema, bei dem es viel zu entdecken gibt. Dieses Buch bietet einen schnellen und klaren Überblick. Ausgewählt wurden nur Originalbilder aus Archiven und Prospekten, um den Lifestyle der Vergangenheit ansatzweise zu porträtieren. Denn sie helfen uns, die Evolution des Motorboot-Designs stärker innerhalb des sozialkulturellen Rahmens zu beobachten, und nicht nur im Sinne des technischen Fortschritts.

Genau wie unsere Gesellschaft sind auch Motorboote größer, schneller und differenzierter geworden. Seit den frühen Runabouts ist vielleicht ein wenig „human touch" verloren gegangen – trotzdem glaube ich, dass es an der Zeit ist, den Motorbooten höheren kulturellen Wert und einen festen Platz in unserer Konsumwelt zuzugestehen.

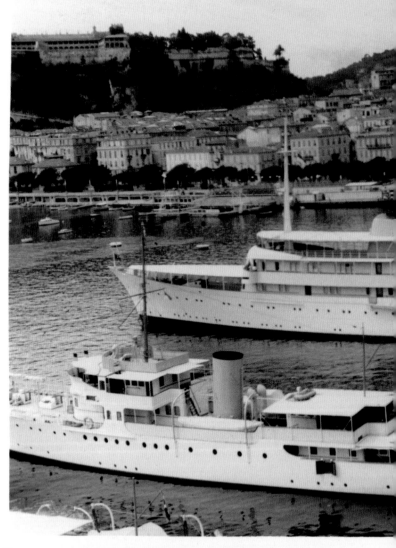

© 05
Onassis' legendary yacht "Christina" in Monte Carlo
1956

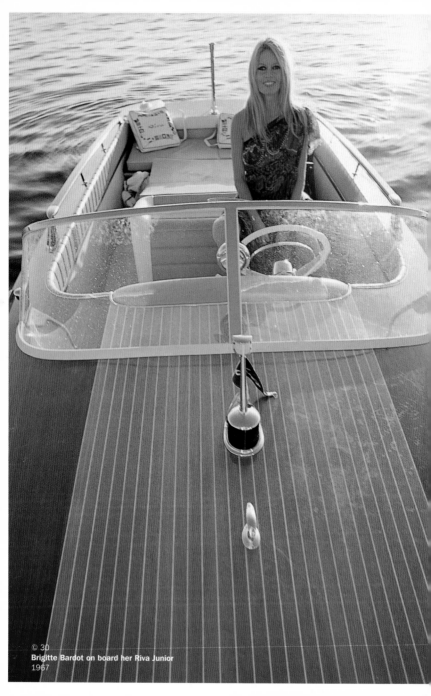

Brigitte Bardot on board her Riva Junior
1967

Introduction

On a tendance à penser que les hors bord rapides sont l'apanage de gens riches, incultes et fondamentalement exhibitionnistes. Je ne partage pas cette opinion. Le bateau est le premier véhicule construit de mains d'homme dont nous conservons aujourd'hui l'héritage : sauvetage, découverte, fascination. La vérité c'est que le hors bord a été inventé par le progrès, car dès l'apparition du moteur à explosion et de l'hélice, on a vu apparaître une nouvelle génération de «canots automobile» qui représentait la vitesse du futur. Suite à la première course sur la Seine en 1900, la fièvre du hors bord a envahi les USA avec la création de la légendaire Gold Cup en 1904. En 1922 cette course a fini par aplanir la voie pour le développement des Runabouts qui donnèrent, à l'homme raffiné, la possibilité de passer désormais ses loisirs sur l'eau.

La révolution des plastiques dans les années 50 a apporté de tous nouveaux paradigmes de formes et de consommation. La fascination commence par le design; les premiers Racers et Runabouts construits en bois, dotés de formes fluides et de magnifiques détails, étaient redevenus simultanément des chefs-d'oeuvre de l'artisanat et de l'art conceptuel. Les bateaux en fibre de verre, moins appréciés, ont acquis entre-temps leurs lettres de noblesse, car progressivement on a développé une grande variété de types et de styles. Les bateaux ont connus divers usages comme la promenade, le bronzage, le camping, le ski nautique, la course, et même la contrebande – ou encore simplement comme objet de prestige. Sans aucun doute un jouet pour adultes.

Malgré une production annuelle de quelques milliers par an, leur variété de formes est très large. Il nous manque toujours certaines connaissances sur un thème où il reste beaucoup à découvrir. Ce livre nous propose une vue d'ensemble rapide et claire. On y a sélectionné uniquement des illustrations originales provenant d'archives et de prospectus, afin de retracer partiellement le mode de vie du passé. Ces dernières nous aident à observer plus intensément l'évolution des formes du bateau à moteur en relation avec le milieu socioculturel, et non pas uniquement dans le sens du progrès technique.

Les bateaux à moteur sont devenus, exactement comme notre société, plus grands, plus rapides et plus différenciés. Il est possible que depuis l'époque des premiers Runabouts, un peu du caractère humain a peut-être disparu – malgré tout, je crois que l'heure est venue d'accorder aux bateaux à moteur une plus grande valeur culturelle et une place déterminée dans notre monde de consommation.

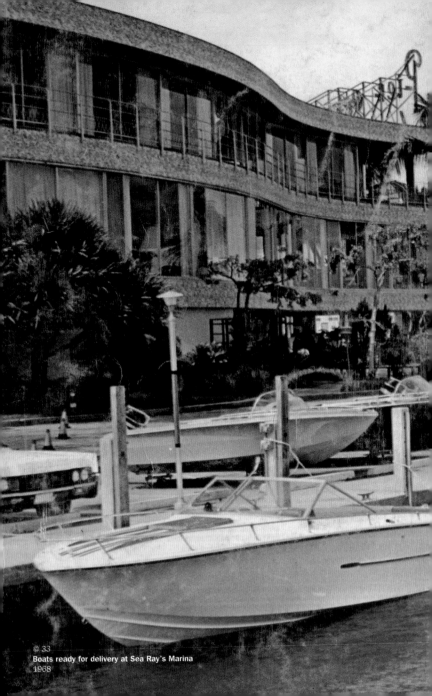

Boats ready for delivery at Sea Ray's Marina
1968

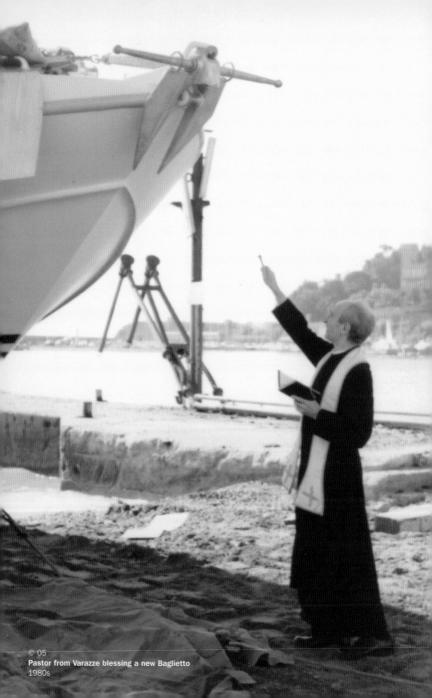

Pastor from Varazze blessing a new Baglietto
1980s

Introducción

Las embarcaciones a motor rápidas pueden ser vistas como un asunto de personas adineradas, poco distinguidas y exhibicionistas desde sus orígenes. Yo no comparto esta opinión. Las embarcaciones fueron los primeros vehículos realizados por el ser humano y cuyo legado conservamos hasta la fecha: rescatar, descubrir, fascinar. Lo cierto es, que la embarcación a motor procede de la modernidad, ya que en el momento que fueron inventados los motores de combustión interna y las hélices, también fue creada una nueva generación de "automóviles de agua" para la velocidad del futuro. Tras las primeras competiciones oficiales en el Sena en el año 1900, la fiebre de las embarcaciones a motor alcanzó los EE.UU. con la legendaria Gold Cup 1904. En el año 1922 esta competición abrió finalmente el camino para el desarrollo de los Runabouts para las personas más refinadas, cuyo tiempo libre ahora pueden disfrutar sobre el agua.

La revolución del plástico en los años 50 aportó paradigmas de diseño y consumo completamente nuevos. La fascinación parte ahora del diseño; con formas fluidas y preciosos detalles, los primeros Racer y Runabout fabricados en madera fueron al mismo tiempo obras maestras de la manufactura y del arte conceptual. Las embarcaciones menos elogiadas de fibra de vidrio entre tanto se ganan el mismo respeto, por que en el transcurso de los años se ha generado una diversidad de estilos y de tipología. Por el contrario las embarcaciones han sido para pasear, tomar el sol, camping, esquí acuático, competencias, hasta contrabandear –o simplemente un ostentoso objeto de presentación. Sin lugar a dudas un juguete para adultos.

Si bien anualmente se fabrican sólo algunas miles de embarcaciones, el diseño es amplio. Sólo faltan conocimientos sobre un tema, del cual puede descubrirse mucho. Este libro ofrece una visión rápida y clara. Se han seleccionado solamente fotografías originales de archivos y folletos, para poder ilustrar en principio el estilo de vida en el pasado. Por que nos ayudan, a observar la evolución del diseño de las embarcaciones a motor, con más fuerza dentro de un marco sociocultural y no en el sentido del progreso técnico.

Al igual que nuestra sociedad, también las embarcaciones a motor se han hecho más grandes, más rápidas y diferenciadas. Desde los antiguos Runabouts quizás se haya perdido algo del "human touch" –a pesar de ello, estoy convencido que ya es tiempo de concederles a las embarcaciones a motor un valor cultural más elevado y un lugar fijo en nuestra sociedad de consumo.

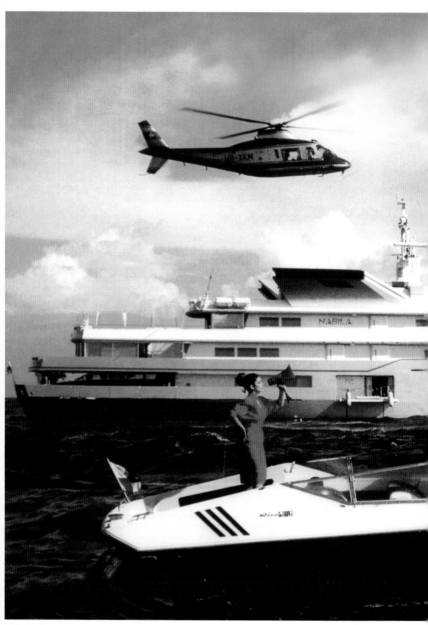

Nabila Kashoggi with few of her toys
1980s

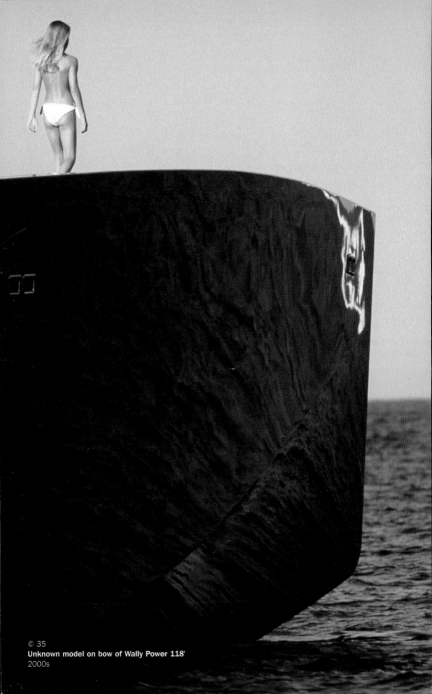

Unknown model on bow of Wally Power 118'
2000s

Introduzione

C'é chi considera le barche a motore come la scelta di gente ricca di scar-
sa cultura e con un innato senso dell'esibizionismo. Io non sono di questo
parere. Barche di tutti i tipi sono state il primo mezzo di locomozione dise-
gnato dall'uomo ed hanno sempre mantenuto la loro promessa di salva-
taggio, scoperta e seduzione. Se è vero che, mente le barche a vela godono
di una tradizione millenaria, le barche a motore sono il sottoprodotto "vol-
gare" di tempi industriali, è anche vero che la nuova generazione di auto-
mobili marittime fu inventata per il conseguimento dell'ideale moderno e
futurista della velocitá. Le prime gare si tennero sulla Senna nei pressi di
Parigi giá nel 1900, nel 1904 la febbre raggiunse l'America dove si fondó
la famosa Gold Cup. Con il nuovo regolamento che favoriva la partecipa-
zione di "Runabout per gentiluomini", fu questa corsa ad aprire nel 1922
la strada alla nautica da diporto.
La rivoluzione di plastica negli anni 50 diede poi vita ad un nuovo paradigma
di design e consumo. L'elevata integrazione formale delle barche a motore
é ció che le rende oggetti affascinanti: con linee filanti e dettagli scultorei,
i primi Racer e Runabout erano al contempo gioielli di ebanisteria e opere
d'arte concettuale. Le barche in vetroresina, spesso denigrate, meritano la
stessa attenzione: con il passare degli anni esse si sono sviluppate in una
pletora di stili e tipologie, spesso in ovvia analogia con l'automobile, e sono
state usate per viaggiare, campeggiare, prendere il sole, fare sci d'acqua,
correre, contrabbandare o semplicemente per mettersi in mostra nel posto
giusto. Senza dubbio rimangono dei giocattoli per adulti.
Pur essendo diventate oggi un prodotto quasi popolare e pur essendoci
molto da scoprire, se ne sa poco e se ne parla di rado. Come un buon
piatto di antipasti misti, questo libro offre una veloce rassegna di facile let-
tura. Solo immagini originali proveniente da archivi o da materiale pubbli-
citario sono state selezionate allo scopo di fornire un quadro genuino dello
stile di vita del tempo. Ció invita a vedere l'evoluzione del design
all'interno del suo tessuto culturale e sociale piuttosto che in un ambito
puramente tecnologico.
Dai tempi dei primi Runabout in legno si è forse perso un pó di tocco
umano: Come la nostra societá, le barche a motore diversificandosi sono
diventate piú grandi e veloci. Credo sia giunto il momento di attribuire loro
un giusto valore culturale ed un posto al sole nel nostro mondo di con-
sumatori.

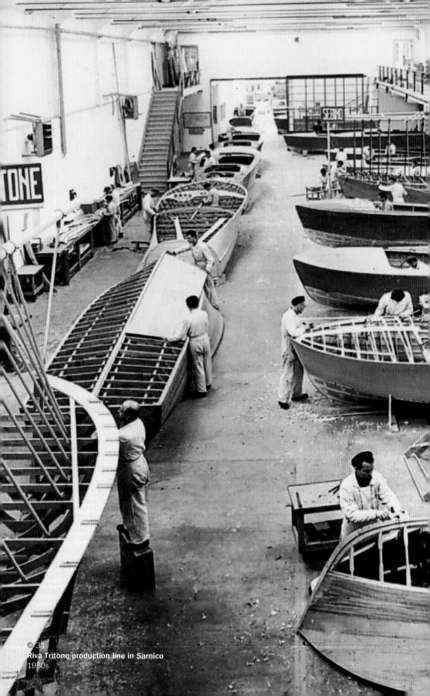

Riva Tritone production line in Sarnico
1950s

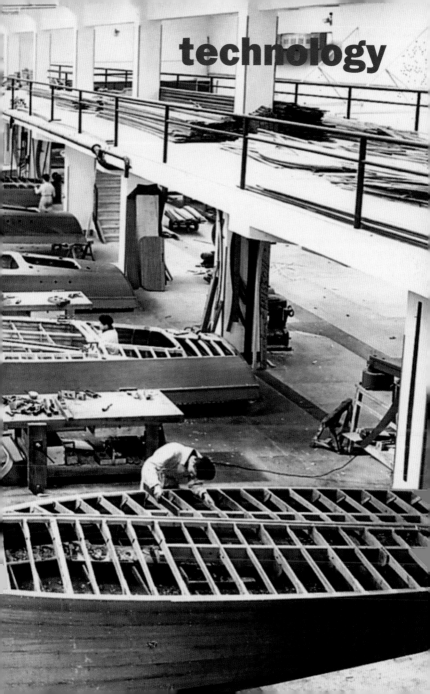

technology

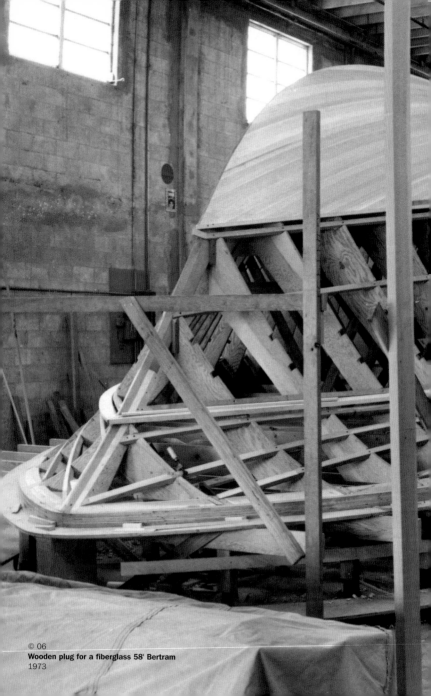

Wooden plug for a fiberglass 58' Bertram
1973

Although iron, aluminum and even concrete have been used in the industry, for well over 4000 years most boats have been made of wood. Basically, a wooden hull is constructed with massive planks fastened to a frame constituted of ribs mounted on a heavy keel. The planks arrangements follows two styles. Clinker style, or lapstrake, has overlapping planks which give a unique look and a smooth ride. Carvel is the newer, more speed-efficient style with a flush hull and edge-to-edge mounted planks. In the 50s hi-tech marine plywood boards gradually substituted the traditional planks, so did Riva since 1957. About the same year, Glastron began manufacturing smaller crafts out of fiberglass, a new material seen on cars since 1953. A composite based on polyester resin, fiberglass enabled the easy reproduction of hulls around one same mould. Less charming than wooden, fiberglass boats are usually stronger, guaranteed waterproof and, with their outer layer of pigmented gelcoat, easier to maintain. Having marked the beginning of popular motor boating, they too are now definitely classic.

Obwohl die Industrie schon Stahl, Aluminium und sogar Beton eingesetzt hat, wurden Boote über 4000 Jahren lang aus Holz gemacht. Grundsätzlich wird der Rumpf aus massiven Planken konstruiert, die an einem rippenförmigen Rahmen befestigt werden, der wiederum auf einem schweren Kiel sitzt. Es gibt zwei Bauarten: Die Klinkerbauweise besteht aus sich überlappenden Planken, was einen einzigartigen Look und eine geschmeidige Fahrweise ergibt. Kraweelbeplankung hingegen ist der neuere, geschwindigkeitseffizientere Stil, mit glattem Rumpf und Kante-an-Kante montierten Planken. In den 50ern ersetzte Hi-Tech-Bootsbausperrholz allmählich die traditionellen Planken, so z. B. bei Riva 1957. Im selben Jahr boten viele amerikanischen Werften kleinere Schiffe aus Fiberglas an. Ein Gemisch aus Polyesterharz und Glasfasern ermöglichte letztlich die einfache und schnelle Produktion von Rümpfen auf Basis einer einzigen Form. Fiberglasboote sind stabiler, garantiert wasserdicht und – mit ihrer äußeren Schicht aus pigmentiertem Gelcoat – leichter zu pflegen. Da sie den Beginn des populären Motorbootfahrens markieren, sind sie mittlerweile definitive Klassiker.

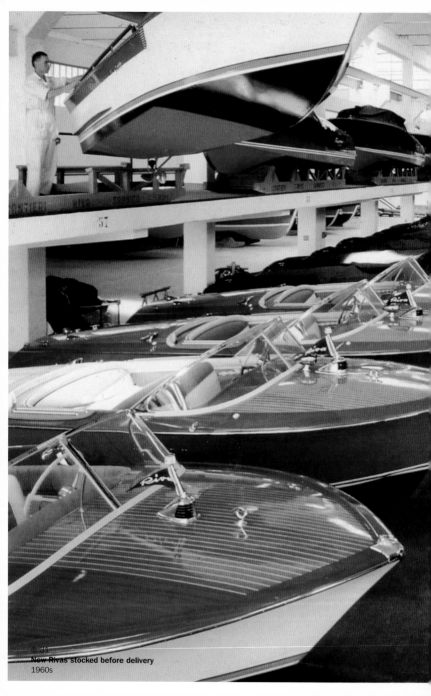

New Rivas stocked before delivery
1960s

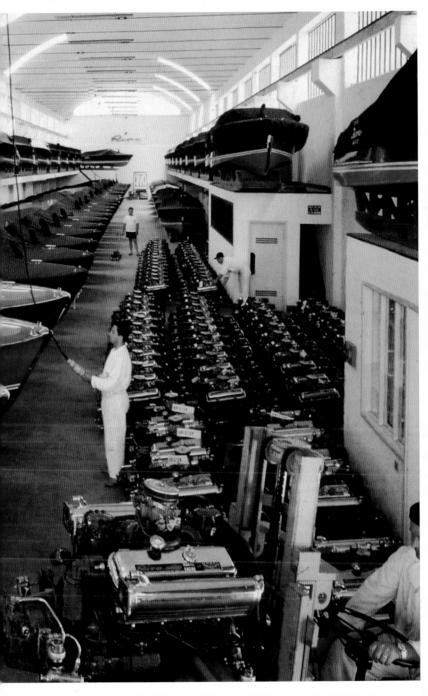

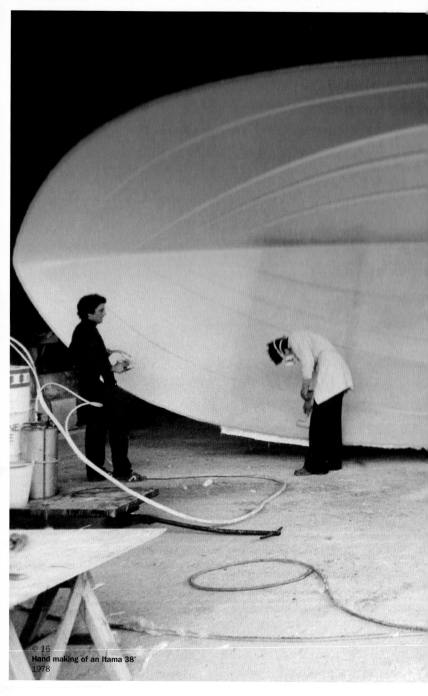

© 16
Hand making of an Itama 38'
1978

Malgré l'emploi dans l'industrie, de l'acier, de l'aluminium et même du béton, les bateaux sont construits en bois depuis plus de 4000 ans. A la base, la coque est construite de planches massives qui sont fixées sur un châssis, ressemblant aux côtes d'un thorax, et qui lui-même repose sur une lourde quille. Il existe deux types de construction : le chevauchement, où les planches se recouvrent, ce qui donne un aspect très particulier, et permet une forme de glissement très harmonieuse. La construction aboutée, la plus moderne apporte un style plus efficace pour la vitesse, une coque lisse et des planches montées bout à bout. Dans les années 50, la construction de navires en bois plaqué de haute technologie, comme par exemple le Riva en 1957, remplaça les planches traditionnelles. La même année, de nombreux chantiers navals américains proposaient des petits navires en fibres de verre. Un mélange de résine polyester et de fibres de verre, permettait enfin une reproduction simple et rapide de coques sur la base d'une seule forme. Les bateaux en fibres de verre sont plus stables, garantis étanches et – grâce à une couche externe en Gelcoat pigmenté – plus faciles à entretenir. Comme ils représentent le début de la navigation populaire en bateau à moteur, ils sont définitivement devenus des classiques.

Si bien la industria ya ha empleado acero, aluminio y hasta hormigón, las embarcaciones han sido hechas más de 4000 años en madera. Fundamentalmente se construye el casco de tablones macizos, sobre los que se fija un marco costiforme, que a su vez asienta sobre una pesada quilla. Existen dos tipos de construcción: el modo de tingladillo está constituido de tablones que se superponen, lo que resulta en un aspecto único y un modo de marcha suave. La tablazón a tope por el contrario es el estilo más nuevo y más eficiente para la velocidad, con un casco liso y tablones montados canto contra canto. En los años 50 la madera contrachapeada de alta tecnología reemplazó gradualmente los tablones tradicionales, así p.ej. en Riva en 1957. En el mismo año muchos astilleros americanos ofrecía pequeñas embarcaciones de fibra de vidrio. Una mezcla de resina poliéster y fibra de vidrio posibilitó finalmente la sencilla y rápida reproducción de cascos sobre la base de un único modelo. Las embarcaciones de fibra de vidrio son más estables, garantizadamente estancas y –con su capa exterior de Gelcoat pigmentado– más fáciles de conservar. Debido a que marcan el inicio de la navegación a motor popular, son entretanto, un clásico definitivo.

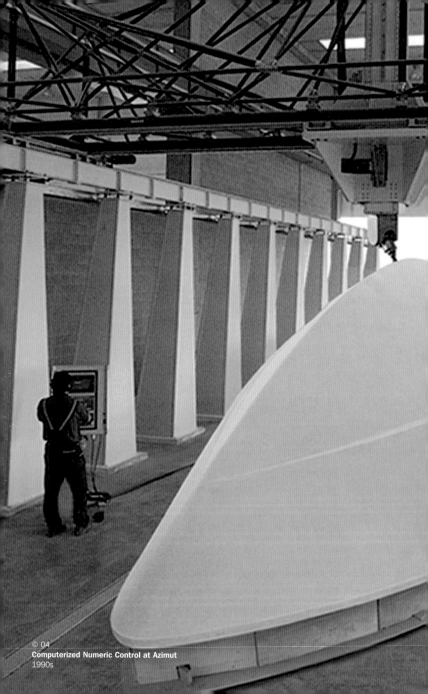

Computerized Numeric Control at Azimut
1990s

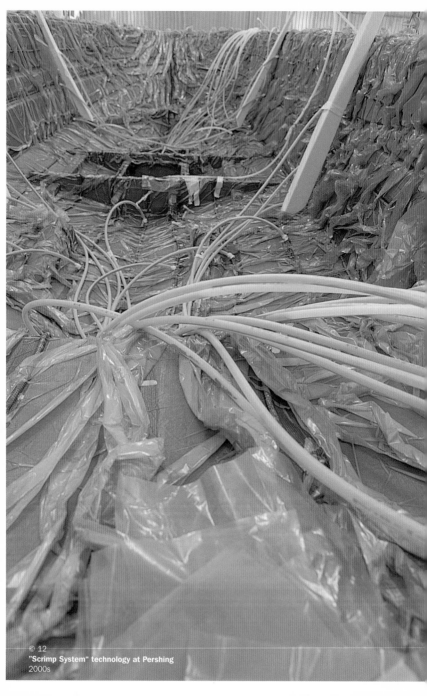

© 12
"Scrimp System" technology at Pershing
2000s

Nonostante si sia usato ferro, alluminio e persino il ferrocemento, per oltre quattromila anni le barche sono state fatte di legno. Tipicamente, uno scafo in legno é costruito con fasciame applicato su un'ossatura di ordinate fissate lungo una chiglia longitudinale. Esistono due stili fondamentali: clinker e carvel. Nel primo, di origine vichinga e dal look caratteristico, il fasciame viene applicato ad orli sovrapposti per una navigazione piú "morbida". Nel secondo, tipico delle barche veloci, il fasciame è liscio per maggiore efficienza ma anche piú durezza sull'acqua. Negli 50, il compensato marino a lastre sostituisce gradualmente il fasciame in legno massello, per esempio sui Riva dal 1957. Nello stesso anno Glastron comincia la produzione di barche in vetroresina, un nuovo materiale giá sperimentato nell'automobile dal 1953. Un composito a base di resina poliestere, la vetroresina permette la veloce riproduzione, sulla base di uno stesso stampo, di carene robuste, a perfetta tenuta e facili da mantenere. Avendo segnato la nascita della nautica popolare, anche gli scafi in vetoresina – nelle loro variazioni di forma e colore – sono ormai a tutti gli effetti dei classici.

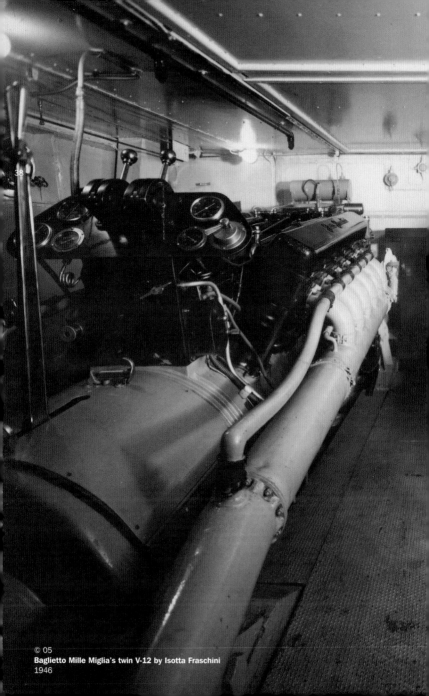

Baglietto Mille Miglia's twin V-12 by Isotta Fraschini
1946

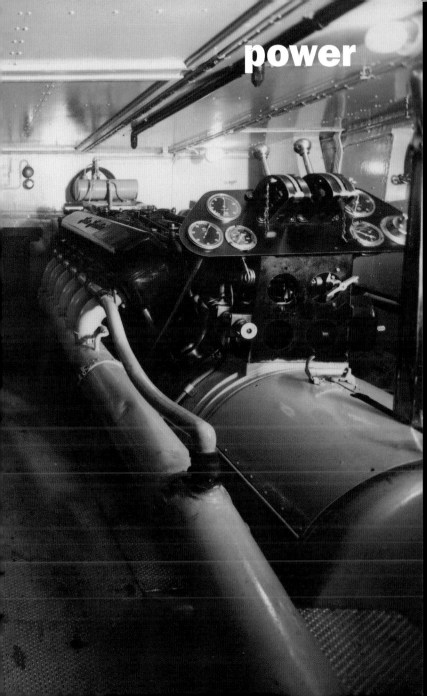

power

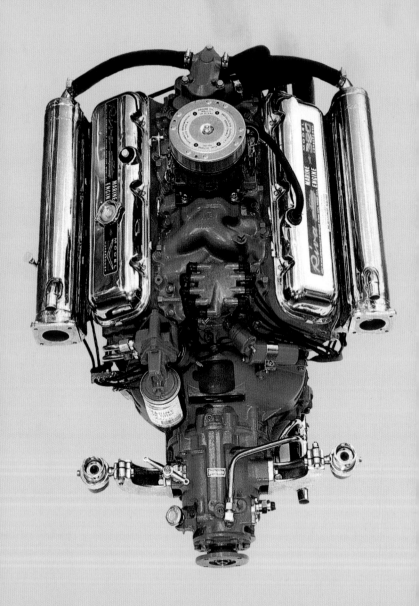

© 31
Riva Crusader 7 Liter V-8 320 hp
1967

True motorboats have inboard engines, V-driven by a shaft linked to a propeller and operated by a rudder via steering wheel. While single engine remains a standard, twin is common for larger and triple engines are not unusual for high-performance boats—these can be mounted side-by-side or in a staggered arrangement. Isotta Fraschini, Dodge, Chrysler and even Cadillac used to provide power to motorboats, but Chris Craft were the first to develop own engines, like the 100 hp V-8 on runabouts for 1922. Straight-6 and powerful V-8 soon became the preferred choice, with power rates steadily growing. Mercury Marine's top engine now turns 1075 hp out of 9.1 Liter displacement. Revolution came in 1959 when Volvo Penta introduced the Aquamatic stern-drive system, by now a standard, which features an inboard mounted engine linked to an outboard unit integrating shaft, steering and a propeller—or, since 1983, twin counterrotating Duoprops. In the 70s they introduced diesel engines that rapidly became a benchmark for power, economy and safety. In 2005 Volvo Penta launched IPS, which promises to be another breakthrough in inboard efficiency and performance.

Echte Motorboote haben ihre Maschine innen. Angetrieben von einer Welle, die mit einem Propeller verbunden ist, werden sie mittels eines mit einem Ruder gekoppelten Lenkrades gesteuert. Doppelmotoren sind Standard in größeren und drei Motoren arbeiten in Hochleistungsbooten – sie können nebeneinander gebaut oder auch gestaffelt werden. Automobilfirmen wie Dodge, Chrysler und sogar Cadillac waren die Hersteller, bis Chris Craft 1922 als erste eigene Maschinen fertigten. Straight-6 und kraftvolle V8-Motoren waren die bevorzugte Wahl, mit ständig steigender Leistung. Mercury Marines bestes Modell holt heute aus 9,1 Liter Hubraum 1075 PS heraus. Volvo Penta löste 1959 mit der Einführung des Aquamatic stern-drive eine kleine Revolution aus. Er ist mittlerweile Standard und besteht aus einem Innenmotor, der mit einer Außeneinheit verbunden ist, die wiederum Welle, Steuerung und Propeller integriert. Oder auch, seit 1983, als Duoprop-Antrieb mit gegenläufig rotierenden Schrauben. In den 70ern führte Volvo Penta Dieselmotoren ein, die schnell zum Maßstab für Leistung, Ökonomie und Sicherheit wurden. 2005 stellten sie IPS vor, das ein weiterer Durchbruch in Sachen Effizienz und Performance zu werden verspricht.

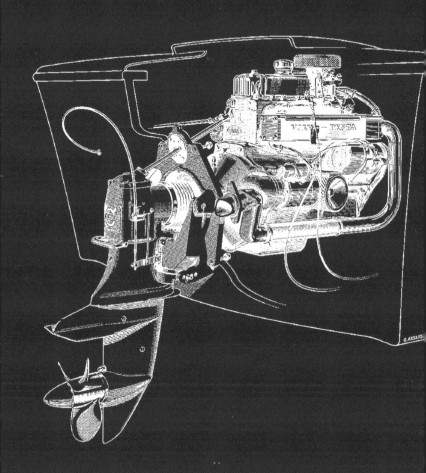

© 34
Volvo Penta Aquamatic
1959

Les vrais bateaux à moteur ont leur machine à l'intérieur du bateau. Entraînés par un arbre relié à une hélice, ils sont commandés par une roue reliée à un gouvernail. Les moteurs doubles sont un standard pour les plus grands, et les moteurs triples travaillent sur des bateaux à hautes performances – ils peuvent être montés en parallèle ou aussi en série. Les fabricants automobiles tels que Dodge, Chrysler et même Cadillac en furent les fabricants, jusqu'à ce que Chris Craft réalise le premier un moteur purement nautique (1922). Le Straight-6 (six cylindres en ligne) et les puissants moteurs V8 furent le choix favori, avec des performances toujours croissantes. Le meilleur modèle de Mercury Marine développait 1075 ch à partir d'un moteur de 9.1 litres de cylindrée. Avec la sortie de son Aquamatic stern-drive, en 1959, Volvo Penta provoqua une petite révolution. C'est devenu un standard, constitué d'un moteur interne, et relié à une unité externe, qui elle-même intègre l'arbre, le gouvernail et l'hélice. Ou aussi depuis 1983, l'entraînement Duoprop avec des hélices qui tournent à contresens. Dans les années 70, Volvo Penta introduisit les moteurs diesel qui rapidement devinrent une référence en matière de performances, économie et sécurité. En 2005 ils présentent le IPS qui promet de devenir un nouveau scénario en matière d'efficacité et de performances.

Auténticas embarcaciones a motor tienen su motor interior. Propulsado por un árbol, unido a la hélice, se timonean mediante un volante acoplado a un timón. Motores dobles son estándar en embarcaciones mayores y tres motores trabajan en embarcaciones de altas prestaciones –pueden ser instalados uno al lado del otro o también escalonados. Empresas automotrices como Dodge, Chrysler y hasta Cadillac eran los fabricantes, hasta que Chris Craft como primero construyó sus máquinas propias (1922). Straight-6 potentes motores V8 eran la elección preferida, con un incremento permanente de la potencia. El mejor modelo de Mercury Marine extrae hoy de 9,1 litros de cilindrada, 1075 CV. Volvo Penta indujo en 1959 con la introducción del Aquamatic stern-drive una pequeña revolución. Éste entretanto es estándar y está constituido de un motor interno, combinado con una unidad externa, que a su vez integra el árbol, el control y la hélice. O también, desde 1983, como accionamiento Duoprop con hélices de rotación a contramarcha. En los años 70 Volvo Penta introdujo los motores diesel, que rápidamente se convirtieron en el modelo de prestaciones, economía y seguridad. En 2005 presento IPS, que promete ser otra irrupción en el tema eficiencia y Performance.

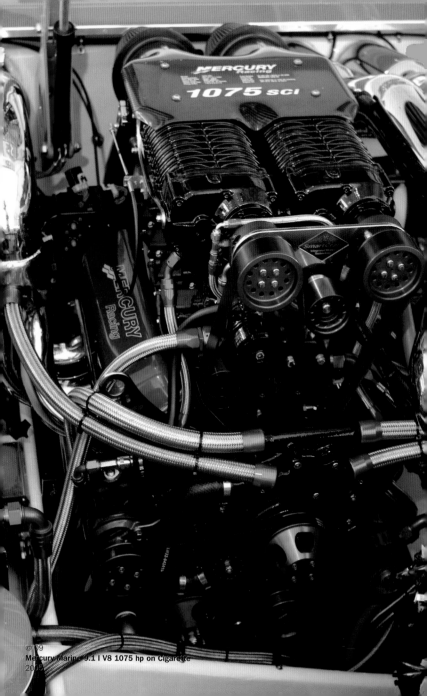

MERCURY
Racing
1075 SCI

Le "vere" barche a motore hanno motore entrobordo, collegato all'elica attraverso un albero e timonate tramite un volante. Barche piú grandi possono avere due o addirittura tre motori, montati in parallelo o sfalsati per guadagnare spazio in larghezza. Inizialmente furono Isotta Fraschini, Dodge, Chrysler e persino Cadillac a fornire motori, nel 1922 Chris Craft è il primo cantiere ad iniziare la produzione in conto proprio. Negli anni 50 i suoi 6 cilindri in linea e poi i robusti V8 diventarono la scelta preferita di Riva, come il famoso 283 di 185 cavalli. Le potenze sono andate via via crescendo: il motore di punta della Mercury di 9,1 litri di cilindrata oggi fornisce 1075 cavalli. La vera rivoluzione arrivó nel 1959 con la trasmissione entrofuoribordo Aquamatic della Volvo Penta, che integrava in un unico elemento albero timone ed elica – o, dal 1983 doppie eliche contororotanti Duoprop. Questo sistema di facile installazione e gestione è oggi uno standard riconosciuto. Negli anni 70 fu ancora Volvo Penta a puntare sul motore turbodiesel, piú economico e sicuro. Del 2005 è il sistema IPS, che promette ulteriori vantaggi in termini di rendimento.

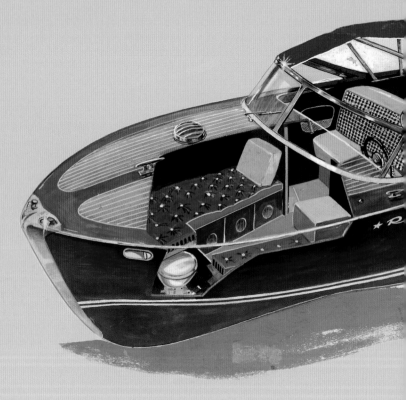

Barilani's cutout drawing of Riva Tritone for the magazine Quattroruote
1958

design

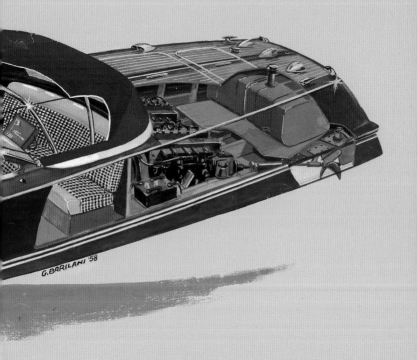

G.BARILANI '58

Soft Chine

Hard Chine | Hydroplane

Deep-V

3-Point | Cathedral

Stern
Heck
Poupe
Popa
Poppa

Hatch
Luke
Écoutille
Escotilla
Boccapo

Transom
Heckspiegel
Arcasse
Espejo de popa
Specchio di poppa

Top sides
Seitenbeplattung
Muraille
Chapas del costado
Murate

Hull | Rumpf | Coque | Casco | Carena

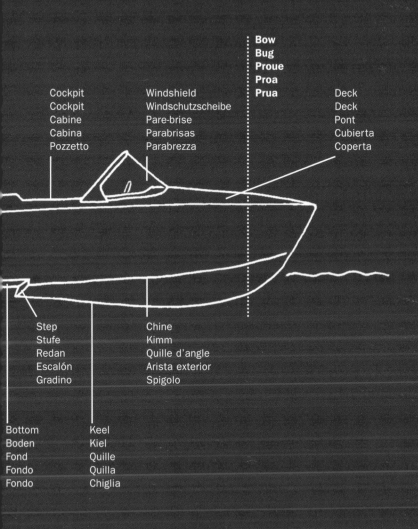

Cockpit
Cockpit
Cabine
Cabina
Pozzetto

Windshield
Windschutzscheibe
Pare-brise
Parabrisas
Parabrezza

Bow
Bug
Proue
Proa
Prua

Deck
Deck
Pont
Cubierta
Coperta

Step
Stufe
Redan
Escalón
Gradino

Chine
Kimm
Quille d'angle
Arista exterior
Spigolo

Bottom
Boden
Fond
Fondo
Fondo

Keel
Kiel
Quille
Quilla
Chiglia

© 14
Basic nautical jargon
2005

A boat family may be created building more superstructures over one same hull, the latter responsible for performance, the former for style. Many hull designs have been tested: hard chine hydroplanes, also with redan-steps, were introduced around 1910. Hulls gradually developed into deep-V, credited to Hunt in 1958 and a standard today. Market growth led to the diversification of typologies. With confusing denominations across all brands, the chart is an attempt to provide a chronological overview. There has been a golden age of racers and runabouts until the 30s, a classic age of utility and cruisers down to the 50s. Both faded away as fiberglass substituted wood. Mass production started with automobile style fins, chromes and colors. New lines became sleeker and cleaner in the 60s—the best years—, more edgy in the 70s—the flat iron style—and rather funky in the 80s. Motor boats have since rapidly grown in size. In the 90s, fiberglass superstructures and glued windows brought about curvy, fuzzy lines that may not be up to everyone's taste. Yet, with an emerging collector's market, Retro has become a trend and classics are now being reedited.

Eine Bootsfamilie besteht aus verschiedenen Aufbauten, die auf den gleichen Rumpf gesetzt werden – letzterer ist verantwortlich für die Leistung, erstere für den Stil. Gleitboote mit harter Kimm und zum Teil Stufen wurden um 1910 eingeführt. Die Rümpfe entwickelten sich allmählich zum Deep-V, der heute Standard ist und Hunt zugeschrieben wird (1958). Das Marktwachstum führte zur Diversifizierung der Typologien; die Chart versucht angesichts verwirrender Bezeichnungen einen chronologischen Überblick zu liefern. Bis in die 30er gab es ein goldenes Zeitalter der Racer und Runabouts, danach ein klassisches der Utilities und Cruiser bis in die 50er. Beide verschwanden, als Fiberglas Holz ersetzte. Die Massenproduktion bediente sich stilistisch mit angelehnten Finnen, Farben und Chrom beim Automobil. In den 60ern – den besten Jahren – wurden die Linien schlanker und klarer, in den 70ern – im „Bügeleisenstil" – kantiger, und ab den 80ern zunehmend verspielt. Seitdem sind Motorboote rapide gewachsen. Die 90er brachten mit Fiberglas-Aufbauten und geklebten Fenstern kurvige, extravagante Formen, die nicht jedem gefallen. Mit einem wachsenden Sammlermarkt kam dann auch der Retro-Trend, so dass die Klassiker nun wieder da sind.

Une famille de bateaux est composée en général d'équipements différents qui sont montés sur une même coque – cette dernière étant responsable des performances, et les équipements du style. Les bateaux glisseurs à bouchain dur et en partie à degrés, ont été introduits vers 1910. Les coques se développent progressivement vers le Deep-V, aujourd'hui devenu un standard, et dont l'invention est attribuée à Hunt (1958). La progression du marché a permis une diversification typologique; le tableau s'efforce de fournir une vision chronologique. Jusque dans les années 30 il y eut l'époque dorée des Racer et Runabouts, ensuite une période classique jusque dans les années 50. Les deux disparurent dès lors que la fibre de verre remplaçait le bois. La production de masse s'inspira des placages, couleurs et chromes de l'industrie automobile. Dans les années 60 – les meilleures années – les lignes se sont clarifiées, dans les années 70 – le «style fer à repasser» était anguleux, et depuis les années 80 le style est devenu de plus en plus inspiré. Les années 90 nous ont offert, avec la fibre de verre, des équipements et des fenêtres collées, des formes courbes et extravagantes qui ne sont pas pour plaire à chacun. Avec un marché de la collection en pleine croissance, on assiste à une tendance rétro.

Una familia de embarcaciones está constituida de diferentes superestructuras, que se colocan sobre el mismo casco –este último es responsable de las prestaciones, las primeras por el estilo. Las embarcaciones deslizantes con pantoque duro y en parte escolando, fueron introducidas en 1910. Los cascos se desarrollaron gradualmente hacia el Deep-V, que hoy es un estándar y se le adjudica a Hunt (1958). El crecimiento del mercado condujo a la diversificación de las tipologías; el Chart intenta a la vista de denominaciones confusas, ofrecer una visión cronológica. Hasta entrados los años 30 hubo una era de oro de los Racer y Runabouts, a continuación una clásica hasta entrados los años 50. Ambas desaparecieron cuando el fibra de vidrio sustituyó la madera. La producción masiva se sirvió de similares acabados, colores y cromo del automóvil. En los años 60 –los mejores años– las líneas se tornaron más claras, en los años 70 en más angulosa al estilo "plancha". Desde ese momento las embarcaciones a motor han crecido rápidamente. Los años 90 aportaron con superestructuras de fibra de vidrio y ventanas pegadas, formas curvilíneas y extravagantes, que no son del gusto de todos. Con un creciente mercado de coleccionistas llegó entonces también la tendencia Retro.

52 **Una famiglia di barche** puó essere creata su una sola carena, elemento prestazionale fondamentale. La carena planante, anche del tipo a uno o piú redan, venne introdotta intorno al 1910. Negli anni 50 essa si trasformó nella famosa V profonda con pattini longitudinali, attribuita ad Hunt ed oggi uno standard riconosciuto. La crescita del mercato ha portato ad una diversificazione tipologica spesso difficile da seguire. Il grafico ne rivede in forma semplificata lo sviluppo cronologico. Dopo gli anni 30, l'etá d'oro dei Racer e Runabout, si é entrati nel periodo classico degli Utility e dei Cruiser fino agli anni 50. Con l'arrivo della vetroresina e della V profonda arriva anche la vera produzione di massa e lo stile automobilistico. Le linee diventano slanciate e orizzontali negli anni 60, squadrate e "stirate" negli anni 70 e sempre piú ricercate negli anni 80. Nella corsa verso barche sempre piú grandi e di effetto, gli anni 90 portano linee curve, fantasiose e non sempre equilibrate. Parallelamente si sviluppa una tendenza Retro, che cerca il recupero di parte dell'eleganza perduta.

Note

When judging a boat's design and features, size does matter. Although European makers prefer the metric system, length is typically indicated in foot. Roughly said, 10 meters equal 33', 10' equal 3 meters. The exact conversion factor is 1 m = 3.28'; 1' = 30.48 cm. Speed matters too: the correct way to measure it is the knot or nautical mile per hour. This is how to compare: 10 knots equal 18.52 km/h or 11.51 mph; 10 mph equals 8.69 knots or 16.09 km/h; 10 km/h equal 5.4 knots or 6.21 mph.

Obwohl europäische Bootsbauer das metrische System bevorzugen, werden Längenmaße typischerweise in Fuß angegeben. 10 Meter entsprechen ungefähr 33', 10' entsprechen 3 Metern. Der exakte Umrechnungsfaktor ist 1 m = 3,28'; 1' = 30,48 cm. Geschwindigkeit zählt ebenfalls: sie wird korrekterweise in Knoten oder nautischen Meilen pro Stunde gemessen. 10 Knoten entsprechen 18,52 km/h oder 11,51 mph; 10 mph entsprechen 8,69 Knoten oder 16,09 km/h; 10 km/h entsprechen 5,4 Knoten oder 6,21 mph.

Malgré, en Europe, l'emploi plus répandu du système métrique, la longueur des bateaux est le plus souvent donnée en pieds. Un 10 mètre correspond à peu près à 33', 10' correspondent à 3 mètres. Le facteur de conversion exacte est 1 m = 3,28'; 1' = 30,48 cm. La vitesse est également importante: l'unité correcte est le noeud ou mile marin à l'heure. 10 noeuds correspondent à 18,52 km/h ou 11,51 mph; 10 mph correspondent à 8,69 noeuds ou 16,09 km/h; 10 km/h correspondent à 5,4 noeuds ou 6,21 mph.

Si bien los constructores europeos de embarcaciones prefieren el sistema métrico. Las medidas de eslora se indican típicamente en pies. 10 metros corresponde aproximadamente a 33', 10' corresponden a 3 metros. El factor exacto de conversión en 1 m = 3,28'; 1' = 30,48 cm. La velocidad cuenta asimismo: se indica correctamente en nudos o millas náuticas por hora. 10 nudos corresponden a 18,52 km/h o 11,51 mph; 10 mph corresponden 8,69 nudos o 16,09 km/h; 10 km/h corresponden a 5,4 nudos o 6,21 mph.

Giudicando il design e le caratteristiche di una barca, le dimensioni contano. Esse sono tipicamente espresse in metri o in piedi. Grosso modo, 10 metri equivalgono a 33', 10' a 33 metri. Il fattore esatto è 1 m = 3,28'; 1' = 30,48 cm. Anche la velocitá conta: essa viene correttamente indicata in nodi o miglia nautiche per ora. 10 nodi equivalgono a 18,52 km/h o 11,51 miglia orarie. 10 km/h equivalgono a 5,4 nodi o 6,21 mph, 10 mph equivalgono infine a 8,69 nodi o 16,09 km/h.

54

1900 10 20 30 40

UTILITY

RUNABOUT

RACER

SEDAN

FAST COMMUTER

CRUISER

1900 10 20 30 40

© 14

types

Racer

Racers cater to a community of wealthy, speed-crazy gentlemen that had one-off boats, with fancy names like Excalibur Breguet, built for the sake of entertainment and pride. Early designs were traditional hulls, with soft chine and front mounted engines. They gradually evolved into Hydroplanes with flat bottom, hard chine and stepped hull for increasing performance. Gar Wood's Miss America of 1920 had twin 400 hp V-12 Liberty engines for 76.66 mph. With Gold Cup regulations calling for simpler boats in 1922, further development was carried on in Europe. The aircraft engineer and boatmaker Vincenzo Vittorio Baglietto is credited with the most striking raceboat designs down to the 30s.

Racer zielten auf die Gemeinschaft wohlhabender, nach Geschwindigkeit gierender Herren. Sie besaßen Einzelstücke mit so schmucken Namen wie „Excalibur Breguet" und dienten der Unterhaltung und der Protzerei. Die frühen Designs hatten traditionelle Rümpfe, mit weicher Kimm und Frontmotor. Sie entwickelten sich graduell zu Gleitbooten mit flachem Boden, harter Kimm und stufigem Rumpf für größere Leistungen. Gar Woods „Miss America" von 1920 hatte eine doppelte 400 PS V-12 Liberty Engine, die 76.66 mph machte. Da die Gold Cup-Regulationen 1922 einfachere Boote erzwangen, fand die weitere Entwicklung in Europa statt. Dem Flugzeugingenieur und Bootsbauer Vincenzo Vittorio Baglietto werden die bedeutendsten Rennbootdesigns bis in die 30er Jahre hinein nachgesagt.

Baglietto, "Montelera"

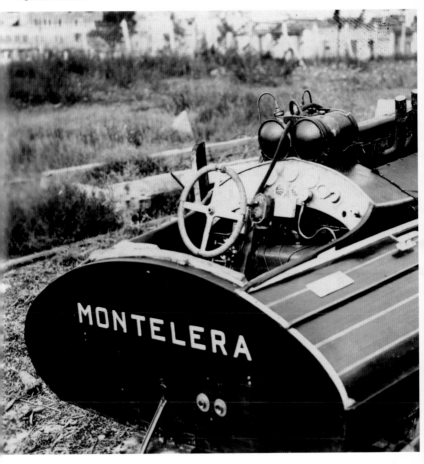

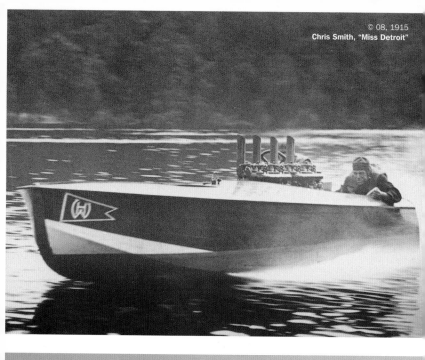

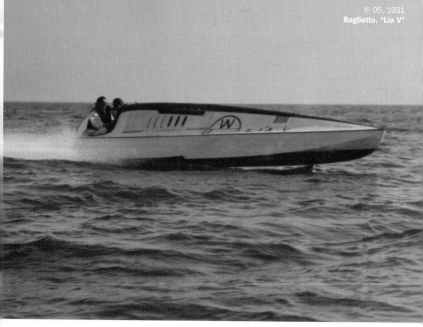

Les Racer devaient cibler la communauté des nantis passionnés de vitesse. Ils étaient des exemplaires uniques portant des noms évocateurs comme «Excalibur Breguet» et servaient le divertissement et l'étalage des richesses. Les premiers designs possédaient des coques traditionnelles avec une étrave douce et un moteur frontal. Ils se sont développés vers le glisseur à fond plat, étrave relevée et coque étagée, pour obtenir de meilleures performances. Gar Woods «Miss America» en 1920, possédait un double moteur V-12 Liberty de 400 ch qui atteignait les 76,66 mph. Comme le règlement de la Gold Cup de 1922 imposait des bateaux plus simples, le développement continua en Europe. On attribue à l'ingénieur aéronautique et constructeur de bateaux Vincenzo Vittorio Baglietto les designs de bateaux de course les plus remarquables jusque dans les années 30.

Racer apuntó a los acaudalados de la sociedad, personas ávidas de velocidad. Ellos poseían piezas únicas con nombres tan decorados como "Excalibur Breguet" y servían al entretenimiento y a la ostentación. Los precoces diseños tenían cascos tradicionales, con quilla blanda y motor delantero. Ellos se desarrollaron gradualmente a embarcaciones deslizantes con fondo plano, quillas dura y casco escalonado para grandes prestaciones. Gar Woods "Miss America" de 1920 tenía una propulsión doble de 400 CV V-12 Liberty Engine, con la que alcanzaba 76,66 mph. Debido a que la reglamentación de la Gold Cup de 1922 obligaba a embarcaciones sencillas, el desarrollo continuó en Europa. Al ingeniero aeronáutico y constructor de embarcaciones Vincenzo Vittorio Baglietto se le atribuyen los diseños más prestigiosos de embarcaciones de competición hasta entrados los años 30.

I Racer sono il frutto della passione per la velocitá, scoppiata all'inizio del XX secolo, e destinata ad intrattenere una comunitá di pochi facoltosi gentlemen e di alimentarne l'orgoglio con nomi altisonanti come "Excalibur Breguet". I primi Racer avevano una carena classica tonda, con motore montato anteriormente. Essi si svilupparono velocemente in idroplani con fondo piatto e carena planante, spesso muniti di uno o piú redan. La Miss America di Gar Wood avava nel 1920 due motori d'aereo per un totale di 800 cavalli e 76,66 miglia orarie. A partire dal 1922, con il cambio delle regole per la Gold Cup, che favoriva i Runabout di serie, lo sviluppo continuó in Europa nelle mani, tra gli altri, di Vincenzo Vittorio Baglietto.

Runabout

The Belle Isle Bearcat of 1920 was the first front-cockpit mid-engine modern runabout, a boat meant to quickly "run about" calm lake or river areas. In 1922 Chris Craft presented their 26' runabout, the first one designed for mass production. Typically, runabouts have one to three cockpits with a rather formal seating layout in rows—sunbathing and water sports were not yet en vogue. Elegant, luxurious, rich in chrome detailing, the classic runabouts have a windshield over an extensive wooden deck that includes flush mounted engine bonnets. The transom is mostly flat but barrel-stern design, introduced by Chris Craft in 1936, makes for the most beautiful boats. The last true runabout, Riva's Ariston, ceased production in 1975.

Die „Belle Isle Bearcat" von 1920 war der erste moderne, mit Frontcockpit und Mittelmotor ausgestattete Runabout – ein Boot, das schnell über ruhige Seen und Flüsse gleiten sollte. 1922 präsentierten Chris Craft mit ihrem 26'-Runabout das erste Massenprodukt in dieser Sparte. Typischerweise haben Runabouts ein bis drei Cockpits, das Sitzarrangement ist wegen der reihenhaften Anordnung eher formal zu nennen – Sonnenbad und Wassersport waren noch nicht en vogue. Elegant, luxuriös und reich an Details aus Chrom, haben die klassischen Runabouts eine Frontscheibe über einem ausgedehnten Holzdeck mit glatt eingefasster Motorhaube. Chris Craft führte 1936 auch den runden, fassförmigen Heckspiegel ein. Die Produktion des letzten echten Runabouts, Rivas Ariston, wurde 1975 eingestellt.

Rudy Vallee on board a Chris Craft Runabout

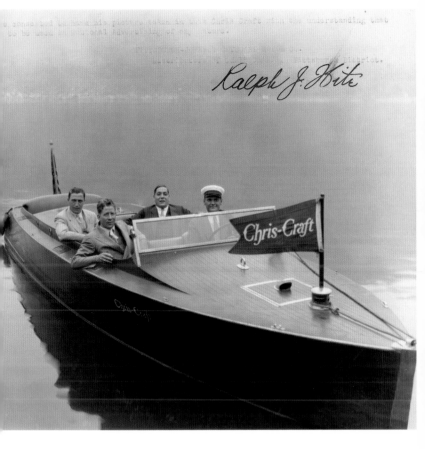

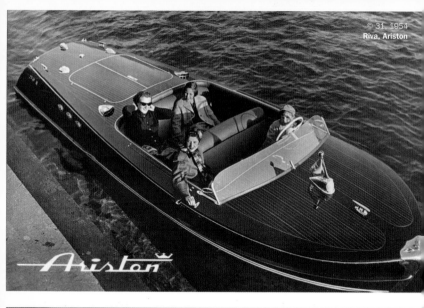

© 31, 1954
Riva, Ariston

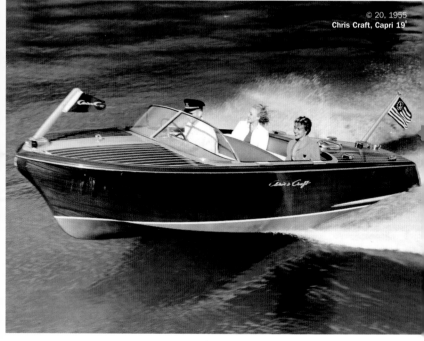

© 20, 1955
Chris Craft, Capri 19'

La «**Belle Isle Bearcat**» de 1920, fut le premier Runabout moderne, équipé d'un cockpit frontal et d'un moteur central – un bateau devant glisser rapidement sur des lacs et fleuves tranquilles. En 1922 Chris Craft présente, dans ce secteur, la première production de masse avec son 26' Runabout. Le Runabout comporte généralement un à trois cockpits, l'arrangement des sièges est plutôt formel en raison de la disposition par rangées – le bronzage et les sports nautiques n'étaient pas encore en vogue à l'époque. Les runabouts classiques sont luxueux et riches en détails chromés, ils possèdent une pare-brise sur un pont de bois très allongé intégrant une écoutille de moteur lisse. En 1936 Chris Craft introduit l'arcasse à tonneau. La production du dernier vrai runabout, le Riva Ariston, a été abandonnée en 1975.

El "**Belle Isle Bearcat**" de 1920 fue el primer Runabout moderno, equipado con cabina delantera y motor central –una embarcación, que debía deslizarse rápidamente sobre lagos y ríos tranquilos. En 1922 Chris Craft presenta con su Runabout 26' el primer producto masivo en este sector. Típicamente los Runabout tienen una a tres cabinas, el arreglo de asientos debe mencionarse, debido a la disposición en fila, más bien formal –baños de sol y deportes acuáticos aún no estaban en boga. Elegante, lujoso y rico en detalles de cromo, los clásicos Runabouts tenían una cristal delantero sobre una cubierta expandida de madera con escotilla de motor incorporada lisa. Chris Craft incorporó en 1936 también el espejo de popa redondo de forma de tonel. La producción del último auténtico Runabout, Ariston de Riva, fue discontinuada en 1975.

La "**Belle Isle Bearcat**" del 1920 viene considerata il primo Runabout moderno, con cockpit avanzato e motore centrale: una barca adatta ad "andare in giro" velocemente per laghi e fiumi tranquilli. Chris Craft presentó il suo primo Runabout seriale da 26 piedi nel 1922. Tipicamente, i Runabout avevano uno, due o tre cockpit con altrettante file di sedili – la tintarella a bordo e gli sport aquatici non erano ancora in voga. Eleganti, lussuosi e arricchiti da dettagli cromati, i Runabout classici avevano un parabrezza sopra una coperta molto estesa che includeva i cofani del vano motore montati a filo. Lo specchio di poppa era solitamente piatto e verticale, ma lo stile a botte – introdotto da Chris Craft nel 1936 – era indubbiamente il piú riuscito. L'ultimo vero Runabout, il Riva Ariston è uscito di produzione nel 1975.

Fast Commuter

Fast commuters were the most upscale fast boats money could buy. They became trendy between the 20s and 30s among the very wealthy, who used them to commute daily between waterfront residences in the Hamptons, Miami or Detroit and their respective city offices. Although the nicest examples were custom made one-offs, Chris Craft's fleet offered stock-built commuters since 1928. Even they sported roomy cabins that looked like posh living rooms with lavish decorations and brocade upholstery. Different, mostly separate, cockpit arrangements were possible. Now socially unthinkable of, the name fast commuter remains in use to indicate large sport yachts with open deck or hardtop configuration.

Fast Commuter waren die edelsten und teuersten Schnellboote. Zwischen den 20ern und 30ern wurden sie zur Mode unter den Reichen, die sie fürs tägliche Pendeln zwischen ihren Uferresidenzen in den Hamptons, Miami oder Detroit und den städtischen Büros benutzten. Obwohl die von Hand gefertigten Exemplare die schönsten waren, bot Chris Craft ab 1928 Commuter von der Stange an. Auch diese hatten geräumige Kabinen, die mit ihren aufwändigen Dekorationen und Möbeln mit Brokat wie piekfeine Wohnzimmer aussahen. In leicht schiefem Sprachgebrauch wird der Name „Commuter" (=Pendler) weiterhin genutzt, um große Sportyachten mit offenem Deck oder in Hardtop-Ausführung zu bezeichnen.

Chris Craft, 34' Commuter

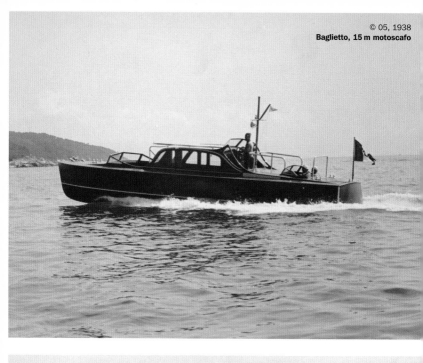

Baglietto, 15 m motoscafo

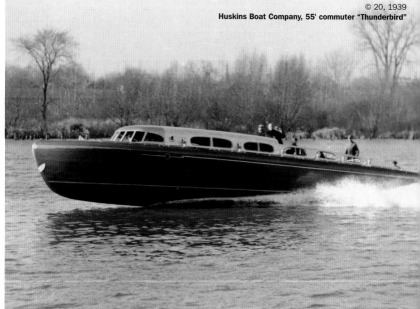

Huskins Boat Company, 55' commuter "Thunderbird"

Les Fast Commuter furent les bateaux à moteur les plus nobles et les plus chers. Entre les années 20 et 30 ils étaient devenus une mode parmi les gens riches qui dans leur quotidien les utilisaient pour la navette entre leur résidence au bord de la rive et leurs bureaux en ville. Bien que les exemplaires construits à la main étaient les plus beaux, Chris Craft proposa des Commuter en serie à partir de 1928. Ceux-ci avaient également des cabines spacieuses enrichies de décorations et de meubles en brocarts et ressemblaient à des salons de luxe. Dans un langage un peu ironique, le nom de «Commuter» (= navette) continue d'être employé pour désigner les grands yachts de sport à pont ouvert ou les modèles à Hardtop.

Fast Commuter fueron las embarcaciones rápidas más elegantes y caras. En los años 20 y 30 se han puesto de moda entre los ricos, que las utilizaban para su traslado personal diario entre sus residencias en la costa hasta sus despachos en la ciudad. Si bien los ejemplares fabricados a mano eran los más bellos, Chris Craft ofreció a partir de 1928 Commuter de fabricación en serie. También estas tenían amplias cabinas, que con sus onerosas decoraciones y muebles de brocato presentaban el aspecto de un salón superelegante. En el uso ligeramente desviado del idioma, se continua utilizando el nombre "Commuter" (=traslados cotidianos), para denominar grandes yates deportivos con cubierta abierta o en ejecución de Hardtop.

I Fast Commuter erano le barche veloci piú lussuose che il denaro potesse comprare. Di moda fra gli anni 20 e gli anni 30 in America, essi erano a servizio di persone agiate che li usavano per il tragitto tra ufficio e le residenze estive degli Hamptons, Miami o Detroit. Anche se i design piú belli furono esemplari unici, Chris Craft offriva giá nel 1928 un Commuter di serie su base Runabout. Anche questo proponeva un salotto galleggiante con tessuti e tendaggi preziosi e decorazioni assortite. Come nei Coupé de Ville, il pilota, ovviamente a servizio, sedeva all'esterno. Ora socialmente impensabili, il nome Commuter resta in voga per indicare grandi Sport Yacht con configurazione Hard Top o Convertibile.

Cruiser

With motor boating becoming more affordable, families were spending more time aboard and the need for more practical designs with day and overnight accommodation was felt. In the 30s the cruiser was born, less sporty than a runabout, with raised top sides and a deck superstructure to give space to cabins, toilets, a dinette and an enclosed galley with driver's cockpit. The finish was initially practical, with painted sides and little chrome. Over the years, numerous cruiser styles have been designed to fit different niches: the 1941 Chris Craft catalogue already offers seven. Fiberglass brought by rapid expansion and further diversification. Now more popular then ever, contemporary cruiser unfortunately lack most of the original elegance.

Mit zunehmender Erschwinglichkeit verbrachten immer mehr Familien ihre Zeit an Bord von Motorbooten, so dass praktischere Modelle für tägliche und nächtliche Unterbringung verlangt wurden: in den 30ern kam es zur Geburt des Cruisers. Mit seinen angehobenen Oberseiten und einem Aufbau, der Platz für Kabinen, Toiletten, Esszeile sowie die integrierte Kombüse mit Cockpit bietet, fällt er weniger sportlich als der Runabout aus. Das Finish war zunächst pragmatisch, mit einfach bemalten Flanken und wenig Chrom. Im Lauf der Jahre haben sich jedoch zahlreiche Stile entwickelt; bereits Chris Crafts Katalog von 1941 bot sieben Modelle an. Obwohl äußerst populär, mangelt es den zeitgenössischen Cruisern an der Eleganz der Originale.

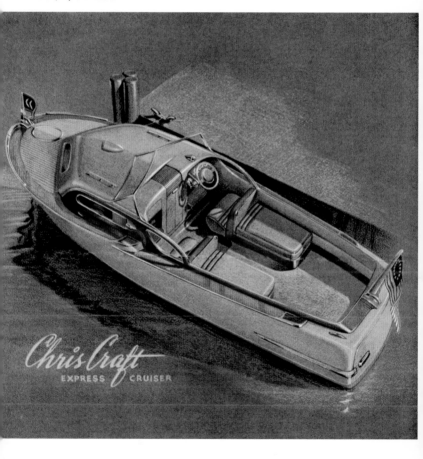

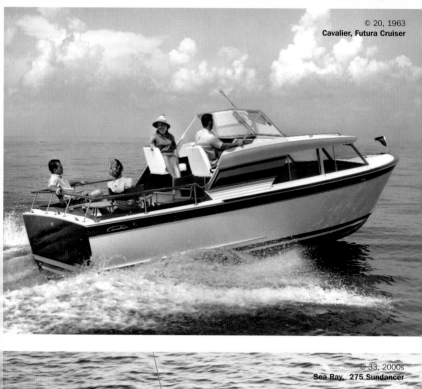

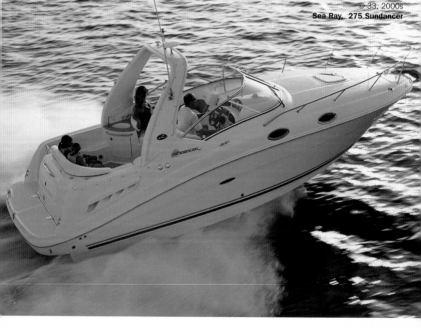

En raison de leur croissante accessibilité, de plus en plus de familles passèrent leurs loisirs à bord de bateaux à moteur, de sorte que la demande s'orienta vers des modèles plus pratiques pour l'habitation de jour et de nuit : dans les années 30 on assista donc à la naissance des Cruisers. Avec une partie supérieure surélevée et des aménagements qui fournissaient de la place pour des cabines, toilettes, salle à manger ainsi qu'une cambuse intégrée et un cockpit, le Cruiser possède une image moins sportive que le Runabout. La finition était au départ pragmatique, avec des flancs simplement peints et peu de chromes. Toutefois, dans le cours du temps, se sont développés de nombreux styles; le catalogue de Chris Craft de 1941 propose déjà sept modèles. Malgré leur extrême popularité, les Cruisers contemporains n'ont pas l'élégance de leurs prédécesseurs.

Con un creciente alcance para todos los bolsillos, cada vez más familias pasaban su tiempo a bordo de embarcaciones a motor, de manera tal que se solicitaron modelos prácticos para un alojamiento diurno o nocturno: en los años 30 vio la luz el Cruiser. Con su parte superior elevada y una superestructura que ofrecía espacio para cabinas, sanitarios, espacio para comer así como una cocina de a bordo con cabina, resulta menos deportiva que el Runabout. Los acabados en principio eran pragmáticos, con superficies sencillamente pintadas y poco cromo. En el transcurso de los años sin embargo se han desarrollado una gran cantidad de estilos; y el catálogo de Chris Craft de 1941 ofrecía siete modelos. Si bien extremadamente popular, en los Cruiser contemporáneos se siente a falta de la elegancia de los originales.

Negli anni 30, mentre la motonautica diventava sempre più accessibile, le famiglie cominicarono a passare sempre più tempo a bordo. Il desiderio di più spazio vivibile e di cabine per la notte cominciava a farsi sentire, segnando la nascita del Cruiser. Meno sportivo del Runabout di cui condivideva la carena, il Cruiser ha fiancate rialzate, una sovrastruttura accentuata per contenere cabine, servizi, posto guida e uno spazio vivibile: la dinette. Dotati di finiture pratiche, con superfici verniciate e poche cromature, il concetto di Cruiser si é evoluto in più direzioni: nel 1941 Chris Crfat ne aveva a catalogo ben sette. La vetroresina ne ha moltiplicato il successo e la diversificazione: ora più popolari che mai, i Cruiser assomigliano peró troppo spesso a suppostone galleggianti.

Sedan

A less sporty, all season version of runabouts and utilities, the sedan, features a wooden superstructure built over the cockpit. First introduced by Chris Craft in 1928, these enclosed-drive boats made it possible to navigate under worse conditions protecting the driver and passengers from rain and water spray. Both in utilitarian standard trim and in deluxe versions, sedans catered for formal use and were often chauffer driven. Convertible sedans, launched 1931, were fitted with a foldable soft-top or a retractable hardtop, thus making them more enjoyable in the hot season. Nevertheless, sedans gradually disappeared as people started using their boats for family entertainment and sports activities.

Die Aufbauten des Sedans, der eine weniger sportliche, dafür ganzjahrestaugliche Version der Runabouts und Utilities ist, sind über dem Cockpit angebracht. Diese von Chris Craft 1928 eingeführten und mit integriertem Antrieb ausgestatteten Boote ermöglichten die Navigation auch unter schlechteren Bedingungen, da sie den Fahrer vor Wasser schützten. Sowohl in der Standard- wie auch in der Deluxe-Version wurde der Sedan oft von einem Chauffeur gesteuert. Die Convertible Sedans (1931) kamen mit faltbarem Stoffdach oder einklappbarem Hardtop, um den sommerlichen Komfort zu steigern. Trotzdem verschwand der Sedan langsam zu der Zeit, als Boote für Familieneinsätze und sportliche Aktivitäten eingesetzt wurden.

© 20, 1948
Chris Craft, 22' Custom Sedan

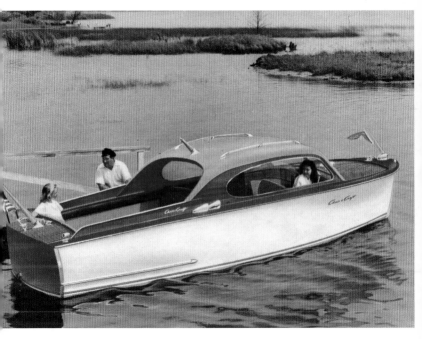

Coronet, 18 Hardtop Sedan

Scimitar, 23' 1/2 T-top sedan

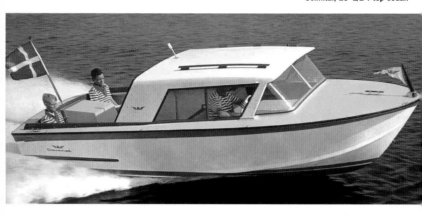

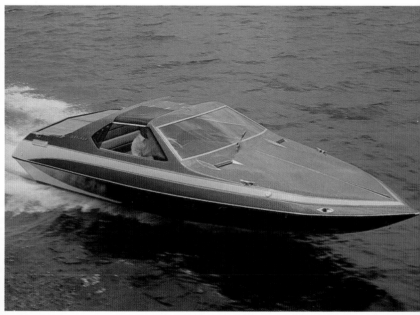

Les aménagements du Sedan, une version de Runabout et Utility moins sportive, mais par contre utilisable toute l'année, sont montés au-dessus du cockpit. Ce bateau introduit par Chris Craft, en 1928, possédait une commande intégrée qui permettait la navigation même dans de mauvaises conditions, car le navigateur était protégé des embruns. Aussi bien dans sa version Standard que Deluxe, le Sedan était souvent dirigé par un chauffeur. Le Sedan Convertible (1931) sera équipé d'un toit en toile repliable ou d'un Hardtop, afin d'augmenter le confort estival. Malgré tout, le Sedan a disparu à l'époque où les bateaux s'orientaient vers des besoins familiaux et des activités sportives.

Las superestructuras del Sedan, versión algo menos deportiva, pero en compensación utilizable todo el año de Runabout y Utility, están ubicadas sobre la cabina. Estas embarcaciones introducidas por Chris Craft en 1928 y equipadas con propulsión integrada, posibilitaban la navegación aún bajo condiciones desfavorables, debido a que protegían al timonel del agua. Tanto en la versión Standard como en la Deluxe el Sedan frecuentemente era conducido por un chofer. Los Convertible Sedan (1931) llegaron con capota de tela plegable o Hardtop escamoteable, para incrementar el confort veraniego. No es de extrañar por ello que el Sedan desapareció en el momento, que las embarcaciones se utilizaron para actividades deportivas o con la familia.

Una versione tranquilla e borghese del Runabout, la Sedan presenta una struttura in legno con finestratura laterale a protezione dei passeggeri. Introdotte da Chris Craft nel 1928, queste barche a guida interna rendevano possibile l'utilizzo anche in climi sfavorevoli. Sia in versione Standard che Deluxe, le Sedan erano adatte ad un uso formale e venivano spesso condotte da uno chauffer. Le versioni convertibili, lanciate nel 1931, erano equipaggiate con tetto apribile permettendo un uso piú gradevole nei mesi estivi. Ciononostante, le Sedan scomparvero gradualmente dal mercato con il dilagare della cultura del tempo libero e degli sport aquatici.

Utility

The Wall Street crash of 1929 left many boatmakers without work and the 30s began without too much hope of quick recovery. In those years, utility boats started being marketed as the more popular answer to the highly desirable but too expensive runabouts. With most of the deck covering left away, the engine covering reduced to a wooden box and no upholstery or chrome-thrills, utilities offered more flexibility at a lower price. The recipe proved successful: with the market growing, utes became more and more performing and refined. Ideal for sunbathing and waterskiing, they later evolved under Riva and Boesch into a more enjoyable boat concept, at least as fine as the runabout which they finally substituted.

Der Crash von 1929 an der Wall Street hinterließ viele arbeitslose Bootsbauer, und die 30er begannen ohne allzu viel Hoffnung auf Besserung. Utility Boats wurden damals als populäre Antwort auf die heiß begehrten, jedoch zu teuren Runabouts annonciert. Sie boten größere Flexibilität zu niedrigeren Preisen, da die Deckplanke wegfiel, der Motor nur von einer Holzbox verdeckt und auf Polstermöbel und Chromdetails ganz verzichtet wurde. Das Rezept erwies sich als erfolgreich: Mit wachsendem Markt wurden die „Utes" immer leistungsstärker und edler. Ideal für Sonnenbad und Wasserski, entwickelten sie sich unter Riva und Boesch zu einem derart komfortablen Bootskonzept, dass sie letztlich das Runabout sogar ersetzten.

Chris Craft, 17' Deluxe Utility

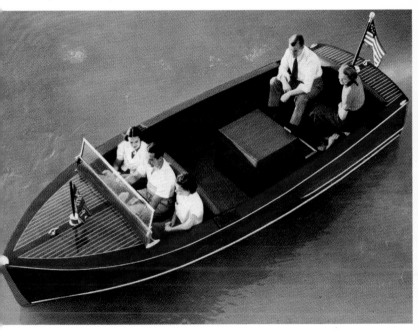

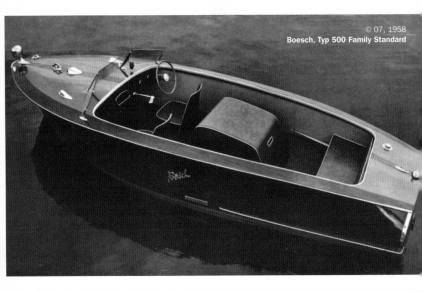

© 07, 1958
Boesch, Typ 500 Family Standard

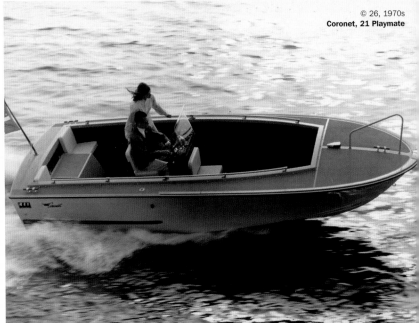

© 26, 1970s
Coronet, 21 Playmate

Le Crash boursier de 1929 à Wall Street, a plongé de nombreux constructeurs de bateaux dans la pénurie, et les années 30 débutèrent sans grande espérance d'amélioration. Les bateaux utilitaires (Utility Boats) furent à cette époque la réponse populaire annoncée aux Runabouts, très attractifs mais toutefois trop chers. Ils permettaient une grande flexibilité à prix abordable, les planches du pont étant supprimées, le moteur n'était plus caché que par une caisse en bois et on avait renoncé aux sièges rembourrés et aux détails chromés. La recette s'est révélée excellente : avec un marché en pleine croissance, les «Utes» devinrent de plus en plus performants et nobles. L'idéal pour le bronzage et le ski nautique, ils se sont développés sous les noms de Riva et Boesch vers un concept de bateaux d'un tel confort qu'ils finirent par détrôner même les Runabouts.

El Crash en 1929 en Wall Street dejó atrás muchos constructores de embarcaciones desempleados, y los años 30 comenzaron sin demasiadas esperanzas de mejora. Utility Boats fueron anunciados en aquel entonces como respuesta popular a los altamente codiciados, sin embargo demasiado caros Runabouts. Ellos ofrecieron mayor flexibilidad a precios bajos, debido a que se omitió el tablón de cubierta, el motor sólo cubierto por una caja de madera y se renunció totalmente a muebles tapizados y detalles en cromo. La receta resultó exitosa: con el crecimiento del mercado las "Utes" cada vez eran más potentes y elegantes. Ideal para tomar baños de sol y practicar el esquí acuático, evolucionaron bajo Riva y Boesch a un concepto de embarcación tan confortable, que finalmente incluso sustituyeron al Runabout.

Il crollo di Wall Street del 1929 lasció molti costruttori senza lavoro e gli anni 30 incominciarono senza grandi prospettive. In quegli anni, le barche Utility cominciavano ad essere proposte come alternativa ai Runabout, belli e desiderati ma troppo costosi. Eliminando gran parte della coperta in mogano e delle cromature e riducendo il cofano motore ad una scatola di legno, gli Utility offrivano maggiore flessibilitá d'uso ad un prezzo inferiore. La ricetta ebbe successo: ideali per la tintarella o gli sport aquatici, gli Utility si svilupparono con Riva e Boesch in barche godibilissime ed altrettanto raffinate quanto i veri Runabout.

Sportboat

The fiberglass, deep-V, and Aquamatic revolution of the 50s signed the
end of the runabout era: New lines were demanded. Automobile design and
detailing became the major source of inspiration for smaller sportboats up
to 23' down to the 60s—poppy colors, fins, chromes and rocket lines. Very
funky designs became available, often described of as the Corvette or the
Mustang among boats. The 70s were even sportier: sleeker lines, long
bonnet-decks with inclined windshields, racecar cockpits with bucket seats.
Sitting was all one could do aboard. The eye-catching look was enhanced
by metalflake colors and elaborate vinyl upholstery. In the 80s, sportboats
gradually lost their appeal but not their high visual impact.

Fiberglas, Deep-V und Aquamatic bedeuteten das Ende der Ära des
Runabout in den 50ern: neue Formen waren gefragt. Design und Details von
Automobilen – poppige Farben, Flossen, Chrom und raketenartige Linien –
waren bis in die 60er die größte Inspirationsquelle für kleinere Sportboote
bis 23'. Ausgefallene Designs führten dazu, dass sie als die Corvettes und
Mustangs unter den Booten galten. Die 70er waren sportlicher: schlanke
Linien, lange, haubenförmige Decks mit geneigten Frontscheiben, Renn-
auto-Cockpits mit Schalensitzen. Mehr als Sitzen war nicht möglich. Ihr
attraktiver Look wurde durch metallische Farben und kunstvolle Vinylbezüge
noch unterstrichen. In den 80ern verloren sie zwar ihren Reiz, nicht aber
ihre visuelle Wucht.

Sea Ray, SRV-180

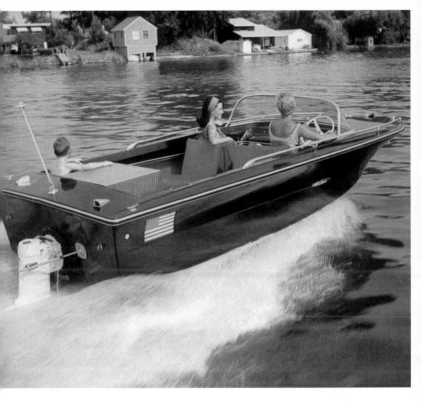

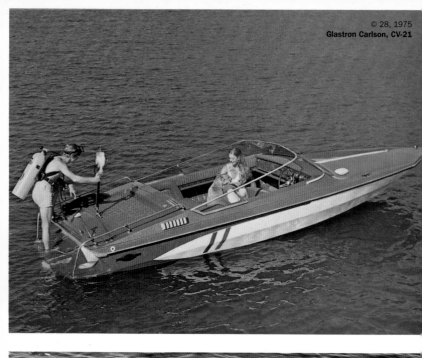

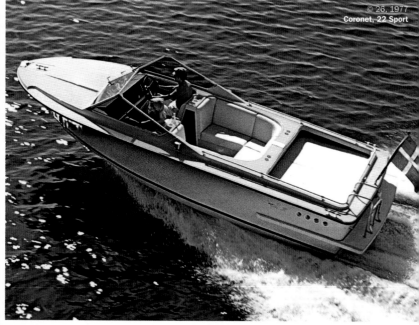

Les fibres de verre, le Deep-V et l'Aquamatic signifient la fin de l'ère des Runabouts dans les années 50 : de nouvelles formes étaient demandées. Le design et les détails d'automobiles – des couleurs criardes, ailerons, chromes et lignes fuselées – furent, jusque dans les années 60, la plus grande source d'inspiration pour les canots de sport jusqu'à 23'. Les designs très originaux en faisaient des Corvette et des Mustang parmi les bateaux. Les années 70 furent plus sportives : des lignes longilignes, des ponts longs en forme de capot avec des pare-brise inclinées, des cockpits de voitures de course avec des sièges à coque. On ne pouvait faire autre chose que de s'asseoir. Leur look attrayant était encore souligné par des couleurs métalliques et des revêtements de vinyle très artistiques. Dans les années 80 ils perdirent de leur attractivité mais pas leur impact visuel.

Fibra de vidrio, Deep-V y Aquamatic significan el fin de la era de los Runabout en los años 50: se demandaban nuevas formas. Diseño y detalles de automóviles –colores llamativos, aletas, cromo y líneas de tipo misil– fueron hasta los años 60 la gran fuente de inspiración para pequeñas embarcaciones deportivas hasta 23'. Los diseños inusitados contribuyeron a que se consideraran los Corvette y Mustang entre las embarcaciones. Los años 70 fueron más deportivos: líneas esbeltas, cubiertas largas de forma de capó con cristales frontales inclinados, cabinas como de automóviles de competición con asientos anatómicos. Más que estar sentado no era posible. Su atractivo Look fue subrayado aún más, a través de pinturas metalizadas y artísticos revestimientos de vinilo. En los años 80 si bien perdieron su atractivo, no lo ha sido su robusta visual.

Con l'introduzione della vetroresina, dela carena a V profonda, e dei motori entrofuoribordo, gli anni 50 segnarono l'inizio di una nuova era. Il design automobilistico divenne fonte di ispirazione per barche sportive negli anni 60: colori sgargianti, pinne, cromature e linee spaziali. Appariscenti Sport Boat, spesso considerate come Corvette e Mustang aquatiche, invasero gli Stati Uniti. Gli anni 70 si rivelarono ancora piú sportivi: linee slanciate, lunghi "cofani" con parabrezza inclinati, cockpit degni di auto da corsa. Sedere infatti era l'unica cosa che si poteva fare a bordo di queste piccole barche. Il look acccattvante delle Sport Boats veniva enfatizzato da vernici ad effetto metallizzato ed elaborati rivestimenti in vinile. Negli anni 80 il trend scompariva velocemente.

Sport Utility

Bertram's first "Moppie" combined 1961 the usability of tenders and utility boats with the performance of offshore racers. With smaller crafts, flexible use of interior space than in sportboats was highly demanded. When fiberglass replaced wood, wholly new layouts were possible. Glastron's Swinger series featured in 1967 a forward cockpit accessible via a walk-through windshield. More so-called bowriders with functional layout, edgy lines and cathedral hull followed. Today, boats with flexible, open-deck seating arrangement around a self-standing cockpit have become trendy among watersport and sunbathing fans. Luxury brands have approached this market too, with upscale models by Chris Craft, Wally and Riva.

1961 kombinierte Bertrams erster „Moppie" die Nützlichkeit von Tendern und Utility Boats mit der Leistung von Offshore-Racern. Die kleineren Schiffe verlangten nach flexibel nutzbarem Innenraum, und die Einführung von Fiberglas schuf ganz neue Gestaltungsmöglichkeiten. Glastrons Swinger Serie hatte z. B. ein von vorne betretbares Cockpit. Es folgten so genannte Bowrider mit funktionalem Aufbau und kantigen Linien. Heutzutage sind unter den Wassersportlern und Sonnenanbetern flexible Boote mit Sitzen auf offenem Deck und eigenständigem Cockpit gefragt. Auch Luxusmarken haben sich dem Markt angenähert, mit hochpreisigen Modellen von Chris Craft, Wally und Riva.

Bertram, 30' "Moppie"

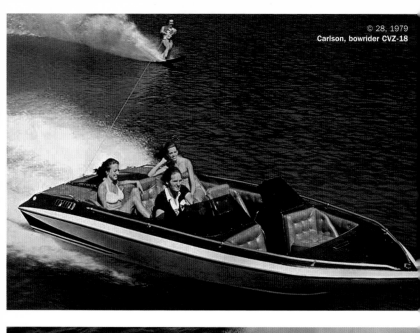
© 28, 1979
Carlson, bowrider CVZ-18

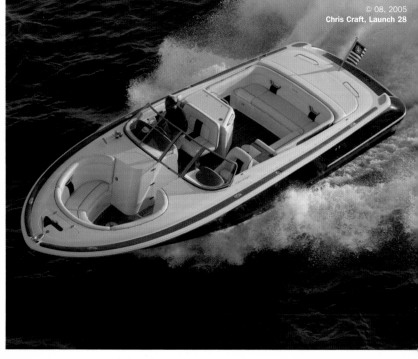
© 08, 2005
Chris Craft, Launch 28

En 1961, le premier «Moppie» de Bertram associe l'aspect pratique des allèges et bateaux utilitaires aux performances des Racer Offshore. Les bateaux plus petits réclamaient un espace interne flexible, et les fibres de verre créèrent introduisirent de toutes nouvelles possibilités d'aménagement. Le Glastron Swinger par exemple, possédait un cockpit accessible par l'avant. Suivirent les Bowrider avec leur aménagement fonctionnel et des lignes anguleuses, Aujourd'hui les amateurs de sports nautiques et du bronzage réclament des bateaux flexibles avec des sièges sur un pont ouvert et un cockpit indépendant. Les marques de luxe comme Chris Craft, Wally et Riva se sont aussi rapprochées de ce marché avec des modèles d'haut de gamme.

En 1961 la primera "Moppie" de Bertram combinaba la utilidad de Tendern y Utility Boats con las prestaciones de Offshore Racern. Los pequeños barcos solicitaban un espacio interior flexible aprovechable, y la introducción de Fiberglas creó posibilidades de concepción totalmente nuevas. Glastron Swinger Line tenía p.ej. una cabina accesible desde la proa. La siguieron los así llamados Bowrider con estructura funcional y líneas angulosas. Hoy en día la demanda entre los aficionados al deporte acuático y los adoradores del sol, son embarcaciones flexibles con asientos sobre la cubierta abierta y cabina independiente. También las marcas de lujo com Chris Craft, Wally y Riva se han acercado al mercado con modelos de nivel elevado.

Il famoso "Moppie" di Bertram combinava nel 1961 la funzionalitá di una barca da lavoro con le prestazioni di un Offshore. Nelle barche di minori dimensioni, un uso dello spazio interno piú flessibile rispetto alle Sport Boats è sempre stato molto richiesto. Quando la vetroresina rimpiazzó il legno, nuovi layout divennero possibili. Nel 1967, la serie Swinger della Glastron presentava un pozzetto di prua accessibile attraverso il parabrezza; negli anni a seguire furono presentate molte barche del tipo tutto aperto con linee squadrate che hanno incontrato il favore degli amanti degli sport aquatici. Oggi persino produttori di alta gamma come Chris Craft, Wally e Riva offrono degli Sport Utility di classe e finiture superiori.

Offshore

Offshore racing was officially born in 1956 with the Miami-Nassau competition, adrenalin source to tough men like Dick Bertram and Don Aronow. The latter—with Cigarette—and the TV serial Miami Vice made the offshore name worldwide famous. Designed to fly over the waves and land hard at speed above 100 mph, offshore boats renounce to all typical accessory. Sleek and narrow, with deep-V hull and a very long deck ending in no windshield, they have racecar proportions and a toy like look, enhanced by the inevitable color customization. In spite of the bad boy—not to say smuggler—image, offshore have been a hit in the 80s in Europe and remain now very fashionable in the US, where gasoline price is irrelevant.

Offshore-Racing wurde offiziell 1956 mit dem Miami-Nassau-Wettbewerb geboren – eine Adrenalinquelle für Haudegen wie Dick Bertram und Don Aronow. Letzterer – mit der Marke Cigarette – und die TV-Serie „Miami Vice" machten den Namen Offshore weltberühmt. Gebaut um über die Wellen zu fliegen und bei über 100 mph zu landen, verzichten Offshoreboote auf jegliche Accessoires. Schlank und schmal, mit Deep-V-Rumpf und einem sehr langen Deck ohne Frontscheibe haben sie die Proportionen eines Rennautos sowie einen Spielzeug ähnlichen Look, der durch individuelle Farbgebung noch verstärkt wird. Trotz Schmuggler-Image waren sie in Europa in den 80ern ein Hit. In den USA, wo der Benzinpreis keine Rolle spielt, sind sie auch heute noch im Trend.

Cigarette Racing Team, 32' "The Cigarette"

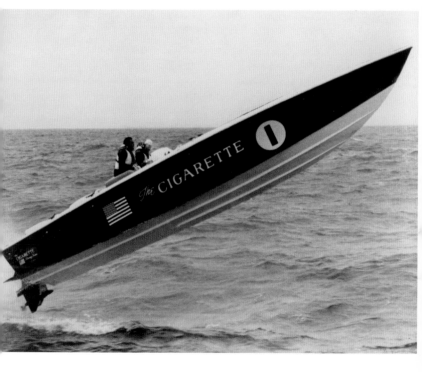

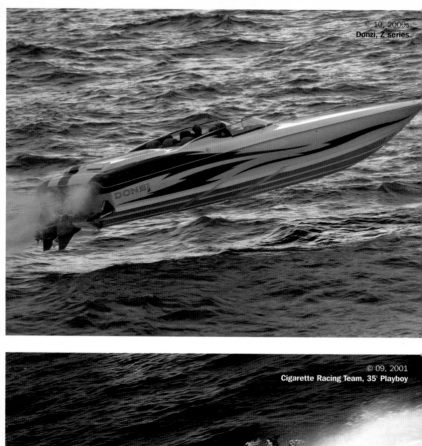

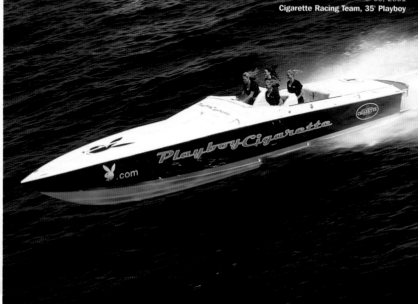

Les courses de Offshore sont nées officiellement en 1956 avec la course
Miami-Nassau – une source d'adrénaline pour des concurrents comme
Dick Bertram et Don Aronow. Ce dernier – avec la Marque Cigarette – et la
série TV «Miami Vice» ont rendu le nom de Offshore célèbre dans le monde
entier. Construit pour voler au-dessus des flots et amerrir à plus de 100
mph, les bateaux Offshore à tout accessoire. Mince et étroit, avec une
coque en Deep-V et un pont très long sans vitre à l'avant, ils ont les pro-
portions de voitures de course et un air de jouet qui est renforcé par des
motifs colorés individuels. Malgré leur image de bateaux de contrebande ils
étaient vraiment au sommet en Europe dans les années 80. Aux USA, où le
prix de l'essence ne joue aucun rôle, ils sont aujourd'hui encore une ten-
dance.

Offshore racing nació oficialmente en 1956 con la competición Miami-
Nassau – una fuente de adrenalina para valentones como Dick Bertram y
Don Aronow. Finalmente Aronow –con el "Cigarette"– y la serie televisiva
"Miami Vice" hicieron el nombre Offshore famoso en el mundo entero.
Construido para volar sobre las olas y caer a más de 100 mph, las embar-
caciones Offshore dispensan de cualquier accesorio. Esbeltas y angostas,
con casco Deep-V y una cubierta muy larga sin cristal frontal, tienen las
proporciones de un automóvil de competición así como un Look similar a
un juguete, que se refuerza aún más mediante la elección individual de
colorido. A pesar de la imagen de contrabandistas, en Europa fueron un Hit
en los años 80. En los EE.UU. donde los recios de la gasolina no tienen
ninguna importancia, aún hoy están dentro de la tendencia.

Le gare di offshore nacquero officialmente nel 1956 con la famosa
Miami-Nassau, una fonte di adrenalina per uomini del calibro di Bertram e
Aronow. Fu quest'ultimo con il suo Cigarette e non senza l'aiuto della serie
TV Miami Vice, a rendere il nome Offshore famoso nel mondo. Disegnate
per saltare sulle onde a più di 160 km/h, i veri Offshore rinunciano ad ogni
ammenicolo. Strette e filanti, con carene a V profonda ed una tuga lun-
ghissima che finisce senza parabrezza, esse hanno proporzioni da auto da
corsa ed un look da giocattolo – evidenziato dalle colorazioni più impensabi-
li. A discapito dell'immagine un po' macho un po' contrabbandiere, gli Off-
shore sono stati un successo negli anni 80 e rimangono in gran voga negli
Stati Uniti – grazie anche al prezzo del carburante.

Sport Classic

The elegant and sophisticated version of the offshore, Sport Classic boats combine performance, utility and style. They were developed around deep-V fiberglass hull starting in the mid 70s to maintain the legacy of the open runabout, yet adapting its concept to a grown up market and a more flexible lifestyle. Typically an Italian handcrafted product by makers like Riva and Colombo, characterized by personal lines and sophisticated detailing, sport classic boats stand out of the fiberglass whiteware and are increasingly being regarded as classics. With the further market expansion in recent years, these now mid-size, usually twin-engined open between 21' and 33' have lost part of their symbolic value.

Als elegante und anspruchsvolle Version des Offshores kombinieren Sport Classic Boats Leistung, Funktionalität und Stil. Sie wurden Mitte der 70er auf Basis des Deep-V-Rumpfes entwickelt, um das Vermächtnis des offenen Runabout fortzuführen. Dabei passte sich das Konzept jedoch an den mittlerweile erwachsenen Markt und den flexibleren Lifestyle an. Sport Classic Boats wurden gewöhnlich von italienischen Konstrukteuren wie Riva und Colombo von Hand gefertigt. Sie zeichnen sich entsprechend durch persönliche Linien und raffinierte Details aus, so dass sie aus der Massenware herausragen. Auf Grund der umfassenderen Marktplatzierung in den letzten Jahren haben diese inzwischen mittelgroße, offenen Zweimotoren zwischen 21' und 33' jedoch an symbolischem Wert verloren.

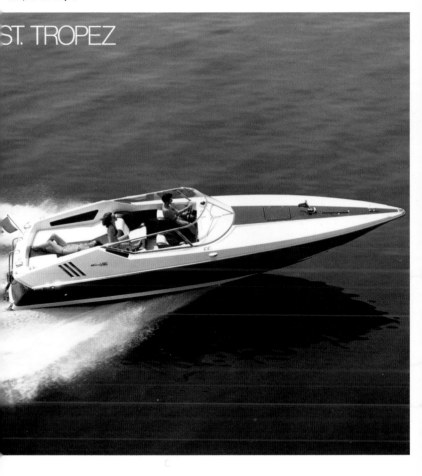

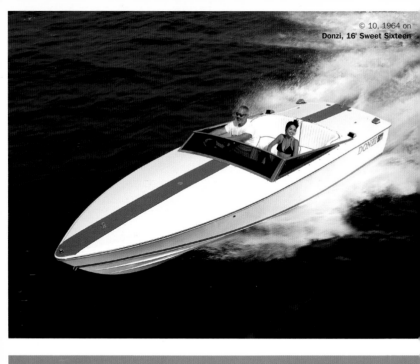

Donzi, 16' Sweet Sixteen

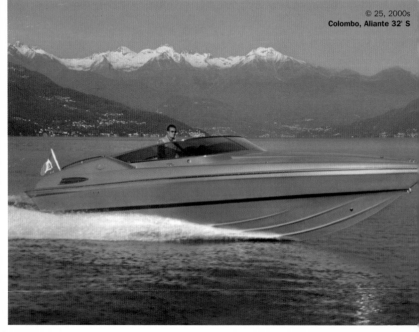

Colombo, Aliante 32' S

En tant que version de Offshore élégante et exigeante, le Sport Classic Boat combine les performances sportives, la fonctionnalité et le style. Ils ont été développés au milieu des années 70, sur la base d'une coque Deep-V, afin de poursuivre lés héritages du Runabout ouvert. Le concept s'est pourtant adapté au marché entre-temps adulte et aux modes de vie plus flexibles. Les Sport Classic Boat étaient habituellement le fruit d'un travail artisanal de constructeurs italiens comme Riva et Colombo. Ils se distinguent ainsi, par des lignes personnelles et des détails raffinés, de sorte qu'ils se démarquent des produits de masse. En raison, ces dernières années, d'un immense découpage du marché ils ont toutefois perdu en valeur symbolique.

Como elegante y exigente versión del Offshore las prestaciones del Sport Classic Boats, combinan funcionalidad y estilo. Estos se desarrollaron a mediados de los años 70 sobre la base de un casco Deep-V, para dar continuidad a la influencia del Runabout abierto. En este caso el concepto sin embargo, se adaptó al entretanto creciente mercado y al estilo de vida flexible. Sport Classic Boats fueron habitualmente construidos a mano por constructores italianos como Riva y Colombo. Estos se caracterizan de acuerdo a las líneas personales y los detalles refinados, de manera que sobresalen entre los productos masivos. No obstante, en función de la amplia ubicación en el mercado en los últimos años, han perdido algo de valor simbólico.

Una versione sofisticata ed elegante dell'Offshore, le Sport Classic combinano elevate prestazioni con funzionalitá e stile. Sviluppati negli anni 70 come adattamento del Runabout ad una carena a V profonda, esse ne adattarono il concetto ad un mercato piú esigente in termini di dimensioni e flessibilitá d'uso. Tipicamente un prodotto italiano d'alta classe, come Riva e Colombo, caratterizzato da linee personali e dettagli ricercati, le Sport Classic risaltano rispetto alla massa di "barche bianche" di design corrente. Oggigiorno meno appariscenti di un tempo, le Sport Classic fra i 21 ed i 33 piedi hanno perso molto del loro valore di status symbol e vengono giá considerate dei classici.

Sport Yacht

Sport yachts are the result of the upscaling market trend, whereby all boat typologies grow up in size. Tracing back to the original fast commuter and to the sport classic boats, sport yachts range between 38' and 88'. As open, day cruiser, hardtop convertibles and the likes, they offer luxury overnight accommodation combined with full outdoor facilities for fast day trips and occasional cruises. While they may share their hull with motoryachts of the same size, they have a less evident superstructure and are much more sporty in style, calling for self-drive usage. As for motoryachts, to fulfill individual ambitions, the classical, straightforward design has gradually lost ground against either fancy-curvy or retro style.

Sportyachten sind das Ergebnis einer Markttendenz, der zufolge alle Bootstypen kontinuierlich größer werden. Sie haben eine Länge zwischen 38' und 88'; ihr Vorläufer sind der Fast Commuter und das Sport Classic Boat. Sie bieten luxuriöse Übernachtungsmöglichkeiten in Kombination mit kompletter Outdoor-Ausstattung für Tagestrips und Spazierfahrten. Obwohl sie einen den Motoryachten ähnlichen Rumpf haben, verfügen sie über kleinere Aufbauten und einen sportlicheren Stil, der das Selberfahren geradezu herausfordert. Wie bei den Motoryachten auch hat das klassisch-geradlinige Design gegenüber den schrill-kurvigen bzw. Retro-Modellen an Boden verloren, um individuellen Ansprüchen zu genügen.

Riva, 51' Turborosso

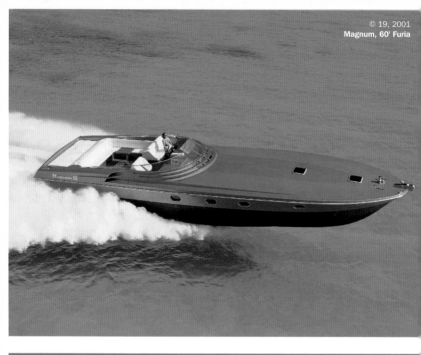

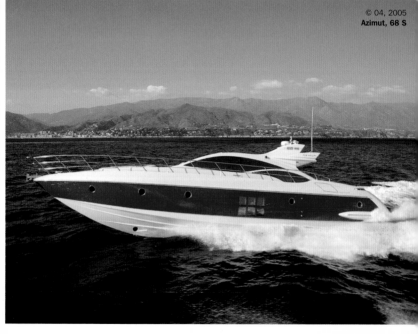

Les yachts sportifs sont le fruit d'une tendance de marché qui fait que tous les types de bateaux deviennent de plus en plus grands. Ils possèdent une longueur entre 38' et 88'; leurs prédécesseurs sont le Fast Commuter et le Sport Classic Boat. Ils offrent des possibilités de couchage luxurieuses en association avec des équipements Outdoor complets pour des promenades d'une journée et la navigation de plaisance. Alors qu'ils possèdent une coque semblable à celle des yachts à moteur, ils disposent d'aménagements plus restreints et d'un style plus sportif qui reste un défi pour les navigateurs. Comme pour les yachts à moteur, le design classique à lignes droites a perdu du terrain par rapport aux modèles rétro à courbes délirantes, afin de s'adapter à l'individualisme.

Los yates deportivos son el resultado de una tendencia del mercado, que se agrandan continuamente como consecuencia de todas las tipologías de embarcaciones. Ellos tienen una eslora entre 38' y 88'; sus antecesores son el Fast Commuter y el Sport Classic Boat. Ellos ofrecen lujosas posibilidades de pernoctar en combinación con un equipo completo Outdoor para turismo de un día y paseos. Si bien poseen un caso similar al de los yates a motor, disponen de superestructuras menores y un estilo más deportivo, que promueve justamente la navegación propia. Como en los yates a motor también el diseño recto clásico ha perdido base contra los modelos estridentes curvilíneos o bien modelos Retro, para satisfacer exigencias individuales.

In mondo di consumi in crescita, gli Sport Yacht sono il risultato della lievitazione dimensionale richiesta dal mercato. Un incrocio fra il Fast Commuter e la barca Sport Classic, gli Sport Yachts raggiungono dimensioni che vanno dai 38 agli 88 piedi. Nelle mille versioni open, cruiser, hardtop o convertibile e via dicendo, essi combinano una sistemazione notturna di lusso con attrezzature e spazi aperti perfetti per lunghe cavalcate diurne e piccole crociere. Spesso identici nello scafo ai Motor Yacht da cui derivano, essi hanno un'immagine più sportiva, adatta ad un uso senza equipaggio. Come per gli yacht, lo stile deciso, sobrio ed elegante dei primi anni 80 è degenerato in linee d'effetto e stile retro molto spesso di gusto discutibile.

Gozzo

The original name for the very original fishermen boat—most Mediterranean cities have their own Gozzo style, Sorrento being the most famous. Originally conceived as heavy duty workboats, they remained unchanged in style for hundreds of years and are characterized by the clinker built wooden structure and flat deck. After WWII, fishermen started installing Jeep engines in older Gozzos. In the mid 80s, semi-planing fiberglass hulls turned Gozzos into relatively fast and extremely sea-proof boats that offer a very liveable wooden deck and convenient below deck facilities. An evergreen trend, the Gozzo eventually grew up in size, with hardtop and cabin versions to offer even more functionality.

Der Originalname für das originale Fischerboot – die meisten mediterranen Städte haben ihren eigenen Gozzo-Stil, von denen Sorrento der berühmteste ist. Ursprünglich als strapazierfähige Arbeitsschiffe gedacht, blieben sie über Jahrhunderte stilistisch unverändert und zeichnen sich durch die Klinkerbauweise und ein flaches Deck aus. Nach dem Zweiten Weltkrieg rüsteten die Fischer sie mit Jeepmotoren aus. Mitte der 80er verwandelten Halbgleiter mit Glasfaserrümpfen die Gozzos in relativ schnelle und äußerst wasserfeste Boote, mit bewohnbarem Holzdeck und bequemen Einrichtung darunter. Der Evergreen Gozzo wurde schließlich immer größer, mit Hardtop und Kabinenversionen, die noch mehr Funktionalität boten.

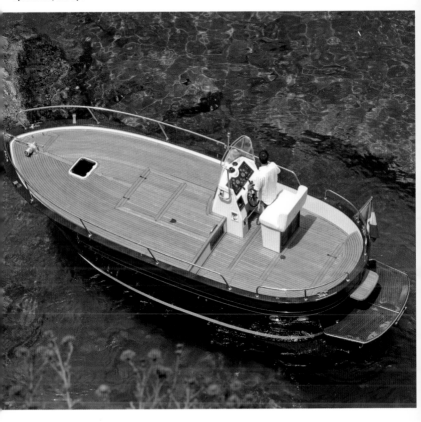

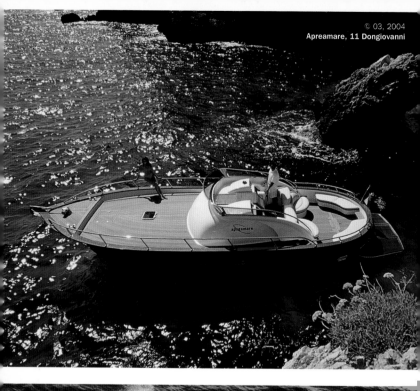

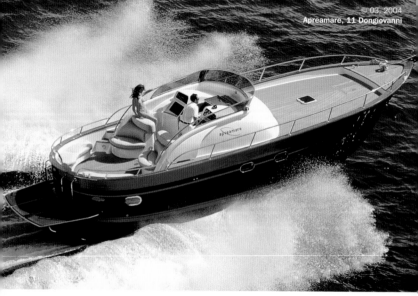

C'est le nom original du bateau de pêche original – la plupart des villes méditerranéennes possèdent leur propre style de Gozzo, dont le Sorrento est le plus célèbre. Il a été pensé à l'origine comme bateau de travail robuste, son style n'a pas bougé pendant des centaines d'années, il se distingue par une construction à chevauchement et un pont plat. Après la 2me guerre mondiale les pêcheurs les ont transformés en leur ajoutant un moteur de jeep. Au milieu des années 80, les coques remplacées par des semi glisseur en fibres de verre, ont transformé les Gozzo en bateaux relativement rapides et extrêmement étanches, avec un pont en bois habitable et des aménagements de confort. Le toujours jeune Gozzo devient de plus en plus grand, avec des versions à Hardtop et à cabines qui offrent plus de fonctionnalités.

El nombre original para la embarcación de pesca original –la mayoría de los estados mediterráneos tiene su propio de Gozzo, de los cuales Sorrento es el más famoso. Originalmente concebidos como resistentes barcos de trabajo, se mantuvieron durante siglos estilísticamente inalterados y se caracterizan por un modo de construcción de tingladillo y una cubierta plana. Después de la 2a guerra mundial los pescadores los reformaron con motor de Jeep. Mediados de los años 80 semi-deslizadores con cascos de fibra de vidrio convirtieron los Gozzos en embarcaciones rápidas y extremadamente resistentes al agua, con cubierta de madera habitable y cómodas instalaciones por debajo. El Evergreen Gozzo finalmente se hizo cada vez más grande, con versiones Hardtop y de cabina, que ofrecieron aún más funcionalidad.

Un nome legato alla vera barca da pescatore, ogni regione del mediterraneo ha avuto il suo stile di Gozzo, il piú famoso dei quali é quello sorrentino, di sette metri e mezzo. Concepite come barche da lavoro e per un mare in burrasca, i Gozzi, con il loro ponte aperto e stiva sottostante rimasero immutati per secoli fino al secondo dopoguerra, quando furono innestati i primi motori da Jeep. Negli ani 80 anche i Gozzi conobbero la vetroresina e, con essa, carene semiplananti. Essi diventarono cosí barche sicure e relativamente veloci, perfette per una giornata di sole e, con la stiva convertita in cabina, per la pennichella pomeridiana. Un trend sepreverde, anche il Gozzo è cresciuto a dismisura, in versioni cabinate e semicabinate che spesso superano i 30 metri.

Fishermen

Known among anglers since the 50s, the Fishermen's success is linked with the advent of Fiberglass deep-V hulls in the early 60s. Offering safe and enjoyable boats to the unexperienced boaters, Bertram and Hatteras have become synonymous with performing and stylish Fishermen. In their pristine design, these had an open galley, a large fishing platform and an additional flybridge cockpit. Sportier than cruisers or yachts, they shared the same sleek 60s lines. Later on, larger convertible Fishermen offered enclosed facilities for the whole family. To gain back the sporty image, observation decks have been added and the front windshield closed. Lines have become more wedgy in the 80s and are smoother today.

Unter Anglern seit den 50ern bekannt, ist der breitere Erfolg des Fishermen mit dem Aufkommen von Fiberglas-Deep-Vs in den frühen 60ern verbunden. Bertram und Hatteras, die komfortable und sichere Boote für Anfänger anboten, wurden zum Synonym für leistungsstarke und schöne Fishermen. In ihrem ursprünglichen Design hatten sie eine offene Kombüse, eine große Angelplattform und ein zusätzliches Flybridge-Cockpit. Sportlicher als Cruiser oder Yachten, teilen sie die schlanken Linien der 60er. Später brachten die Convertible Fishermen eine Ausstattung für die ganze Familie mit. Um das sportliche Image zurückzugewinnen, wurden Aussichtsplattformen hinzugefügt und die Frontscheibe geschlossen. Die Linien gerieten in den 80ern kantig, sind heute aber runder.

Bertram, 38 Convertible

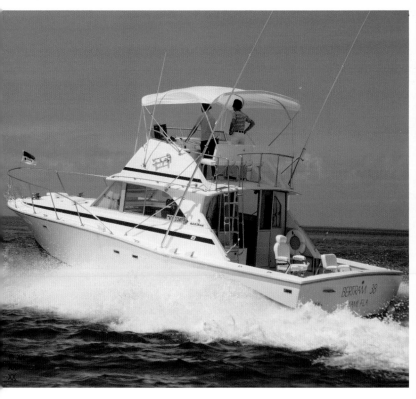

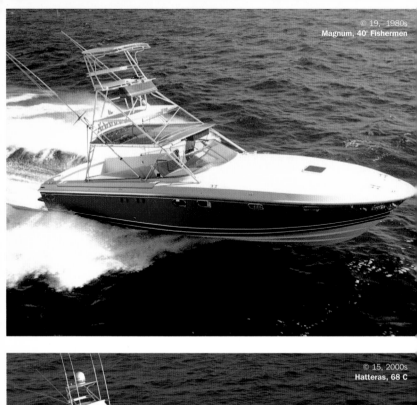

Magnum, 40' Fishermen

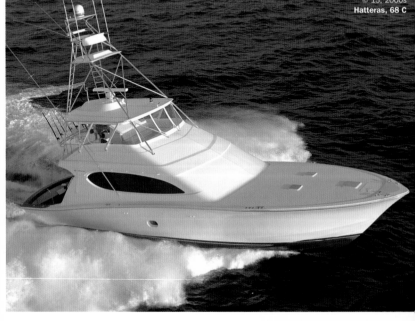

Hatteras, 68 C

Connu par les pêcheurs depuis les années 50, le large succès du Fishermen est dû à l'arrivée du Deep-V en fibre de verre au début des années 60. Bertram et Hatteras qui proposaient des bateaux de pèche confortables et sûres pour les débutants, sont devenus un synonyme pour des Fishermen performants et beaux. Dans leur design d'origine ils offraient une cambuse ouverte et une grande plateforme pour la pèche à la ligne, et un pont de cockpit supplémentaire Flybridge. Plus sportifs que le Cruiser ou le yacht, ils se partagent la ligne amincie des années 60. Plus tard, les Fishermen convertibles reçurent un aménagement pour toute la famille. Pour reconquérir son image sportive, on lui a adjoint des plateformes d'observation et la fenêtre du cockpit a été fermée. Dans les années 80 les lignes devinrent anguleuses, mais elles sont aujourd'hui redevenues arrondies.

Conocidos entre los aficionados a la pesca desde los años 50, el amplio éxito del Fishermen está ligado al surgimiento del Deep-V de fibra de vidrio en los inicios de los años 60. Bertram y Hatteras, las confortables y seguras embarcaciones para principiantes, se convirtieron en sinónimo para el bello y potente Fishermen. En su diseño original tenían una cocina de a bordo abierta, una gran plataforma de pesca y una cabina adicional Flybridge. Más deportivo que Cruiser o yates, comparten la línea esbelta de los años 60. Más tarde los Convertible Fishermen incorporaron un equipamiento para toda la familia. Para volver a ganar la imagen deportiva, fueron adicionadas plataformas de observación y cerrado el cristal delantero. En los años 80 las líneas se tornaron angulosas, sin embargo hoy son más redondeadas.

In voga tra i pescatori d'altura giá negli anni 50, il Fishermen ha conosciuto il suo successo con l'avvento della vetroresina, quando Bertram ed Hatteras cominciarono a fornire barche sportive e veloci ma anche divertenti e sicure da guidare in ogni condizione di tempo. Nel loro assetto classico, queste hanno una cabina aperta sulla piattaforma da pesca ed un cockpit di guida ed osservazione sul flybridge. Piú sportivi degli Yacht contemporanei, i Fishermen ne condividevano le linee eleganti degli anni 60. Piú tardi, grandi Fishermen "convertibili" offrivano accoglienza al coperto per tutta la famiglia. Per riguadagnare l'immagine sportiva, si sono aggiunti torri d'osservazione e sono scomparsi i parabrezza anteriori. Dalle linee squadrate degli anni 70 ed 80 si è poi passati ad un disegno arotondato e filante negli anni 90.

Flybridge

The name flybridge indicates an upper deck built upon the cabin of a typical cruiser or motoryacht and accessible through an external ladder or staircase. Flybridges provide an additional raised driving position with seating accommodation for two or more people. This layout adds outdoor space in smaller crafts and makes the driver experience much more enjoyable then it is in a boat with enclosed cockpit. Its introduction traces back to the mid 50s, when it became a standard on Fishermen boats and a beloved option on all other cruisers. On larger motoryachts, the flybridge becomes a real sundeck with all amenities and facilities.

Der Name Flybridge zeigt an, dass das Oberdeck, welches sich über eine Leiter oder Treppe von außen betreten lässt, auf die Kabine eines typischen Cruisers oder einer Motoryacht gebaut wird. Flybridges bieten Sitze für zwei oder mehr Personen in zusätzlich erhöhter Fahrposition. Dieses Konzept vergrößert den Außenraum in kleineren Schiffen und macht das Fahrerlebnis weitaus schöner als in Booten mit geschlossenem Cockpit. Eingeführt Mitte der 50er, wurde es zum Standard beim Fishermen sowie zur beliebten Option bei allen anderen Cruisern. Auf größeren Motoryachten wird die Flybridge zu einem echten Sonnendeck.

Hatteras, 41' Convertible

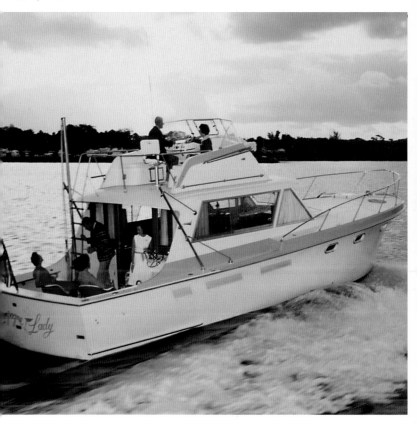

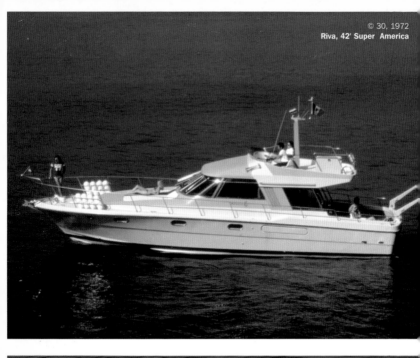

Riva, 42' Super America

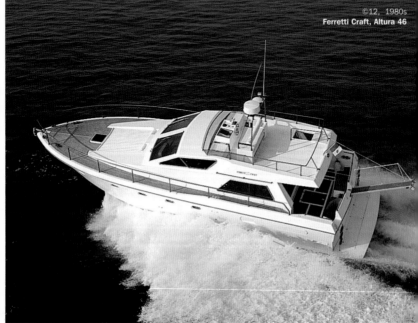

Ferretti Craft, Altura 46

Le nom de Flybridge indique qu'un pont supérieur, accessible par échelle externe ou escalier, a été construit sur la cabine typique d'un cruiser ou d'un yacht à moteur. Les Flybridge offrent des places assises pour deux ou plusieurs personnes, sur un emplacement de conduite surélevée. Ce concept augmente l'espace extérieur sur les navires plus petits, et rend la conduite beaucoup plus agréable que sur les navires à cockpit fermé. Introduit dans le milieu des années 50, il est devenu un standard des Fishermen ainsi qu'une option très appréciée sur tous les autres cruisers. Sur les grands yachts à moteur le Flybridge devient un véritable pont de bronzage.

El nombre Flybridge indica, que la cubierta superior, a la cual se puede acceder desde el exterior mediante una escalera o escalada, se construye sobre la cabina de un típico Cruiser o un yate a motor. Flybridges ofrecen asientos para dos o más personas en una posición de marcha adicionalmente elevada. Este concepto aumenta el espacio exterior en barcos pequeños y convierte la vivencia del viaje mucho más agradable que en embarcaciones con cabina cerrada. Introducido a mediados de los años 50, se ha convertido en un estándar en Fishermen así como una opción apreciada en todos los otros Cruiser. En yates a motor grandes, el Flybridge se convierte en una autentica cubierta de solario.

Il nome Flybridge indica un ponte superiore a cielo aperto, tipicamente ricavato sul tetto della cabina di un Cruiser o Motoryacht, equipaggiato di un posto di guida ed accessibile attraverso una scala esterna. Questo layout aumenta lo spazio aperto disponibile in barche piccole e regala una guida molto piú piacevole rispetto a barche a guida interna. La sua introduzione risale alla metá degli anni 50, quando divenne uno standard sui Fishermen ed una opzione molto desiderata sui cruiser. Sui Motoryacht di grandi dimensioni, il Flybridge diventa un vero ponte sole con tutte le amenitá del caso, vasca idromassaggio inclusa.

Motoryacht

The Motoryacht implies exclusive lifestyle with luxury accommodation on long cruises. Typically a custom made product, Chris Craft offered in 1930 a stock 48' Motor Yacht, since then considered the entry level size. The motoryacht evolved as a self driven fast boat with planing hull and a prominent superstructure including one or more decks and/or flybridges. The 60s remain the golden era for design, with classic beauties as Baglietto's Ischia. The wedgy lines of the 70s gave birth to the flat iron style for the affluent new rich. With the market expanding and fiberglass being used all over, curvy-fancy lines have been developed, real elegance now mostly to be found as retro.

Die Motoryacht steht für exklusiven Lifestyle mit luxuriöser Unterbringung auf langen Fahrten. Eigentlich eine Maßanfertigung, bot Chris Craft 1930 auch ein Serienmodell von 48' Länge an, die seitdem als Einstiegsgröße gilt. Die Motoryacht entwickelte sich als ein selbst zu steuerndes Schnellboot mit Gleiter und prominentem Aufbau, der aus einem oder mehreren Decks und/oder Flybridges bestand. Die 60er bleiben das goldene Zeitalter ihres Designs mit klassischen Schönheiten wie der Ischia von Baglietto. Die kantigen Linien der 70er brachten den Bügeleisenstil, bis schließlich ein expandierender Markt und die allgegenwärtigen Glasfasern schnörkeligen Linien den Vorzug gaben, so dass wahre Eleganz fast nur noch bei Retromodellen zu finden ist.

Cantieri di Pisa, 15 m Super Polaris

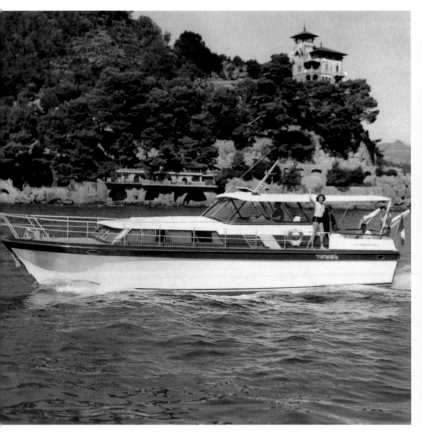

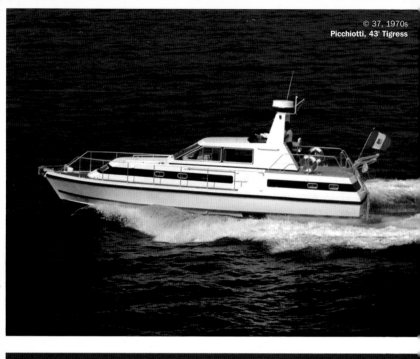

Picchiotti, 43' Tigress

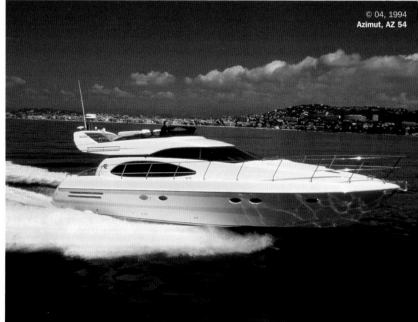

Azimut, AZ 54

Le Motoryacht est l'expression d'un style de vie exclusif avec un habitat luxueux pour de longues croisières. En fait c'est une production de masse que propose Chris Craft en 1930 avec son modèle de série de 48' de long, qui depuis représente le bas de gamme en matière de longueur. Le Motoryacht s'est développé sous la forme d'un bateau rapide à conduire soi-même, avec une structure de glisseur et un équipement proéminent composé d'un ou plusieurs ponts et/ou Flybridge. Les années 60 restent l'âge d'or de ce design. Les lignes anguleuses des années 70 ont apporté le style fer à repasser, jusqu'à ce que finalement un marché en pleine expansion et les fibres de verre omniprésentes donnent l'avantage à des lignes plus complexes, de telle sorte que la véritable élégance n'existe presque plus que sur les modèles rétro.

El Motoryacht representa un estilo de vida exclusivo con acomodaciones lujosas para viajes largos. En realidad una construcción a medida, Chris Craft ofreció en 1930 también un modelo de serie de 48' de eslora, que desde ese momento vale como tamaño accesible. El Motoryacht se desarrolló a si mismo como una embarcación rápida para ser timoneada por uno mismo, con deslizadores y superestructura prominente, constituida de una o varias cubiertas y/o Flybridges. Los años 60 permanecen como la era de oro de su diseño. Las líneas angulosas de los años 70 aportaron el estilo de plancha, hasta que finalmente un mercado en expansión y la omnipresente fibra de vidrio le dieron la preferencia a líneas de fantasía, de manera que la verdadera elegancia casi sólo aún puede encontrarse en los modelos Retro.

Il termine Motoryacht rimanda ad uno stile di vita esclusivo e lussuoso. Per quanto si tratti tipicamente di un prodotto realizzato su misura, Chris Craft ne offriva giá nel 1930 uno di 48 piedi fabbricato in serie. Col tempo, il Motoryacht si é evoluto in uno scafo veloce a carena planante, adatto ad essere portato senza equipaggio, dotato di una sovrastruttura ad uno o piú ponti e flybridge. Mentre gli anni 60 rappresentano l'apice stilistico per i modelli di impostazione classica come il Baglietto Ischia, le linee spigolose degli anni 70 degenerano nell'estetica dei "ferri da stiro" per I nuovi ricchi. I troppi Motoyacht contemporanei sbandierano spesso un'estetica siliconata, fantasiosa e di puro effetto.

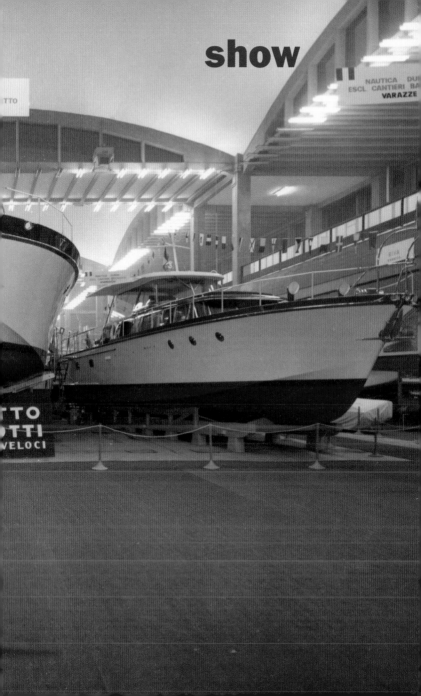

show

"Miss America III"
USA 1919

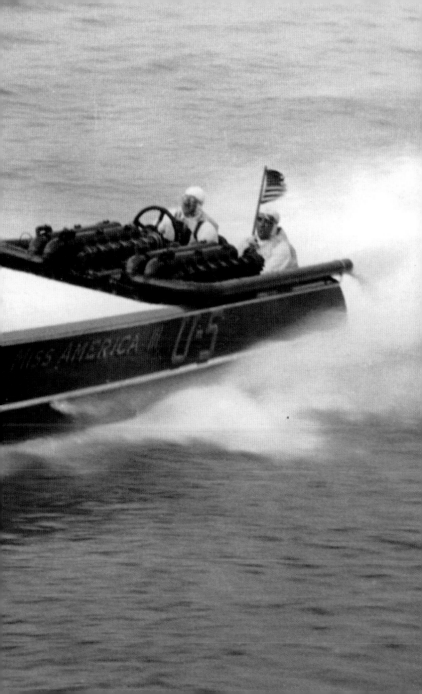

Belle Isle, Bear Cat
USA 1920, 26'

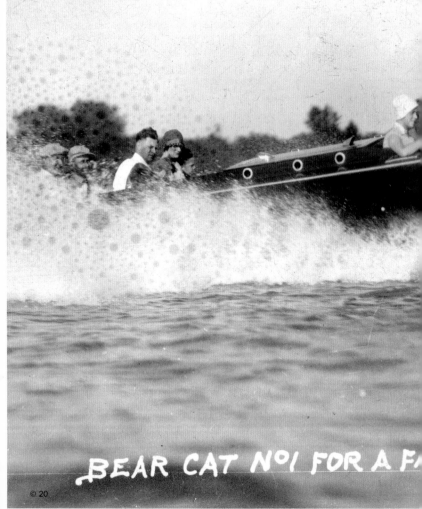

BEAR CAT Nº1 FOR A F

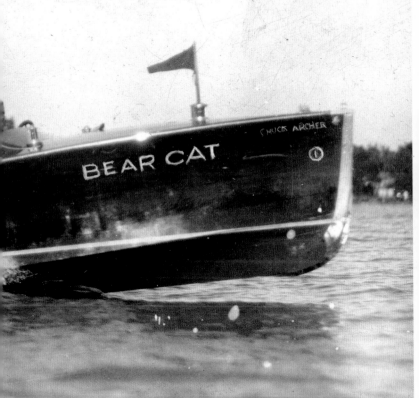

AND THRILLING RIDE,
CHUCK ARCHER.

Baglietto, "Lia V"
I 1931

The typical racer architecture: aft-cockpit, step-hull, streamlined body. Lia V, equipped with a 12 liter Isotta Fraschini engine, won in 1934 the Palm Beach international Gold Cup.

Die typische Architektur der modernen Rennmaschine: Heck-Cockpit, Redan-Stufe, aerodynamische Form. Lia V, mit 12 Liter Isotta Fraschini Motor, gewinnt 1934 das internationale Gold Cup Rennen in Palm Beach.

L'architecture typique des machines de course modernes : cockpit arrière, redan, forme aérodynamique. Lia V avec moteur de 12 litres Isotta Fraschini, gagne en 1934 la Gold Cup internationale à Palm Beach.

La típica arquitectura de la moderna máquina de competición: cabina trasera, escalón Redan, formas aerodinámicas. Lia V, con motor Isotta Fraschini de 12 litros, ganó en 1934 la competición internacional Gold Cup en Palm Beach.

Architettura da Racer: cockpit di poppa, carena con gradino a "redan", forma affusolata. Lia V, equipaggiata con un motore Isotta Fraschini, vinse i campionati del mondo a Palm Beach nel 1934.

Dodge, Watercar
USA 1931, 21' 1/2

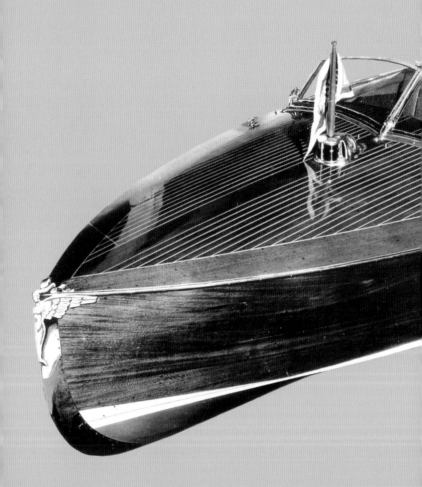

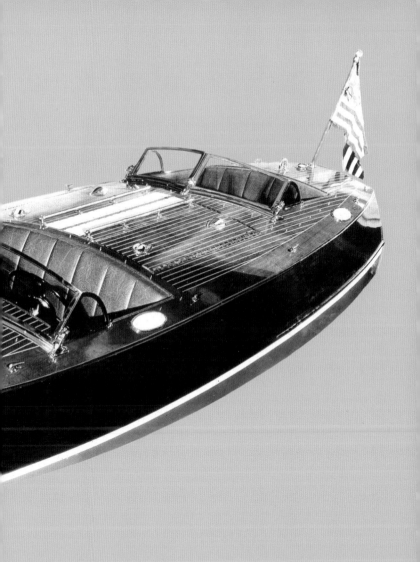

Baglietto
I 1938, 15 m

Outside racy, inside cosy: the personal fast commuter of His Majesty the King of Italy. 127

Außen schnell, innen komfortabel wie ein Wohnzimmer: Der persönliche Fast Commuter des Italienischen Königs.

Rapide à l'extérieur, confortable à l'intérieur comme dans un salon : le Fast Commuter personnel du roi italien.

Exteriormente rápida, interiormente confortable como un salón: el personal Fast Commuter del Rey de Italia.

Fuori corsaiolo, dentro confortevole: il Fast Commuter personale del Re d'Italia.

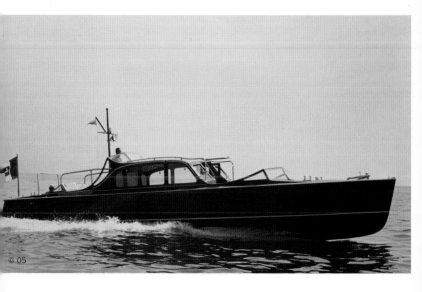

Chris Craft, Special Race Boat
USA 1936, 19'

Eyecatching speedsters: the first barrelback runabouts were painted in patrotic colors.

Bunter Flitzer: Die ersten Runabout mit Fassdeckelheck wurden in patriotischen Farben lackiert.

Une fusée colorée : les premier runabouts avec un arrière en forme de couvercle de tonneau étaient laqués de couleurs patriotiques.

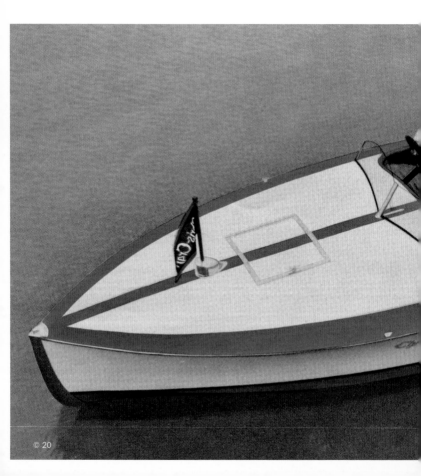

© 20

Rápidos y coloridos: Los primeros Runabout con popa de tapa de tonel fueron pintados en colores patrióticos.

Un bolide bello da vedere: i primi Runabout con specchio di poppa a botte erano verniciati in colori patriottici.

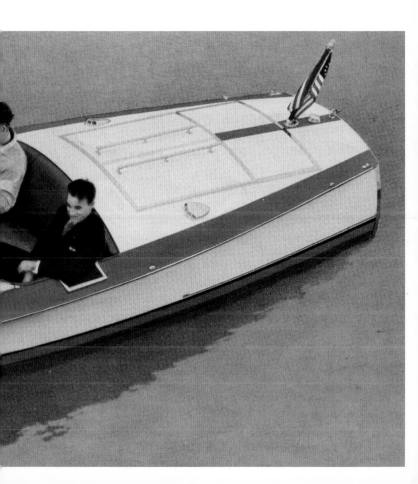

Chris Craft, Deluxe Utility
USA 1938

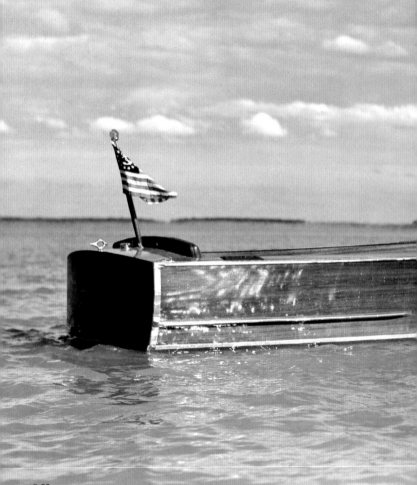

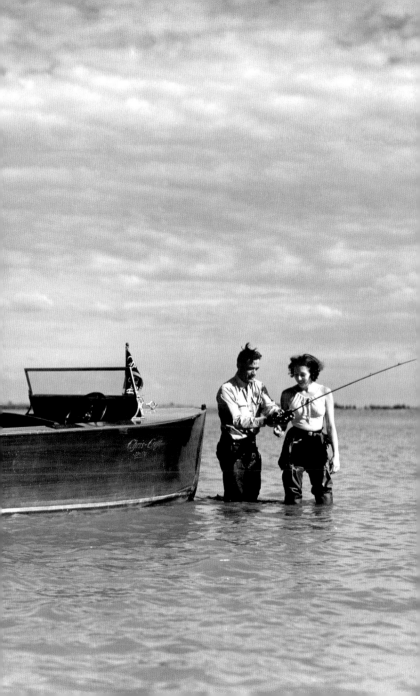

Chris Craft, Triple State Room Cruiser
USA 1937, 32'

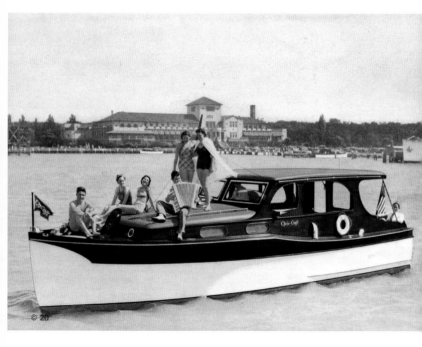

© 20

Either roomier or sportier: from the very beginning cruiser were available in different configurations. The largest of all were in fact motoryachts.

Mal wohnlicher, mal sportlicher: von Anfang an wurden Cruiser in zahlreichen Varianten angeboten. Die größten hießen dann Motoryacht.

Quelquefois plus confortables et d'autres fois plus sportifs : depuis le départ les Cruiser ont été proposés dans un grand nombre de versions. Les plus grands ont été nommés Motoryacht.

Chris Craft, Express Cruiser
USA 1939, 28'

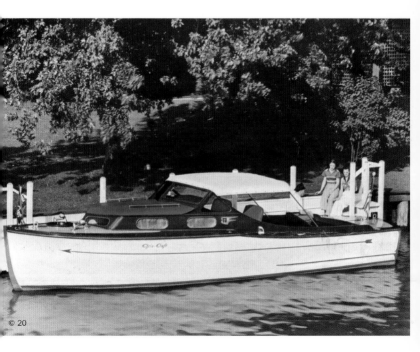

Una vez más confortables, otra vez más deportivos: desde el inicio los Cruiser fueron ofertados en un sinnúmero de variantes. Los mayores se llamaron entonces Motoryacht.

Piú spaziosi o piú sportivi: dall'inizio furono disponibili diverse versioni di Cruiser. Quelli piú grandi vennero chiamati con buona ragione Motoryacht.

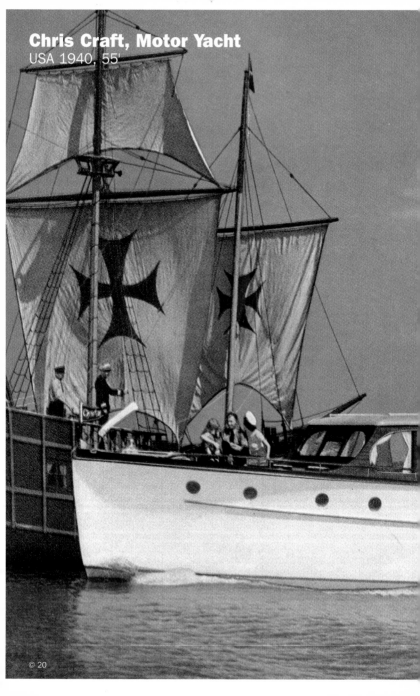

Chris Craft, Motor Yacht
USA 1940, 55'

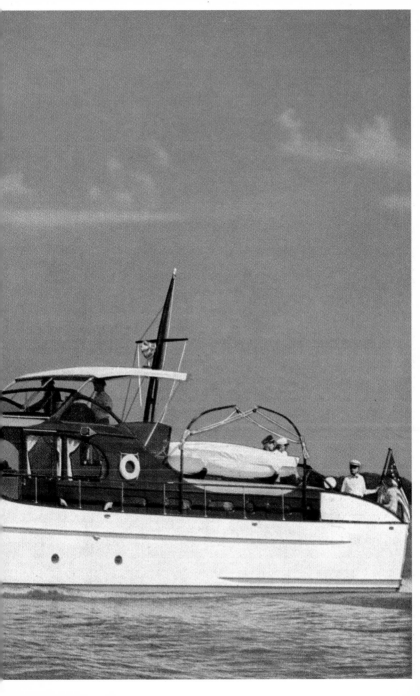

Chris Craft, Express Cruiser
USA 1940, 34'

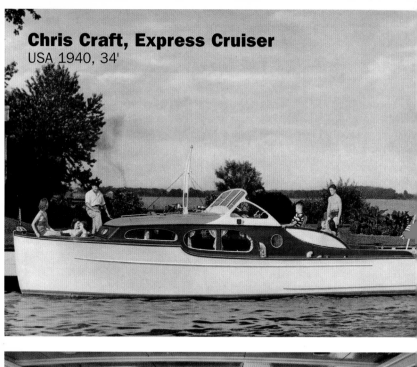

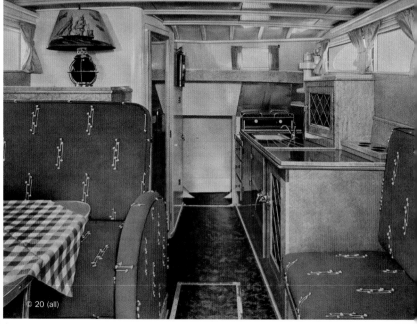

Chris Craft, Express Cruiser
USA 1941, 40'

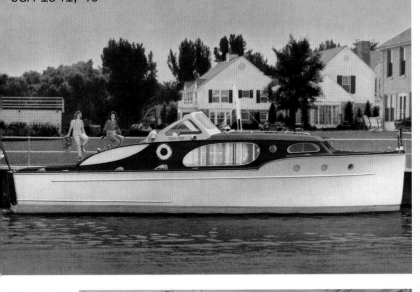

Chris Craft, "Red White" Express Cruiser
USA 1940, 26'

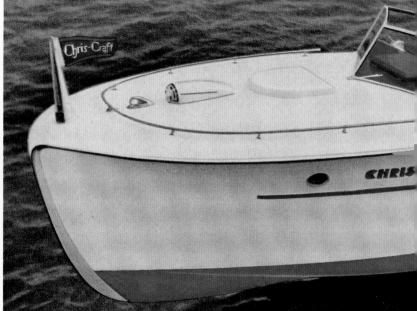

A one-off inspired by the 1939 International Exhibition: Lines and graphics in fashionable Art Deco soon became a standard.

Von der Weltausstellung von 1939 inspiriert: Linienführung und Grafik im modischen Art Deco sind später in der Serienproduktion zu finden.

Inspiré par l'exposition mondiale de 1939 : lignes et graphisme de tendance Art Déco se retrouvent plus tard dans les productions de série.

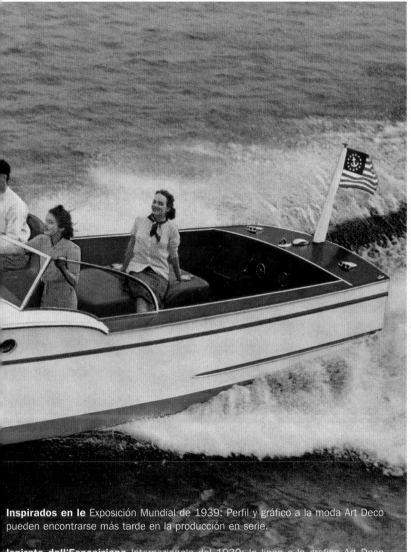

Inspirados en le Exposición Mundial de 1939: Perfil y gráfico a la moda Art Deco pueden encontrarse más tarde en la producción en serie.

Ispirato dall'Esposizione Internazionale del 1939: le linee e la grafica Art Deco fecero subito moda.

Baglietto, "Gim"
I 1940, 12 m

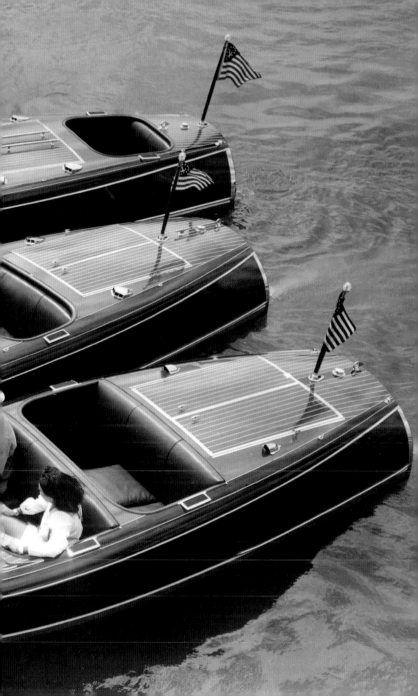

Chris Craft, Rocket Runabout
USA 1947, 16'

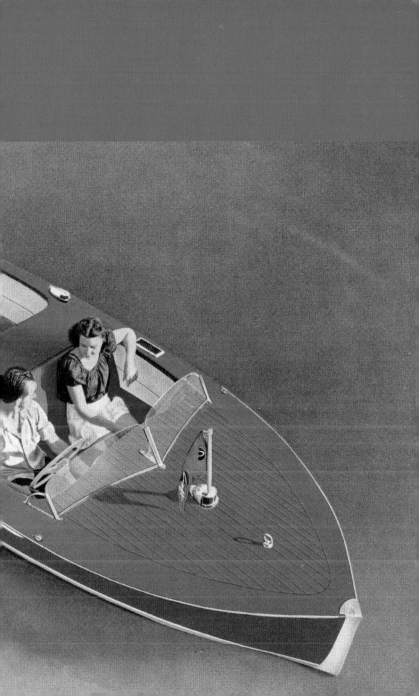

Baglietto, "Mille Miglia"
I 1939–46, 26 m

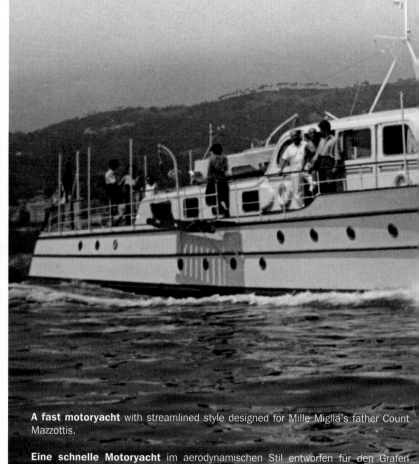

A fast motoryacht with streamlined style designed for Mille Miglia's father Count Mazzottis.

Eine schnelle Motoryacht im aerodynamischen Stil entworfen für den Grafen Mazzotti, Vater der Mille Miglia.

Un Motoryacht rapide dessiné dans un style aérodynamique pour le Comte Mazzotti, le père de la Mille Miglia.

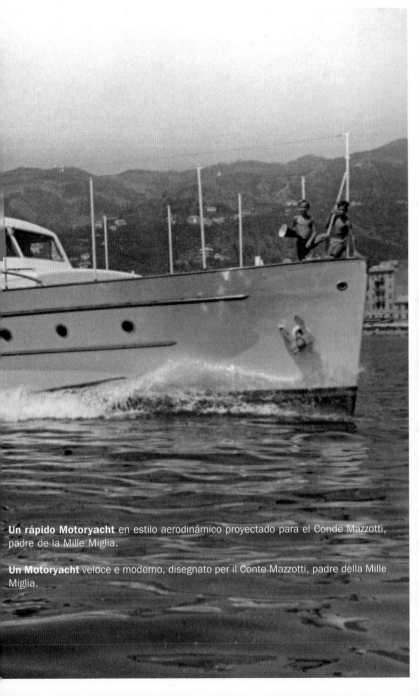

Un rápido Motoryacht en estilo aerodinámico proyectado para el Conde Mazzotti, padre de la Mille Miglia.

Un Motoryacht veloce e moderno, disegnato per il Conte Mazzotti, padre della Mille Miglia.

Hutchinson, "Pardon Me"

USA 1948–53, 48'

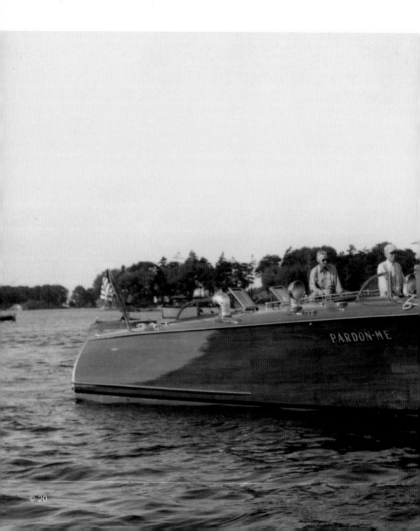

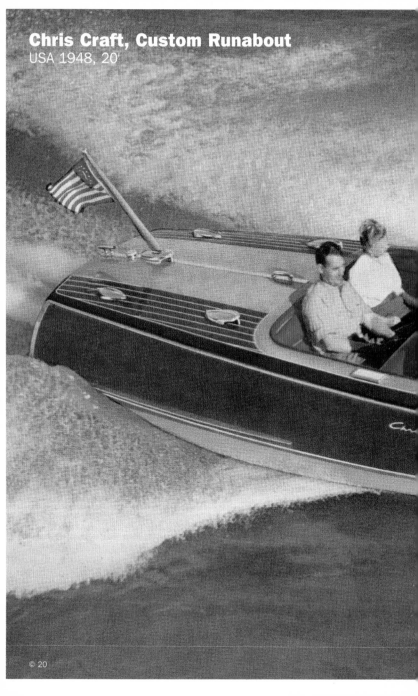

Chris Craft, Custom Runabout
USA 1948, 20'

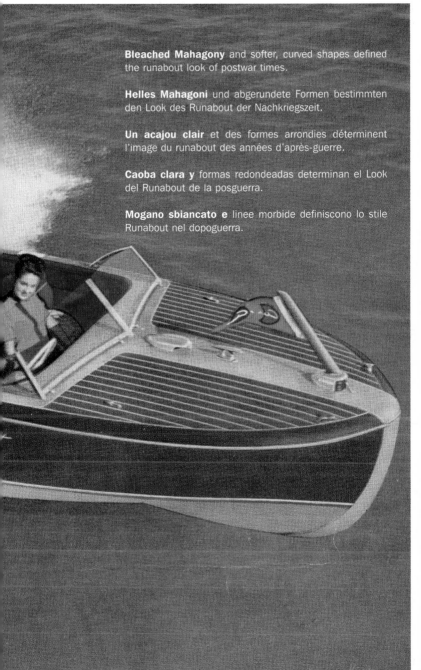

Bleached Mahagony and softer, curved shapes defined the runabout look of postwar times.

Helles Mahagoni und abgerundete Formen bestimmten den Look des Runabout der Nachkriegszeit.

Un acajou clair et des formes arrondies déterminent l'image du runabout des années d'après-guerre.

Caoba clara y formas redondeadas determinan el Look del Runabout de la posguerra.

Mogano sbiancato e linee morbide definiscono lo stile Runabout nel dopoguerra.

Riva, Sebino
l 1952–57, 4.9–5.1 m

152 **Cute, fine and sporty:** the first serial produced Riva.

Klein, fein und sportlich: die erste in Serie gefertigte Riva.

Petit, fin et sportif : le premier Riva produit en série.

Pequeña, elegante y deportiva: la primera Riva fabricada en serie.

Carino, raffinato, sportivo: il primo Riva di serie.

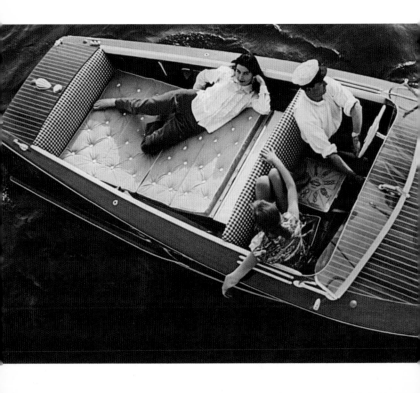

153

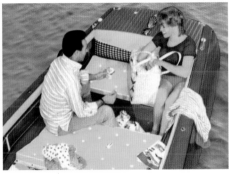

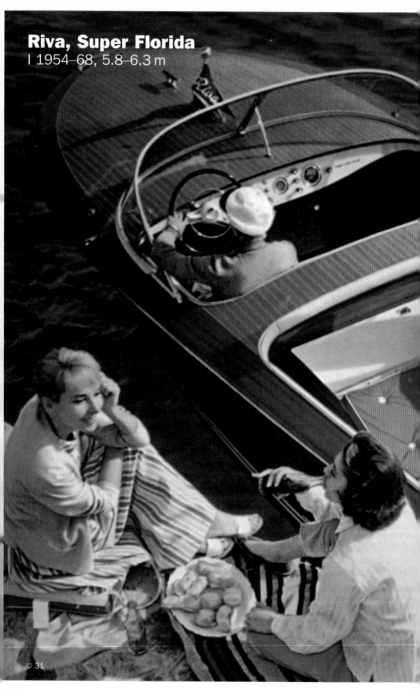

Riva, Super Florida
I 1954–68, 5.8–6.3 m

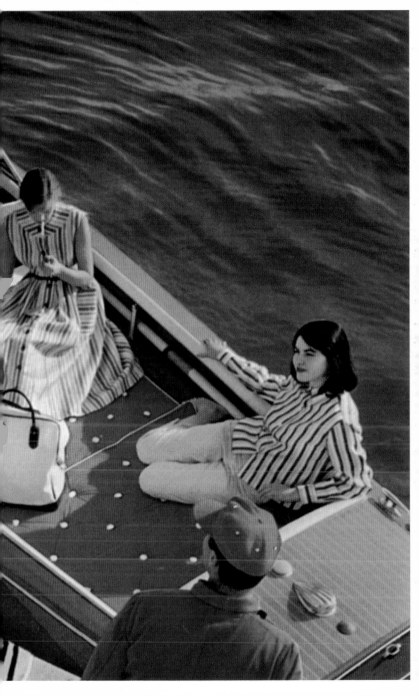

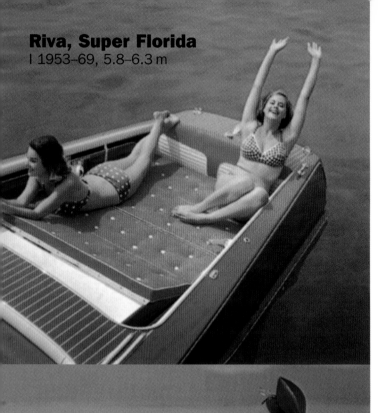

Riva, Super Florida

l 1953–69, 5.8–6.3 m

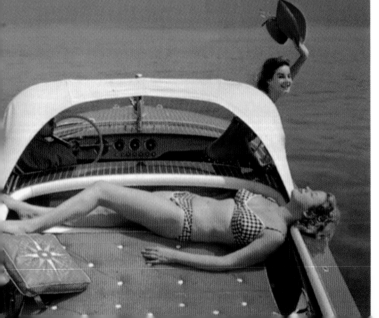

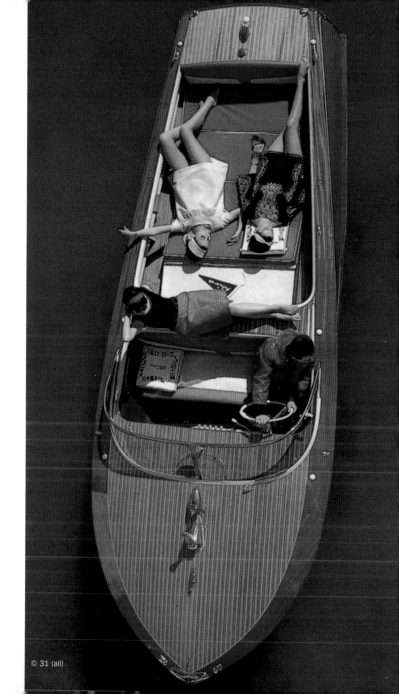

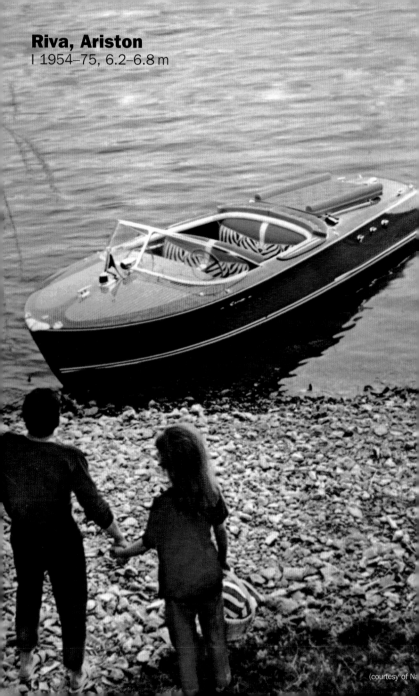

Riva, Ariston
| 1954–75, 6.2–6.8 m

Love at first sight: the Ariston counts among the most beautiful runabouts of all times.

Liebe auf den ersten Blick: die Ariston gilt als schönstes Runabout aller Zeiten.

Un vrai coup de foudre : le Ariston est considéré comme le plus beau Runabout de tous les temps.

Amor a primera vista: el Ariston vale como el más bello Runabout de todos los tiempos.

Amore a prima vista: esiste un Runabout piú bello dell'Ariston?

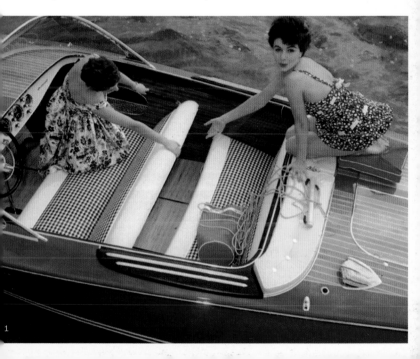

1

Riva, Tritone
I 1950–66, 7.6–8 m

160 **King of the Oceans:** with her sovereign shape, classic proportions and perfect detailing the twin-engined Tritone is the finest of all Rivas. She then evolved into the more famous and desirable Aquarama.

König der Meere: Imposante Form, klassische Proportionen und Perfektion im Detail machen die doppelmotorige Tritone eindeutig zur feinsten aller Rivas. Aus Ihr wurde später die berühmte und heute noch begehrte Aquarama.

Le roi des mers : une forme imposante, des proportions classiques et la perfection des détails font de ce Tritone à double moteur assurément le raffiné de tous les Riva. C'est de lui qu'est issu le célèbre Aquarama, aujourd'hui encore très demandé.

El rey de los mares: Formas imponentes, proporciones clásicas y perfección en los detalles hacen de la Tritone de dos motores la más elegante de todas las Rivas. De ella surgió más tarde la famosa y aún hoy codiciada Aquarama.

Il Re degli oceani: linea maestosa, proporzioni classiche, dettagli perfetti fanno del Tritone bimotore – da cui nel 1962 nacque l'Aquarama – il piú raffinato di tutti i Riva.

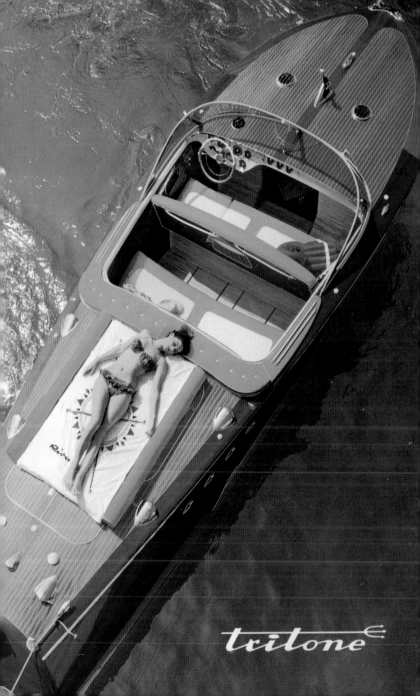

tritone

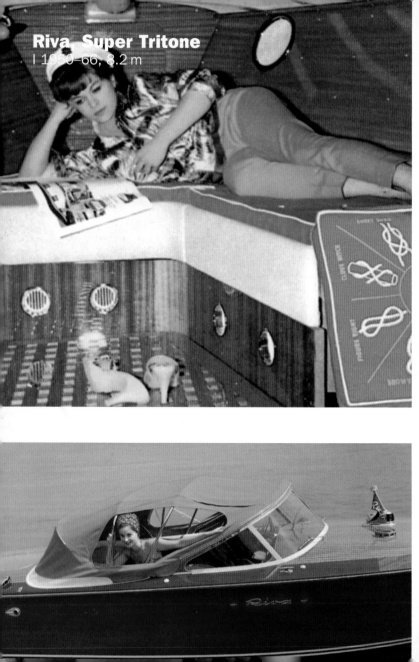

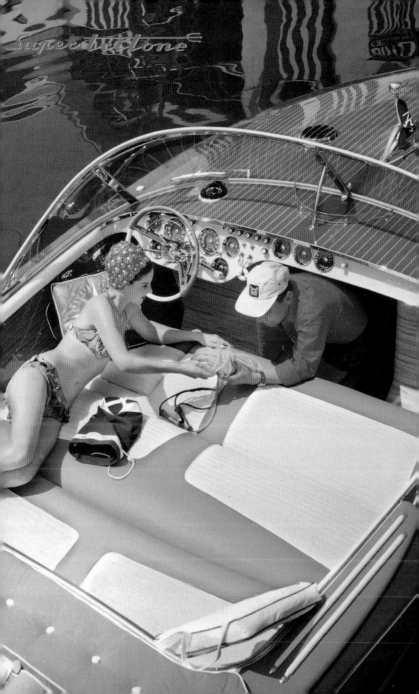

Boesch, Monaco 640
CH 1958, 6.4 m

164 **Rationality and Roominess** inspire Boesch's designs. This is a very unique walk-through cockpit offering flexible accomodation.

Rationalität und Raumökonomie prägen die Entwürfe von Boesch, hier in einer sehr originellen Walk-through-Cockpit Ausführung.

La rationalité et l'économie des espaces caractérisent les prototypes de Boesch, ici, un modèle à cockpit Walk-through très original.

Racionalidad y economía de espacio destacan los proyectos de Boesch, aquí en una ejecución muy original de Walk-through-Cockpit.

Razionalitá e spaziositá ispirano il design di Boesch. il Monaco presenta un insolito layout del cockpit Walk-through.

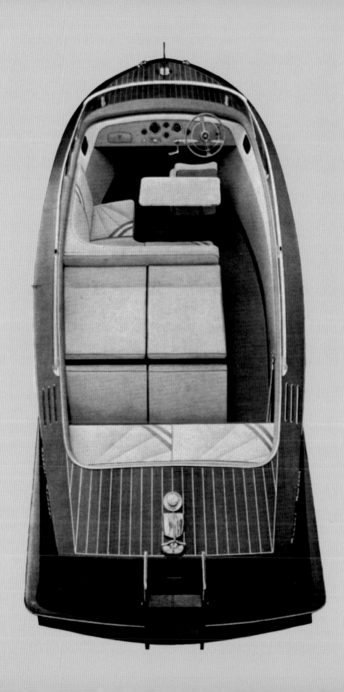

Boesch, Typ 510 Water-ski

CH 1965

© 07

Boesch, Typ 580 Deluxe

CH 1965, 5.8 m

Boesch, Typ 580 Lemania
CH 1965, 5.8 m

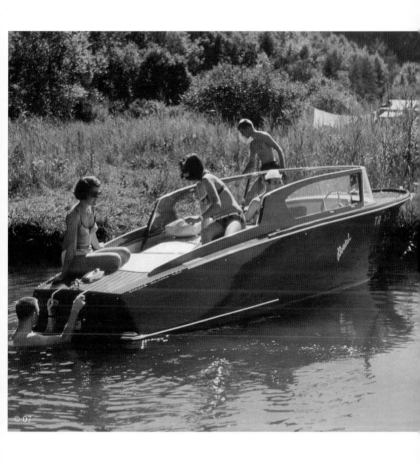

1955 FREEDOM FLEET

Chris ☆ Craft

WORLD'S LARGEST BUILDERS OF MOTOR BOATS

Chris Craft, Cobra
USA 1955, 18'

NEW... ADVANCE DESIGN!

CHRIS★CRAFT SHOWBOAT

ra SPORTS EXPRESS

Chris Craft, Silver Arrow
USA 1957, 19'

Fashionable with cars and boats: at the end of the 50s, fins were everywhere.

Ob Auto oder Boot: Heckflossen treten Ende der 50er überall in Erscheinung.

174 **Pour automobiles ou bateaux :** les ailerons arrières apparaissent partout à la fin des années 50.

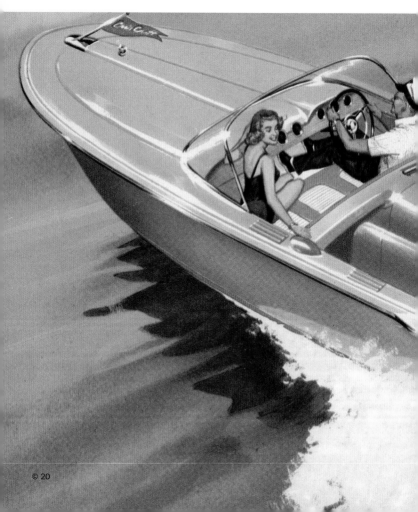

Sea automóvil o embarcación: Las aletas traseras aparecen en escena a fines de los años 50 en todas partes.

Di moda su auto e barche: verso la fine degli anni 50 le pinne erano dappertutto.

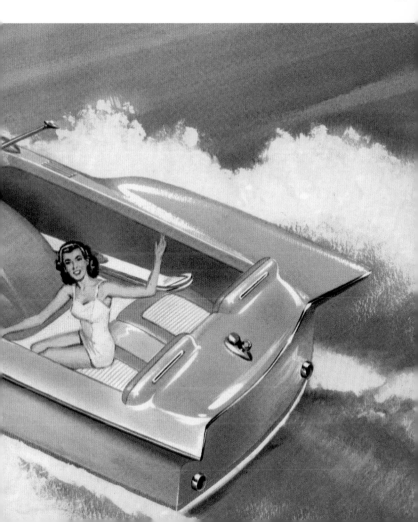

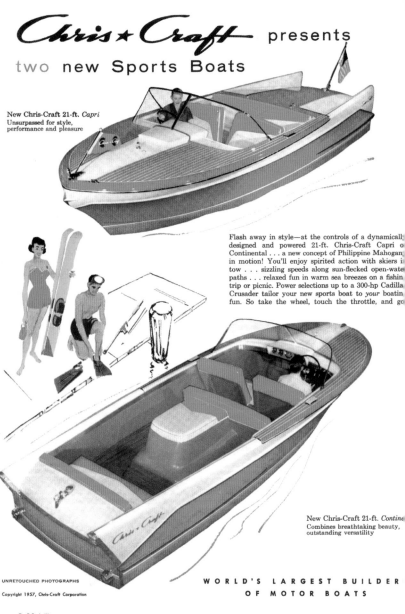

Chris ★ Craft presents
two new Sports Boats

New Chris-Craft 21-ft. *Capri*
Unsurpassed for style,
performance and pleasure

Flash away in style—at the controls of a dynamically
designed and powered 21-ft. Chris-Craft Capri o
Continental . . . a new concept of Philippine Mahogan
in motion! You'll enjoy spirited action with skiers i
tow . . . sizzling speeds along sun-flecked open-wate
paths . . . relaxed fun in warm sea breezes on a fishin
trip or picnic. Power selections up to a 300-hp Cadilla
Crusader tailor your new sports boat to *your* boatin
fun. So take the wheel, touch the throttle, and go

New Chris-Craft 21-ft. *Contine*
Combines breathtaking beauty,
outstanding versatility

**WORLD'S LARGEST BUILDER
OF MOTOR BOATS**

© 20 (all)

Chris Craft, Continental
USA 1957, 21'

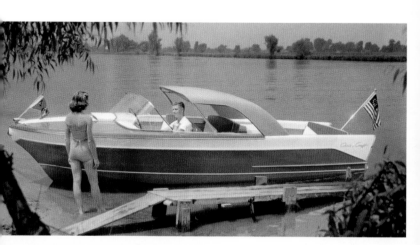

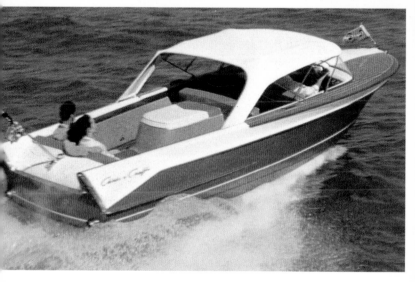

Baglietto, Ischia
I 1958–65, 16 m

Baglietto, Ischia
I 1958–65, 16 m

Milestone: this elegant interpretation of classic US design sports an innovative layout. Well over 100 Ischias were produced, thus influencing the whole branch.

Meisterwerk: Innovatives Raumkonzept in einer eleganten Interpretation klassisches amerikanischen Designs. Über 100 mal produziert, wurde Bagliettos Ischia zum Leitbild für die Branche.

Un chef-d'oeuvre : un concept innovant d'organisation de l'espace dans une élégante interprétation de design américain classique. Produit à plus de 100 exemplaires, l'Ischia de Baglietto fut le point de mire du secteur.

Obra maestra: Innovador concepto de espacio en una elegante interpretación del diseño clásico americano. Producido más de 100 veces, el Ischia de Baglietto se tornó el ideal del ramo.

Pietra Miliare: Un'elegante interpretazione del calssico design americano unita ad un innovativo layout. I piú di 100 ischia prodotti influenzarono tutta l'industria.

© 05

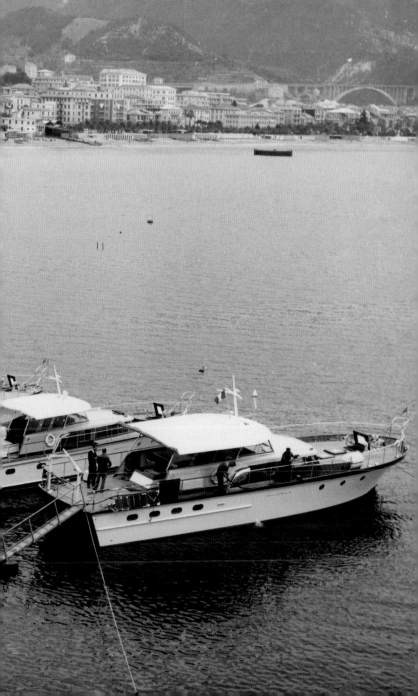

Baglietto, Ischia
I 1958–65, 16 m

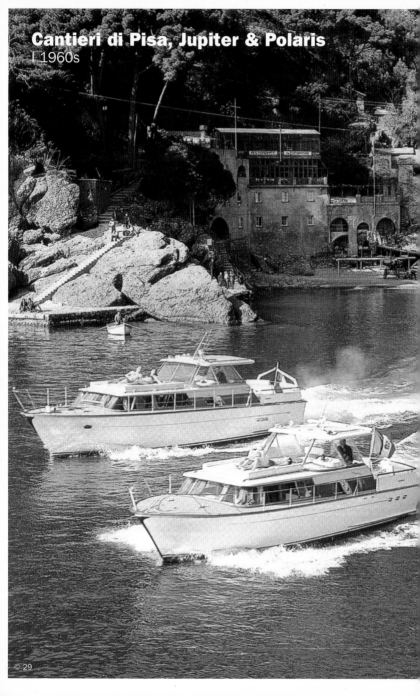

Simply a stilish life: motor-yachts of the 60s are functional, elegant and at the same time very sophisticated.

Einfach stilvoll leben: Motor-yachten der 60er sind funktional, schlicht und gleichzeitig raffiniert.

Un art de vivre simple et stylé : les Motoryacht des années 60 sont fonctionnels, sobres et en même temps raffinés.

Sencillamente vivir con estilo: Los Motoryacht de los años 60 son funcionales, sencillos y al mismo tiempo refinados.

Vivere con stile è semplice: i Motoryacht degli anni 60 sono funzionali, sobri ed allo stesso tempo raffinati.

© 29 (all)

Cantieri di Pisa, Super Polaris

I 1960s

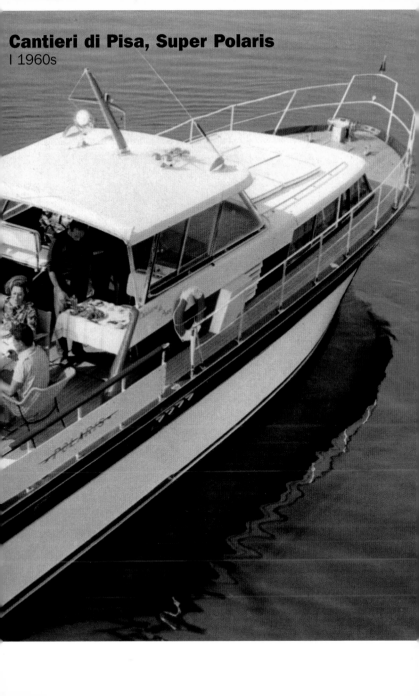

Coronet, 21 Daycruiser
DK 1965, 21'

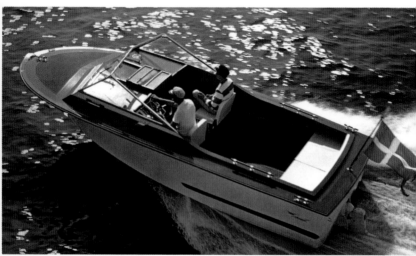

Scandinavian appeal in a no-thrills design. Coronet produced the first boat with aquamatic.

Skandinavisches Flair in einem Design ohne Schnörkel: Coronet produzierte das erste Boot mit Aquamatic.

Un caractère scandinave avec un design épuré : Coronet produit le premier bateaux avec Aquamatic.

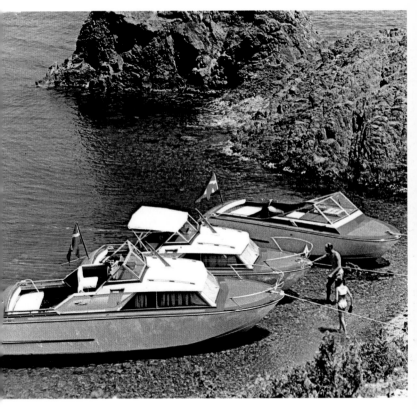

Aire escandinavo en un diseño sin fantasías: Coronet fabricó la primera embarcación con Aquamatic.

Design scandinavo dal gusto sobrio. Coronet fu il primo cantiere ad adottare l'Aquamatic.

Bertram, 31 Fishermen
USA 1961–on, 31'

190 **Caribic sportiness:** The first Bertram soon became the classic among Fishermen.

Karibische Sportlichkeit: Die erste Bertram wurde zum Klassiker unter den Fishermen.

La sportivité des Caraïbes : le premier Bertram est devenu un classique parmi les Fishermen.

Deportividad caribeña: El primer Bertram se transformó en el clásico entre los Fishermen.

Sportivitá caraibica: il primo Bertram è diventato il piú classico tra i Fishermen.

© 06

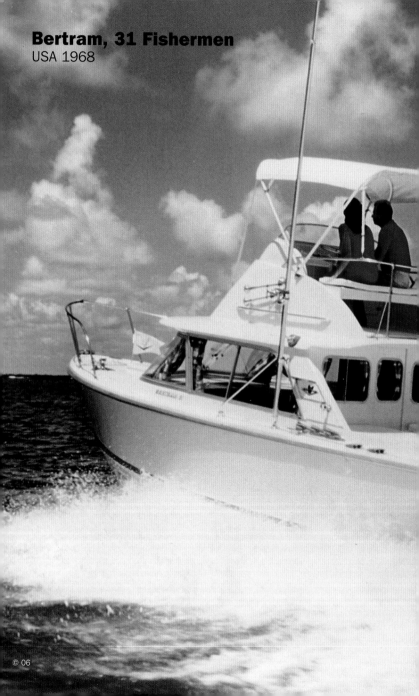

Bertram, 31 Fishermen
USA 1968

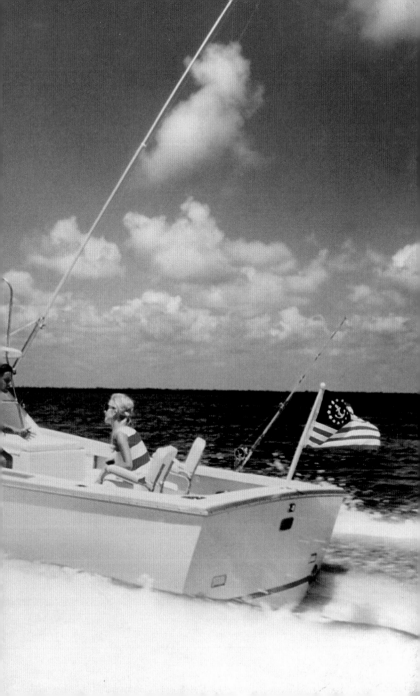

Magnum, 35
USA 1966, 35'

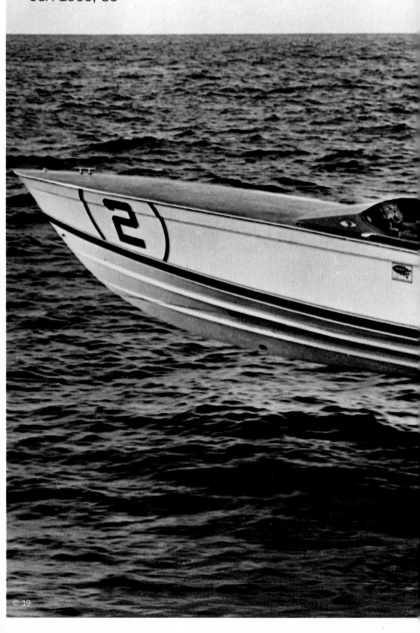

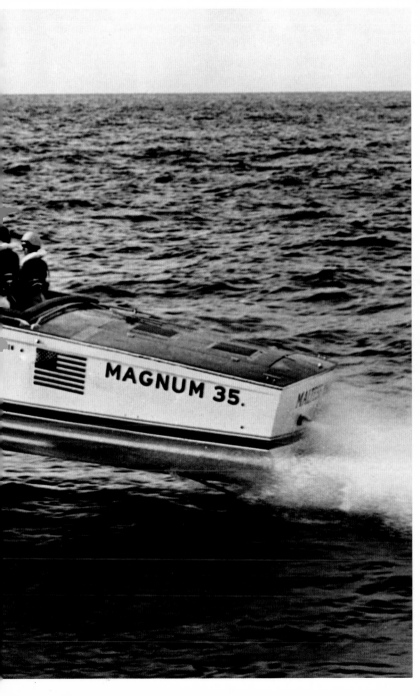

Chrysler, Lone Star Mustang

USA 1966, 15'

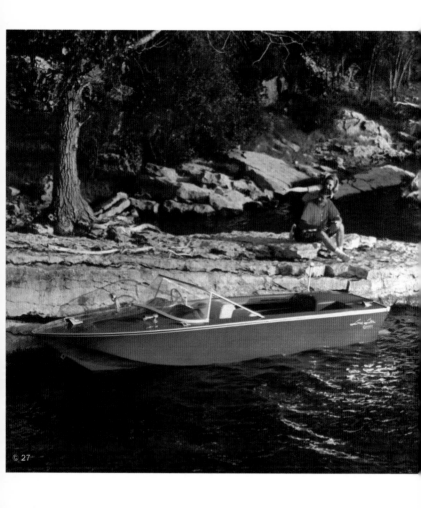

Chrysler, Lone Star Southwind
USA 1966, 22'

Sea Ray, SRV 180
USA 1967, 18'

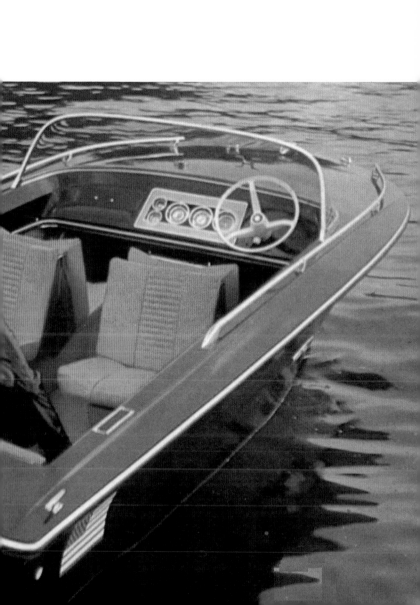

"More fun per foot!"

CHRYSLER

BOATS

FOR '67

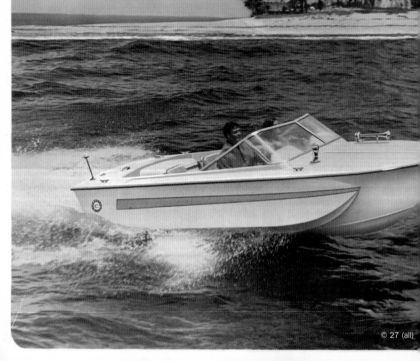

Chrysler, Courier
USA 1967

Chrysler, Charger
USA 1967

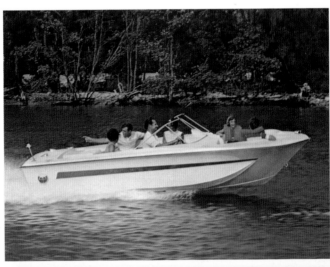

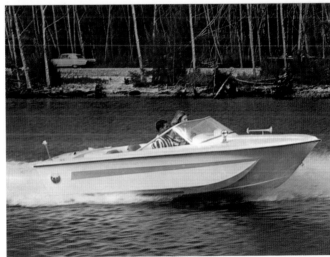

Sea Ray, SRX Pachanga
USA 1969, 16'

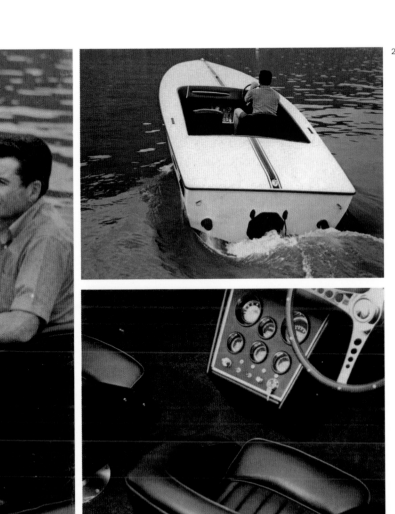

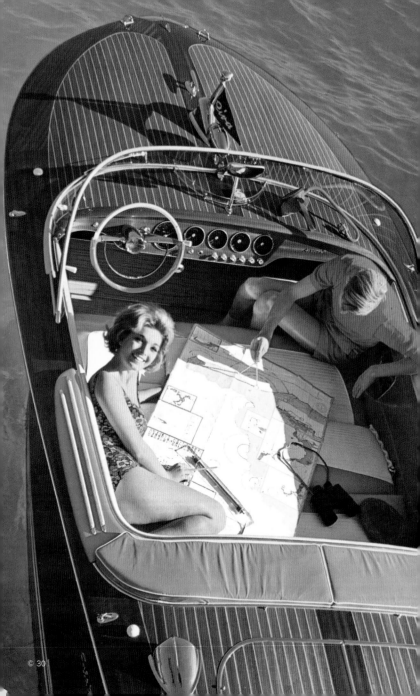

Riva, Ariston
| 1968, 6.8 m

The visibile joy: Rivas were finely designed down to the last detail. The Ariston was the last true runabout to be produced, the Aquarama Special ended 1996 a tradition in boatbuilding that has so far gained cult status.

Die sichtbare Freude ist begründet: Rivas sind in jedem Detail ein Augenschmaus. Mit dem Super Ariston lief 1975 der letzte wahre Runabout aus. Mit dem Aquarama Special endet 1996 eine Bootsbautradition, die heute Kultcharakter hat.

Le plaisir visible est inventé : les Riva sont un régla pour les yeux dans chaque détail. Le Super Ariston, fut en 1975 le dernier des vrais Runabouts. Avec l'Aquarama Special, disparaît en 1996 toute une tradition de construction de bateaux qui aujourd'hui prend le caractère d'un culte.

La visible alegría es justificada: Rivas son en cada detalle una alegría para los ojos. En el Super Ariston en 1975 se discontinuó el último verdadero Runabout. Con el Aquarama Special finalizó en 1996 una tradición de construcción de embarcaciones, que hoy tiene carácter de culto.

Gioia visibile: i Riva erano disegnato con cura fin nel minimo dettaglio. Il Super Ariston fu l'ultimo vero Runabout, con l'Aquarama Special termina nel 1996 una tradizione che è diventata un vero e proprio culto.

Riva, Aquarama Special
I 1972–96, 8.8 m

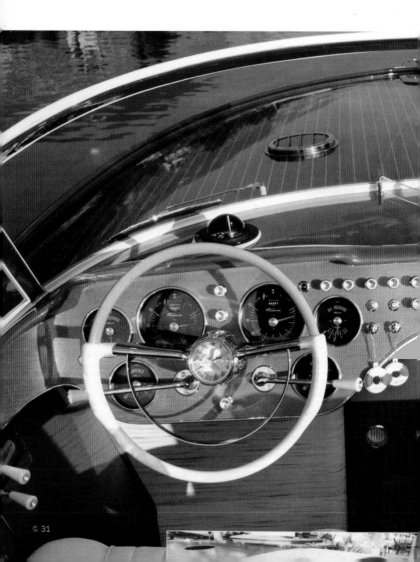

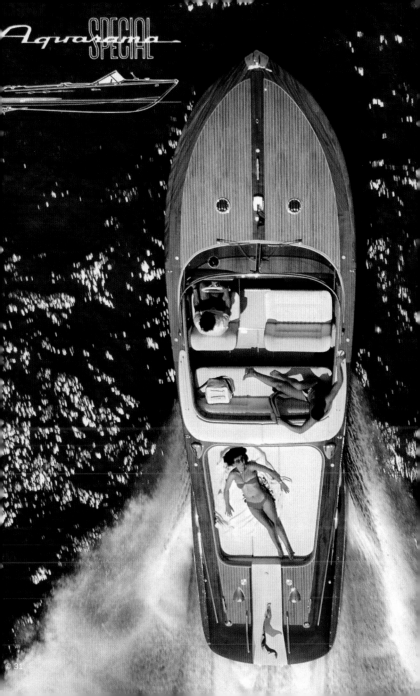

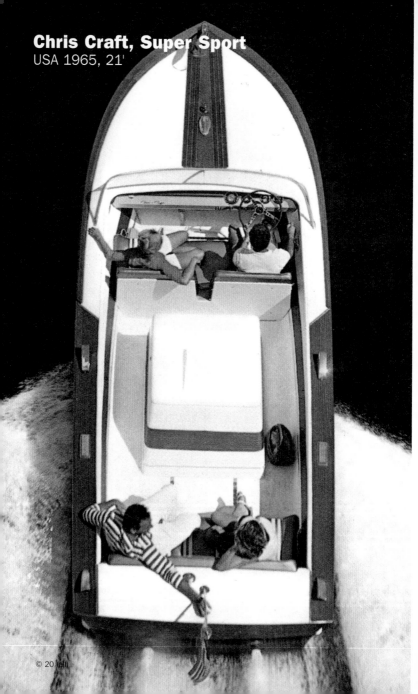

Chris Craft, Super Sport
USA 1965, 21'

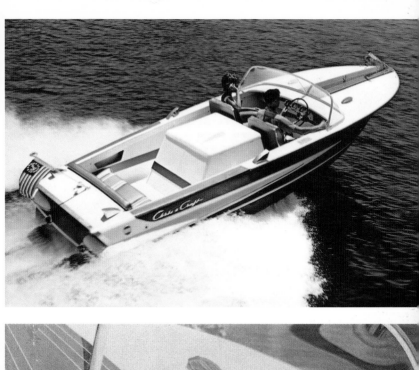

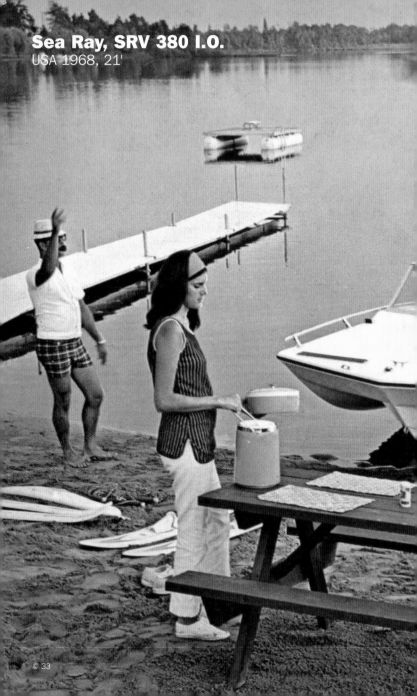

Sea Ray, SRV 380 I.O.
USA 1968, 21'

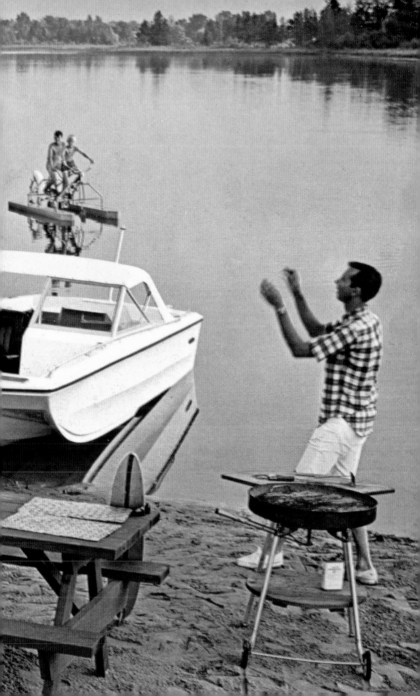

Chrysler '69 boats

CHRYSLER FUN IS FOR EVERYONE

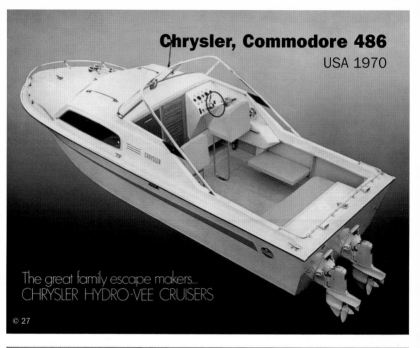

Chrysler, Commodore 486
USA 1970

The great family escape makers...
CHRYSLER HYDRO-VEE CRUISERS

© 27

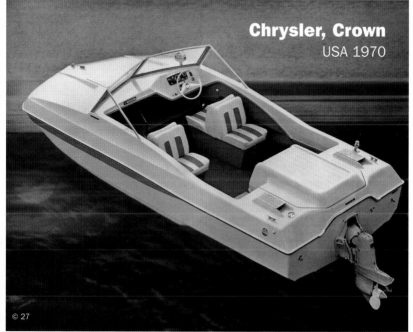

Chrysler, Crown
USA 1970

© 27

Sea Ray, SRV 190
USA 1970

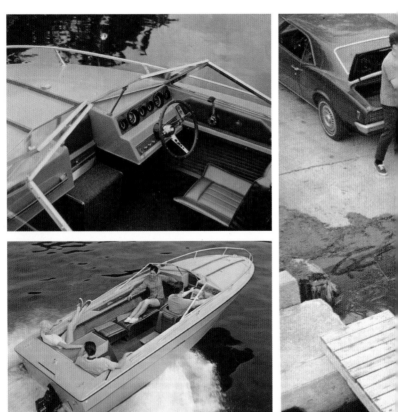

© 33 (all)

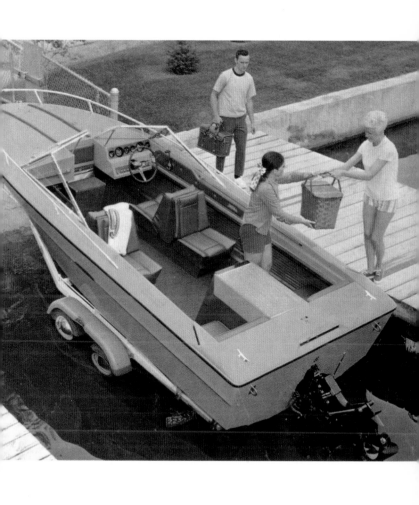

Riva, Junior
I 1966–72, 5.7 m

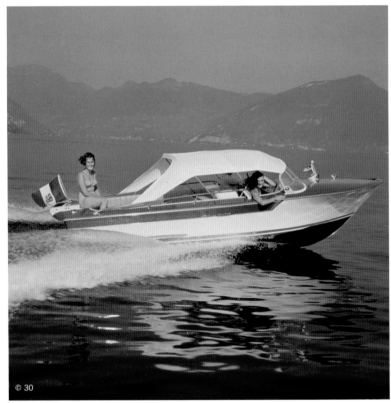

216

© 30

Riva Bertram, Bahia Mar
USA–I 1970–74, 20'

Chris Craft, Commander Cruiser
USA 1966, 31'

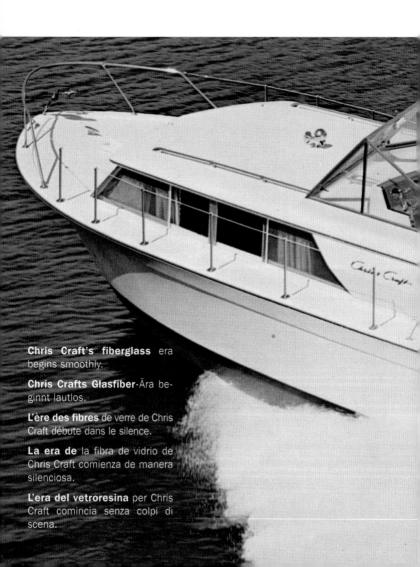

Chris Craft's fiberglass era begins smoothly.

Chris Crafts Glasfiber-Ära beginnt lautlos.

L'ère des fibres de verre de Chris Craft débute dans le silence.

La era de la fibra de vidrio de Chris Craft comienza de manera silenciosa.

L'era del vetroresina per Chris Craft comincia senza colpi di scena.

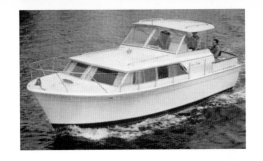

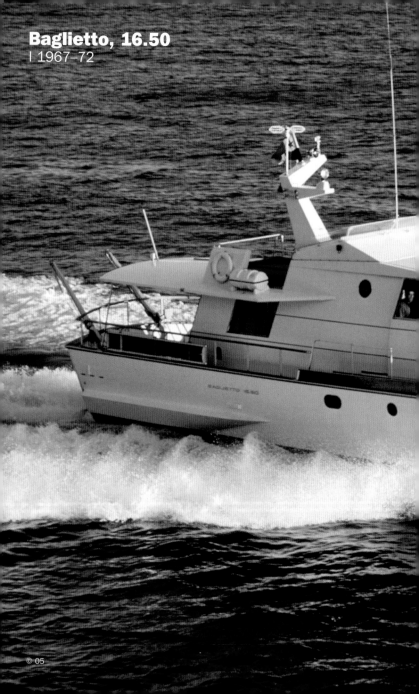

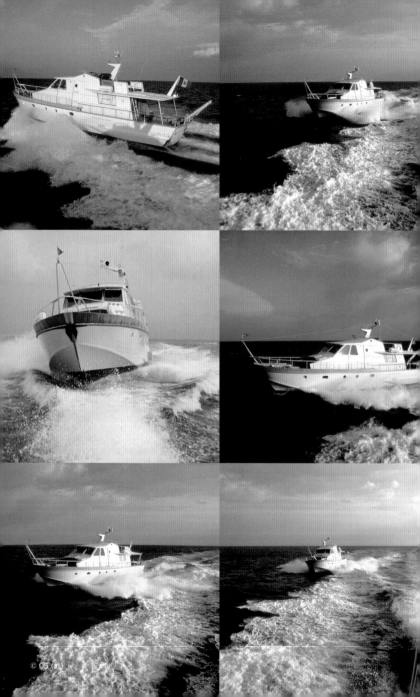

Baglietto, 16.50
I 1967–72

Inner values vs. pin-up look: the understated design results from a careful planning of the modular-built interiors. One more milestone from Baglietto.

Innere Werte statt Schaulust: die Bescheidenheit der Form resultiert aus der sorgfältigen Planung der modular gebauten Innenräume. Ein weiterer Meilenstein von Baglietto.

Des valeurs intérieurs au lieu de spectaculaire : la modestie de la forme est le fruit d'une étude soigneuse des espaces intérieurs aménagés par modules. Une nouvelle étape pour Baglietto.

Valores interiores en lugar de afición a los espectáculos: la discreción de las formas resulta de una cuidadosa planificación de los interiores construidos de forma modular. Un otro hito de Baglietto.

Valori intrinsechi contro un look da star: il design semplice e sobrio deriva dalla progettazione modulare deli interni. Un'altra pietra miliare di Baglietto.

Baglietto, 16.50
I 1967–72

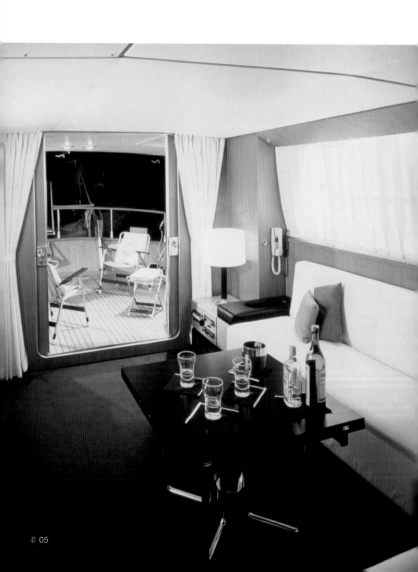

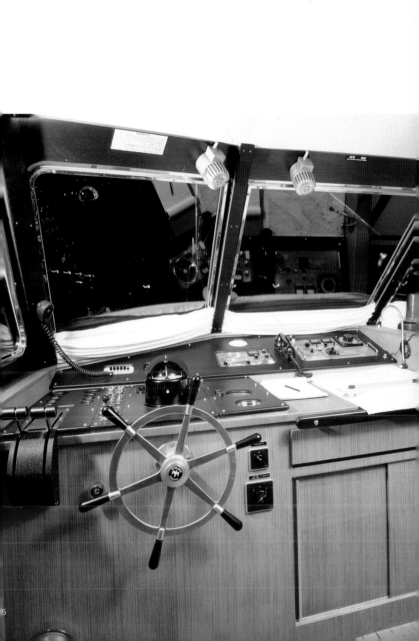

Baglietto, "Silver Shark"
I 1968

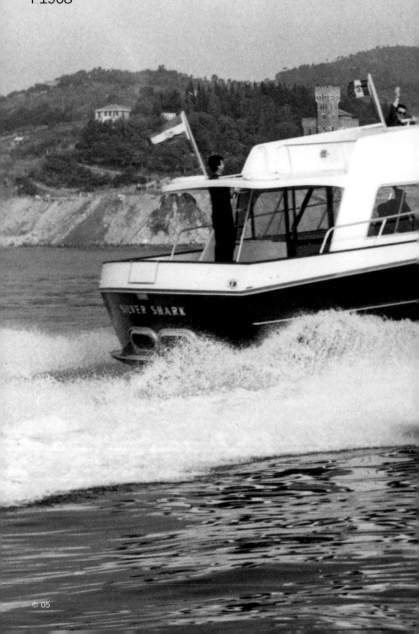

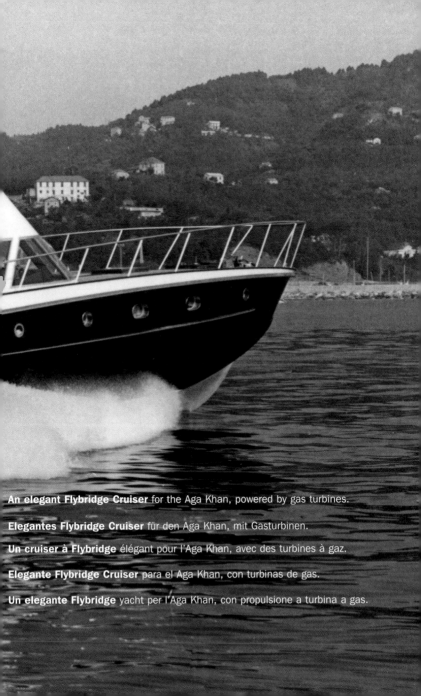

An elegant Flybridge Cruiser for the Aga Khan, powered by gas turbines.

Elegantes Flybridge Cruiser für den Aga Khan, mit Gasturbinen.

Un cruiser à Flybridge élégant pour l'Aga Khan, avec des turbines à gaz.

Elegante Flybridge Cruiser para el Aga Khan, con turbinas de gas.

Un elegante Flybridge yacht per l'Aga Khan, con propulsione a turbina a gas.

Coronet, 31 Seafarer

DK 1975–79

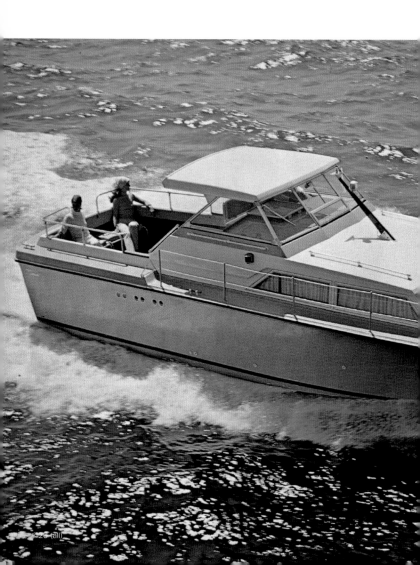

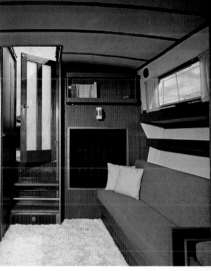

Sea Ray, SRV 240 Cuddy Cabin
USA 1976

230 **Less styling, more** usability. Simple, practical design of the 70s.

Design minimieren, Nutzen maximieren. Quadratisch, praktisch gut sind die 70er.

Minimalisation du design, maximalisation des utilisations. Carré, pratique, simple, c'est le leitmotiv des années 70.

Minimizar el diseño, maximizar el uso. Cuadráticos, prácticamente buenos son los años 70.

Meno fantasia, piú funzione nel semplice e pratico design degli anni 70.

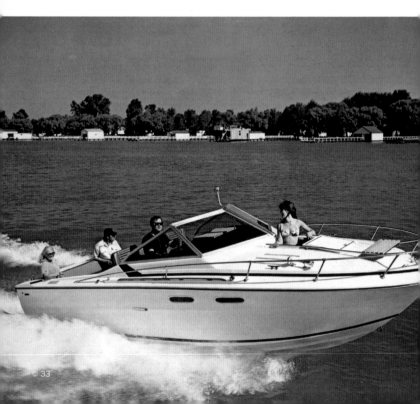

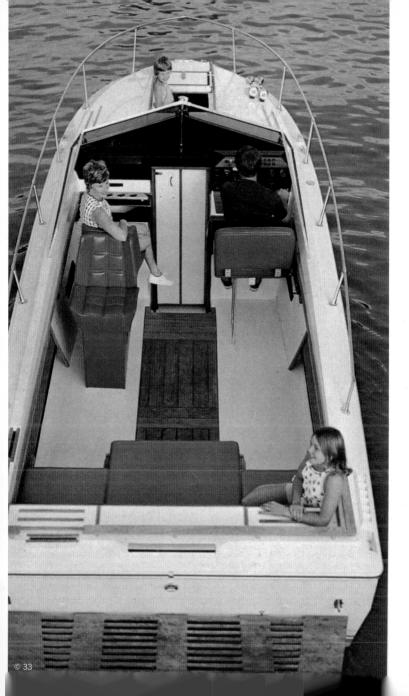

Coronet, 44 Yacht
DK 1970s

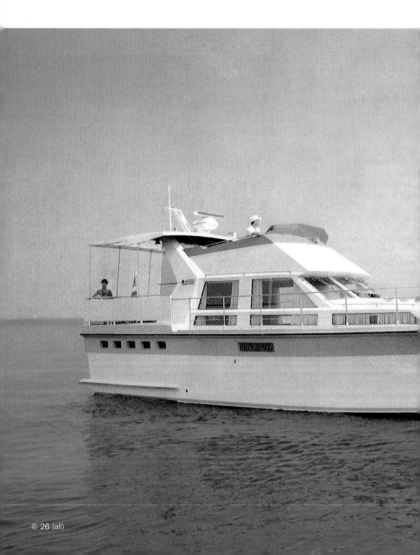

Coronet 44 Yacht

Cantieri di Pisa, Akhir 18

I 1972

The Akhir 18 is to the boat industry what Bertone's 33 Carabo was to the auto-mobile: a radical cut with the past whose new lines were a breakthrough. Condemned to be the perfect status symbol, this design gradually faded into an exaggerated flat-iron style.

Was 1968 Bertones keilförmige Carabo im Automobildesign war, war der Akhir 18 für die Bootsbranche: ein radikaler Bruch mit der Vergangenheit, eine neue Liniensprache, die Furore machte. Eigentlich weniger zum sehen als zum gesehen werden gedacht, wandelte sich die Linie später in übertriebene Bügeleisen-Ästhetik.

Ce que représentait la Carabo de Bertone à formes anguleuses, pour le design automobile de 1968, l' Akhir 18 en était le pendant dans le secteur nautique : une rupture fondamentale avec le passé, un nouveau langage des lignes qui faisait fureur. En définitive moins pensé pour l'appréciation que pour en jeter plein la vue, le style se transforma plus tard pour donner le look surfait de fer à repasser.

Lo que en 1968 fue el Carabo de forma de cuña de Bertone para el diseño del automóvil, fue también el Akhir 18 para el ramo de las embarcaciones: Una ruptu-ra radical con el pasado, un nuevo lenguaje de líneas que hizo furor. En realidad más pensado para ver que para ser visto, este se transformó más tarde en una exa-gerada estética de plancha.

L'Akhir 18 rappresenta per la nautica quello che la Carabo di Bertone è stato per l'automobile: nuove linee geometriche per un taglio radicale con il passato. Un per-fetto status symbol, questa linea degrada negli esagerati "ferri da stiro".

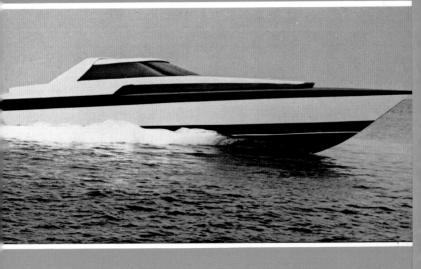

AKIR 18

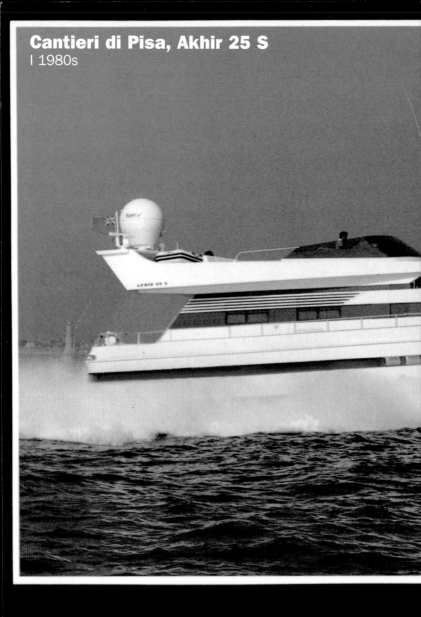

Cantieri di Pisa, Akhir 25 S
| 1980s

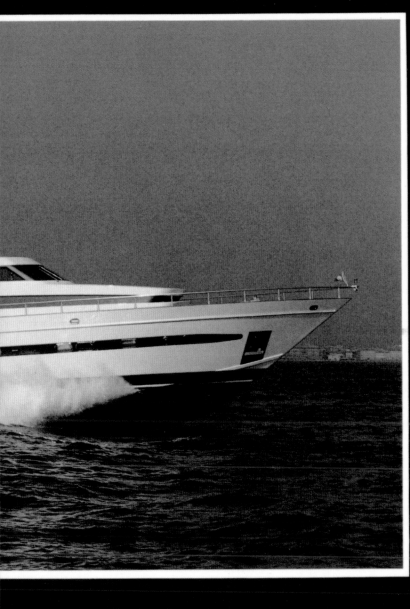

AK‖‖R 25 S

Riva, 2000
I 1975–80, 34'

Sex machine: three engines and a very individual character in the Italian Gigolo among Offshores.

Sex-Maschine: Drei Motoren und eigenwilligen Charakter im italienischen Gigolo unter den Offshores.

Sexe Machine : trois moteurs et un caractère individualiste de gigolo italien parmi les Offshore.

Sex-Machine: Tres motores y un carácter caprichoso en el Gigoló italiano entre las Offshores.

Sex Machine: tre motori ed uno stile unico fanno del 2000 l'Italian Gigolo fra gli Offshore.

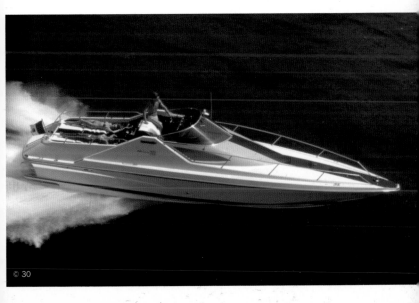

© 30

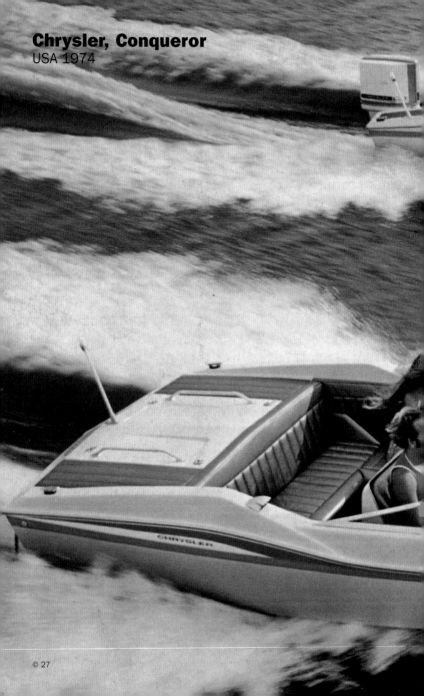

Chrysler, Conqueror
USA 1974

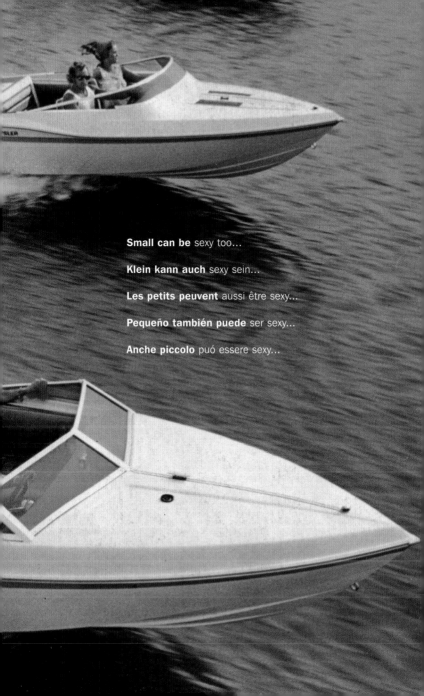

Small can be sexy too...

Klein kann auch sexy sein...

Les petits peuvent aussi être sexy...

Pequeño también puede ser sexy...

Anche piccolo puó essere sexy...

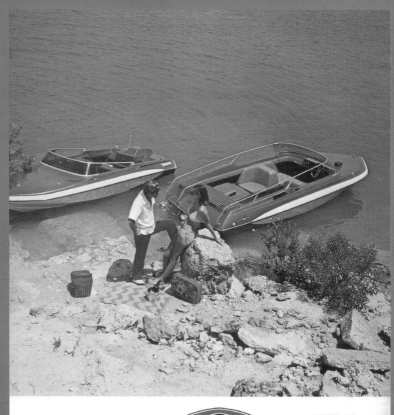

*Extraordinary boat
for the Extraordinary Man*

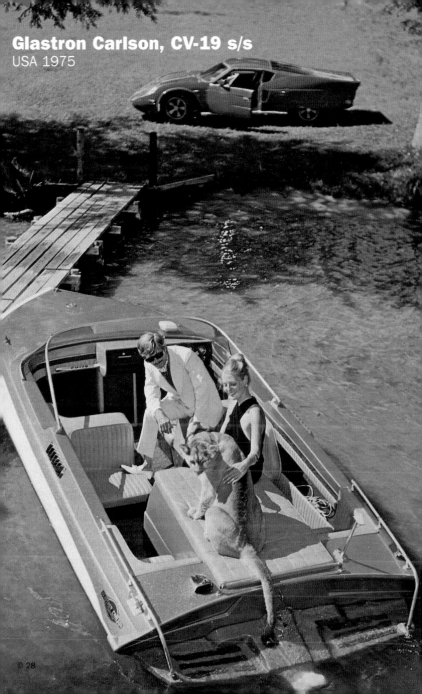

Glastron Carlson, CV-19 s/s
USA 1975

Glastron Carlson, CV-16 V8
USA 1975

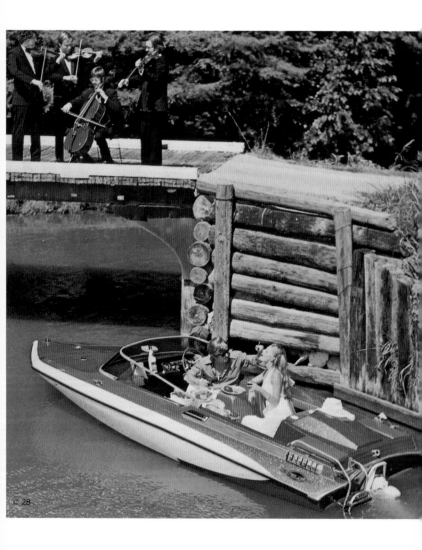

Glastron Carlson, CV-16 s/s
USA 1975

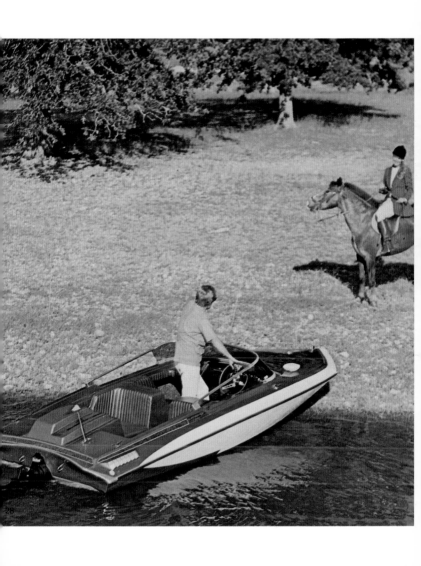

Boesch, Typ 530 Competition
CH 1984

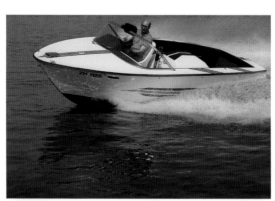

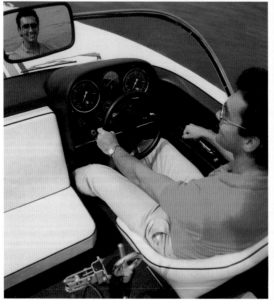

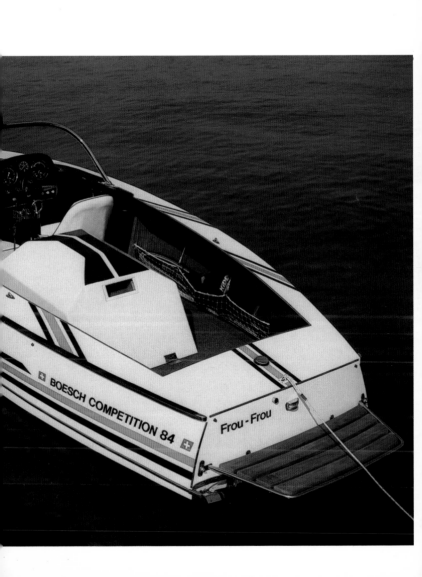

CARLS
SPORT

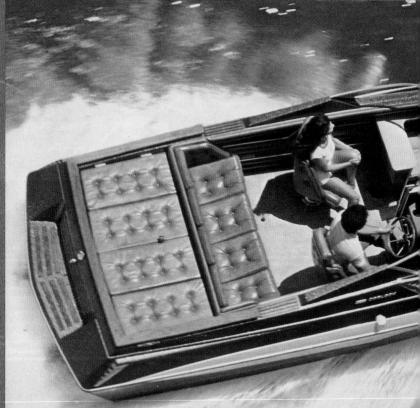

ON 79
BOATS

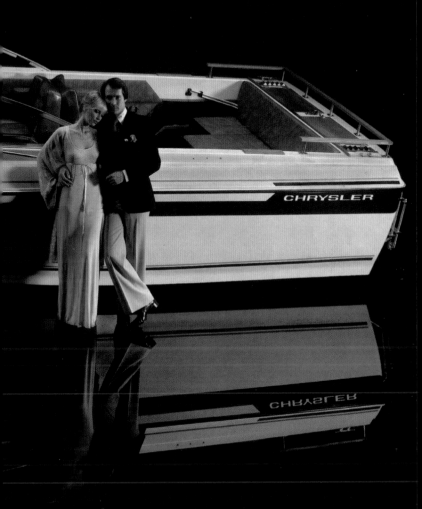

Sea Ray, SRV 360 Express Cruiser
USA 1981, 36'

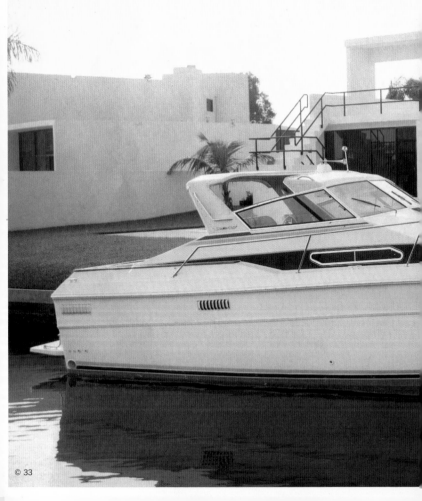

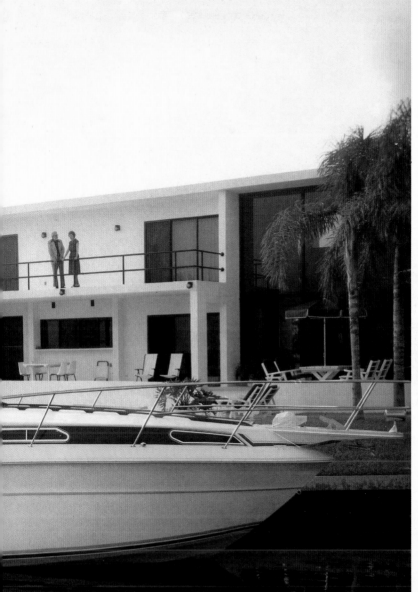

SRV 360
Express Cruiser

Bertram, 58

USA 1977

Fishermen-style life as a part of the Bertram experience.

Fishermen-Style Leben im Bertram.

La vie en Bertram, le style Fishermen.

Vivir el Fishermen-Style en el Bertram.

Vita da Fishermen su un Bertram.

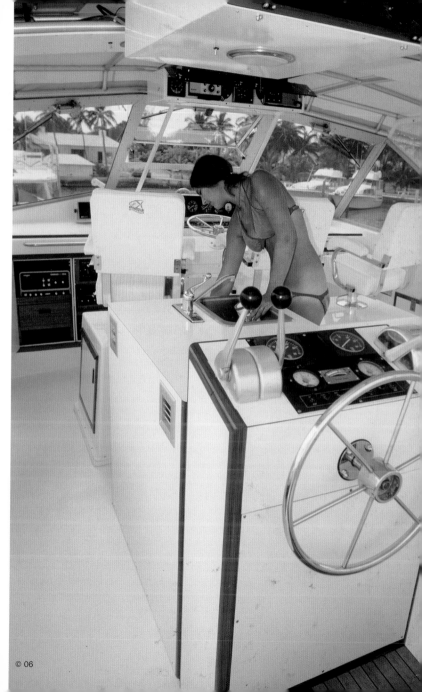

Baglietto, Ischia 80
I 1980

© 05

The Boat as a weapon. Design in the 80s is mostly concerned with overstatement expressed through a martial, sovereign look.

Das Boot als Waffe. Martialisch und auffällig wirkt das Design der 80er Jahre.

Le bateau comme une arme. Le design des années 80 est martial et voyant.

La embarcación como arma. Marcial y llamativo se presenta el diseño de los años 80.

La barca come arma: il design degli anni 80 diventa overstatement expresso da un look marziale ed aggressivo.

Riva, Black Corsair
I 1985–90, 60'

The begin of the Sport Yacht era: (nice) adult toys.

Die Ära der Sport Yacht beginnt: (schöne) Spielzeuge für Erwachsene.

L'ère des Sport Yacht à débuté : des (beaux) joujoux pour adultes.

Se inicia la era de los Sport Yacht: (bellos) juguetes para adultos.

L'inizio dell'era degli Sport Yacht: (bei) giocattoli per adulti.

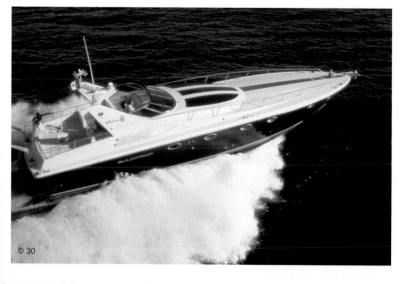

© 30

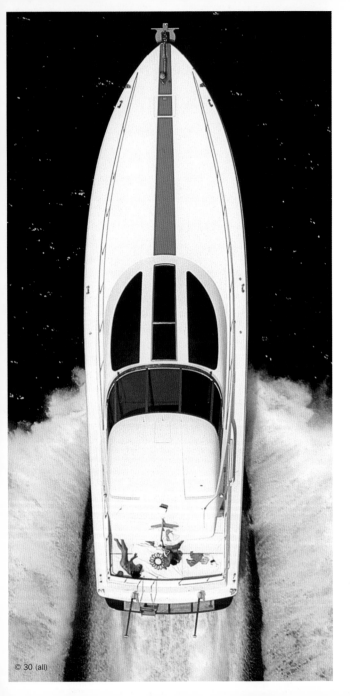

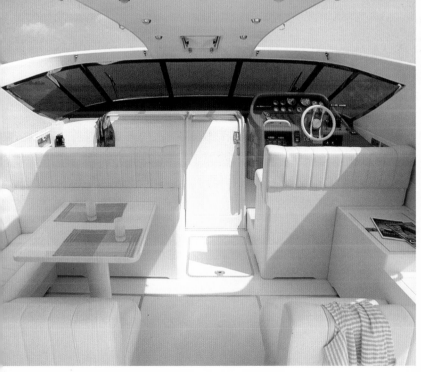

Magnum, "63"
USA 1983

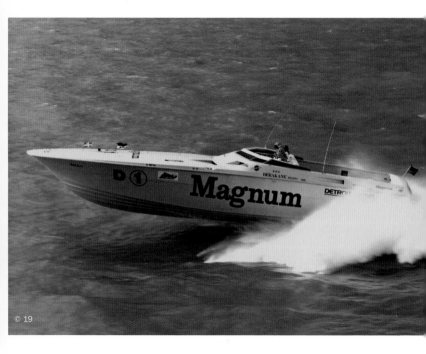

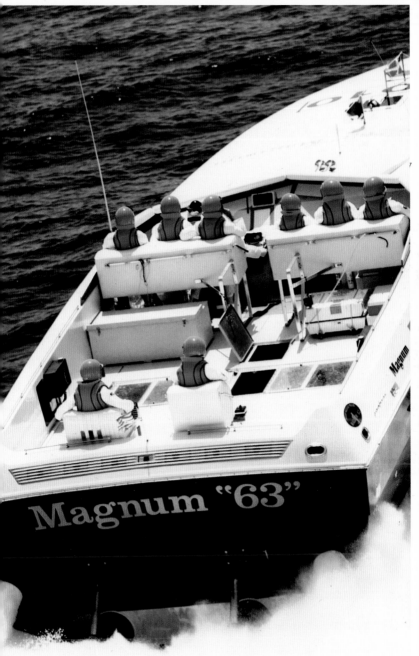

Cigarette, Bullet
USA 1980s, 31'

Penetrating as a bullet, funny to play with. Erotic is a persistent metaphor in the world of Cigarette.

Penetrant wie ein Projektil, womit man gerne spielt. Die Erotik-Metapher ist eine beliebte Konstante im Erscheinungsbild des Cigarette.

Pénétrant comme un projectile avec lequel on aime à jouer. La métaphore érotique est une constante appréciée pour désigner l'image du Cigarette.

Penetrante como un proyectil, con lo que se juega a gusto. La metáfora erótica en una constante valorada en la imagen de apariencia del Cigarette.

Penetrante come un proiettile, con cui si gioca volentieri. Erotismo metaforico del Cigarette.

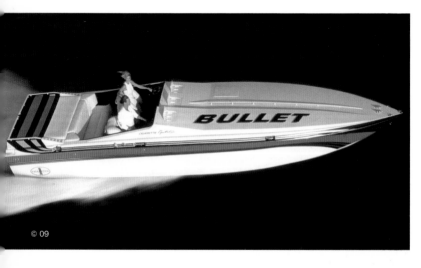

© 09

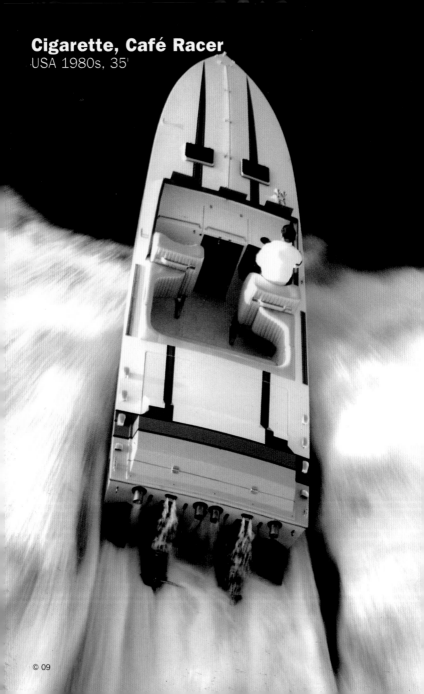

Cigarette, Café Racer
USA 1980s, 35'

© 09

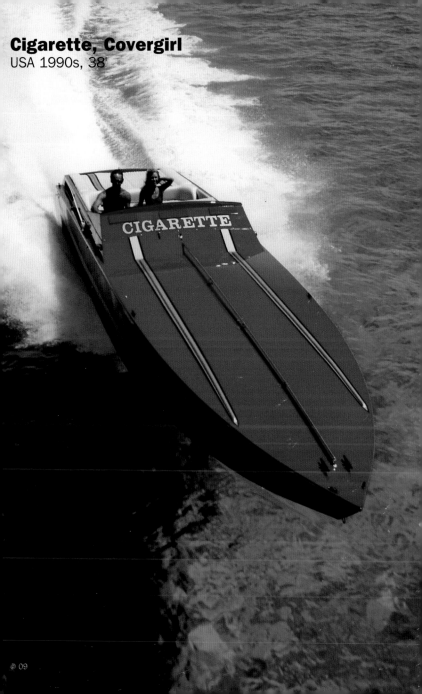

Cigarette, Covergirl
USA 1990s, 38'

Cigarette, Covergirl
USA 1990s, 38'

The covergirl cabin has become a standard Cigarette option. The reason appears to be obvious.

Die Cover-Girl-Kabine wurde zur Standardbezeichnung bei Cigarette. Grund und Zweck sind eindeutig.

La cabine Cover-Girl devint une désignation standard du Cigarette. La raison et le but en sont évidents.

La cabina Cover-Girl se tornó una denominación estándar en el Cigarette. Razón y finalidad son evidentes.

Il motivo per cui la cabina detta Cover-Girl fa parte dell'equipaggiamento standard di un Cigarette appare ovvio.

© 09

Riva, Ferrari
I 1989–91, 32'

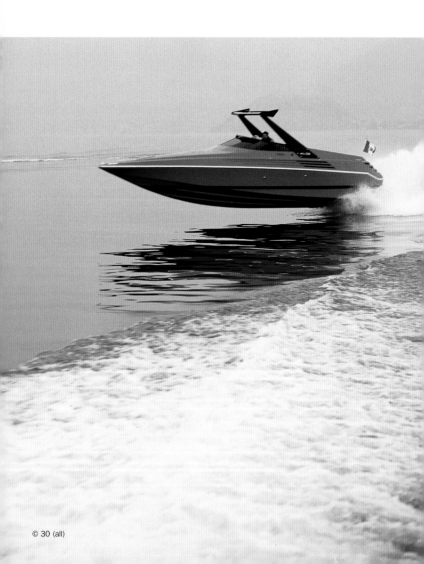

Itama, 40
I 2000s

Puristic, timeless design: Itamas are the Porsche 911 among large open sport yachts.

Puristisches, zeitloses Design macht Itama zum Porsche 911 unter den großen offenen Sportyachten.

Un style épuré et intemporel fait du Itama une Porsche 911 parmi les grands Sport Yacht.

Diseño purista, intemporal hacen del Itama el Porsche 911 entre los grandes Sport Yacht abiertos.

Design puro e senza tempo: l'Itama è come la Porsche 911 fra i grandi Sport Yacht aperti.

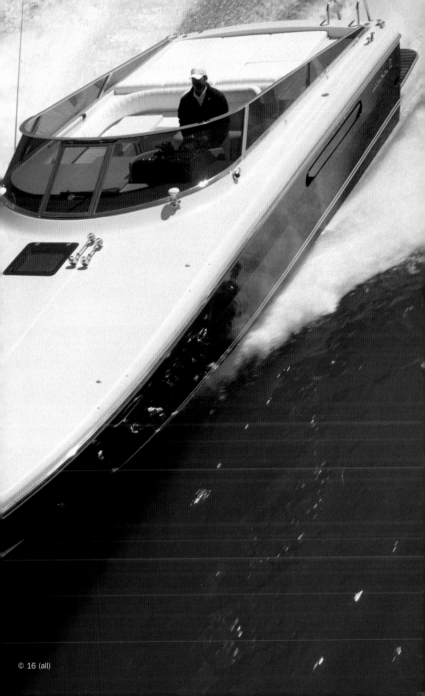

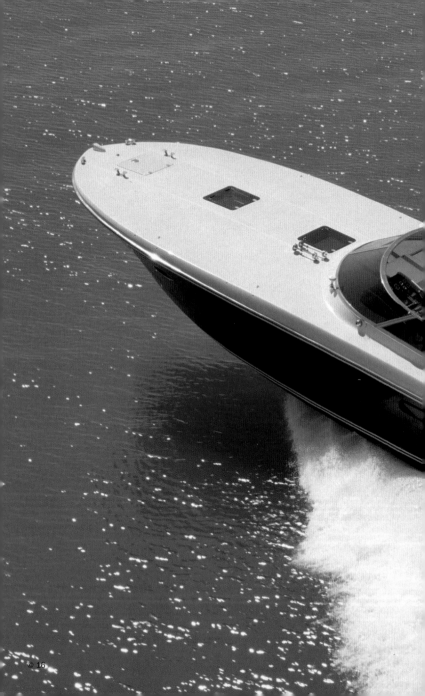

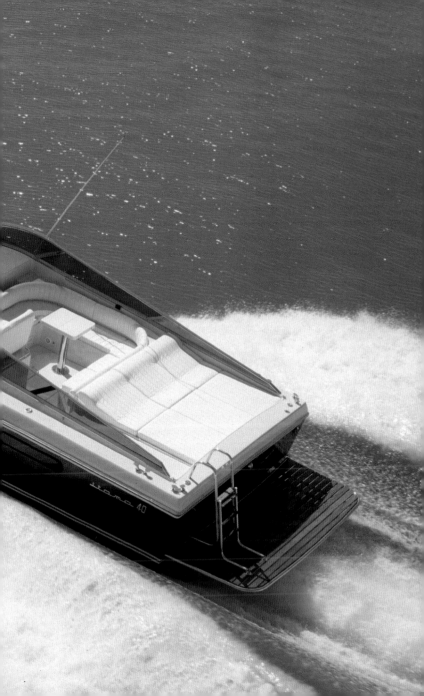

Colombo, Romance
I 1994, 32'

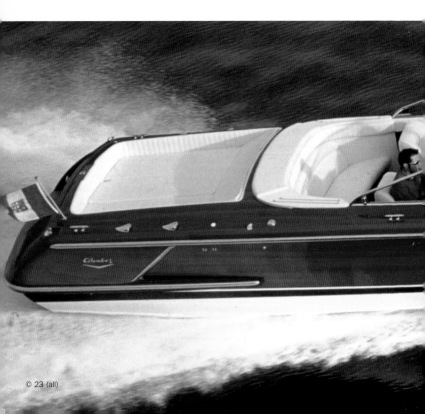

280 **Fiberglass body with** Mahagony skin. Retro elegance is suddenly back in place.

Glasfiber mit Mahagoni-Beplankung: Retro-Eleganz ist plötzlich wieder da.

Fibres de verre à placage d'acajou : l'élégance rétro réapparaît soudain.

Tablazón de fibra de vidrio con caoba: La elegancia Retro sorpresivamente está de vuelta.

Corpo di vetroresina rivestito di mogano: L'eleganza Retro è di nuovo in auge.

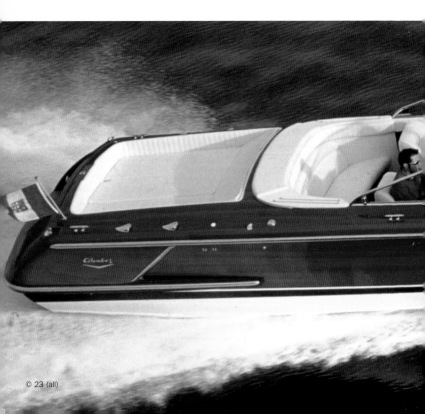

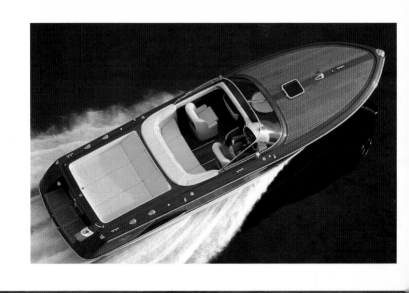

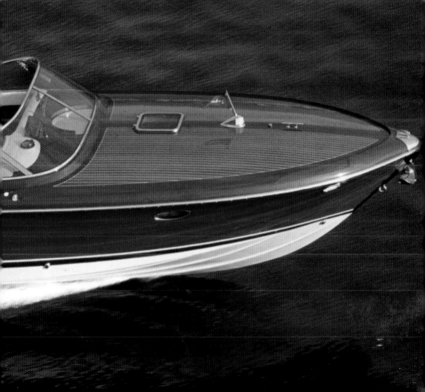

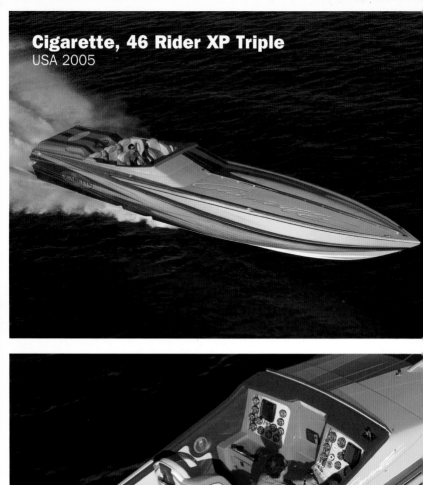

Cigarette, 46 Rider XP Triple
USA 2005

Cigarette, 38 Top Gun
USA 1987–on

Only Flying is better: twin-step hull of a Cigarette, whose name says it all.

Nur fliegen ist schöner! Doppelstufe im Rumpf des Cigarettes, dessen Namen alles sagt.

Seul voler est plus beau ! Coque à double dégradé pour le Cigarette dont le nom seul est déjà explicite.

© 09

¡Sólo volar es más bello! Doble escalón en el casco del Cigarette, cuyo nombre lo dice todo.

Solo volare è piú bello: carena a doppio redan per un Cigarette, il cui nome dice tutto.

Magnum, 80
USA 2000

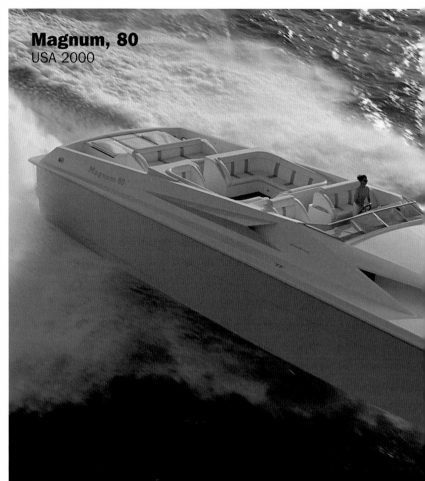

Endless big! Designed by Pininfarina.

Endlos groß! Entworfen von Pininfarina.

Infiniment grand ! Design de chez Pininfarina.

¡Infinitamente grande! Diseño de Pininfarina.

Sei grande grande grande... disegnato da Pininfarina.

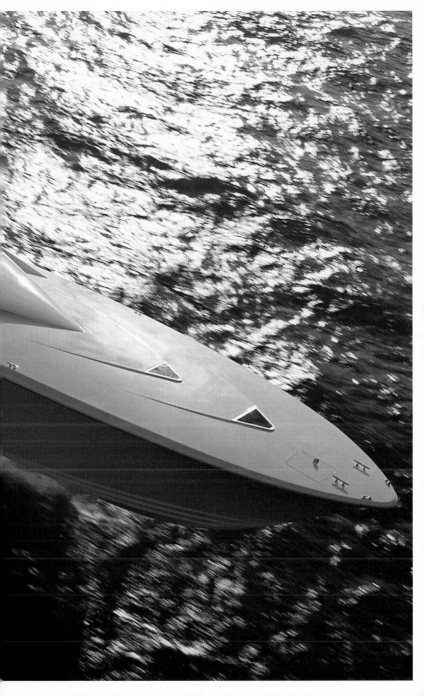

Wally, Wally Tender
F 2001, 45'

288 **For the discerning individual.** Wally's hi-tech.

Stoff für Individualisten: Hi-Tech bei Wally.

La chose pour les individualistes : le Hi-Tech de chez Wally.

Material para individualistas: Hi-Tech en Wally.

Hi-Tech di Wally per individualisti.

© 35

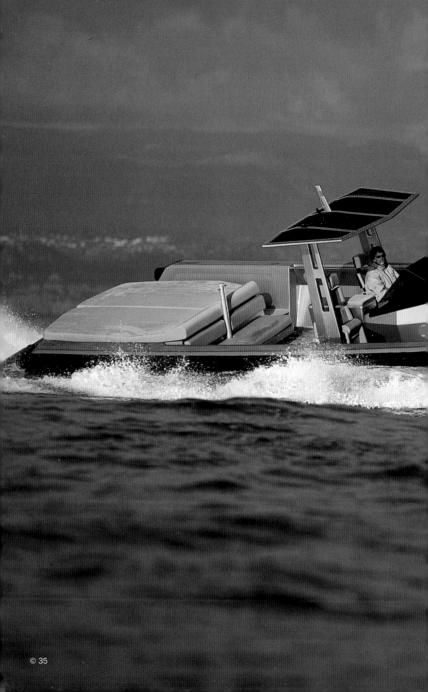

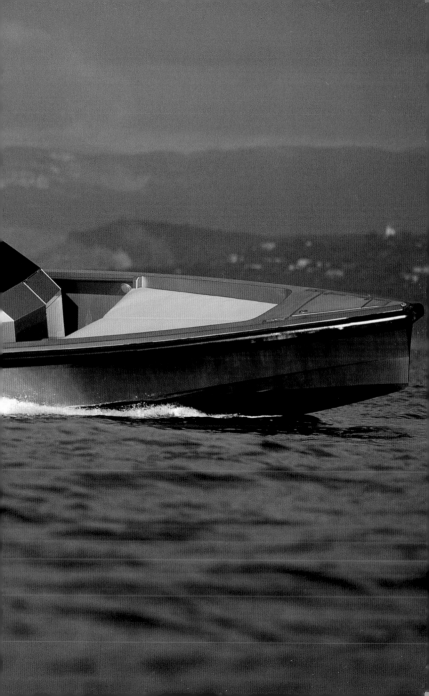

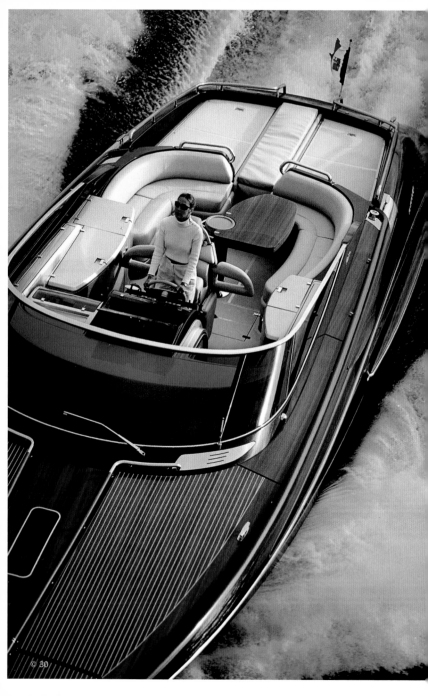

© 30

Riva, Rivarama
I 2000s, 44'

Lost emotions in new shapes: never ever had a "true" Riva been so huge.

Vergangene Gefühle erlebt man wieder im Rivarama. So groß war ein „echtes" Riva-Boot noch nie.

Le Rivarama fait remonter la nostalgie retrouver. Aucun «vrai» Riva n'a jamais été aussi grand.

Sensaciones pasadas se vuelven a revivir en el Rivarama. Tan grande no fue nunca una "auténtica" embarcación Riva.

Emozioni ritrovate in nuove forme: un "vero" Riva non era mai stato cosí grande.

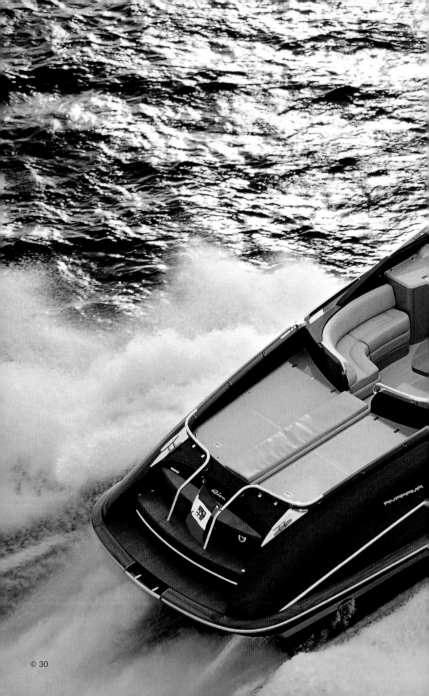

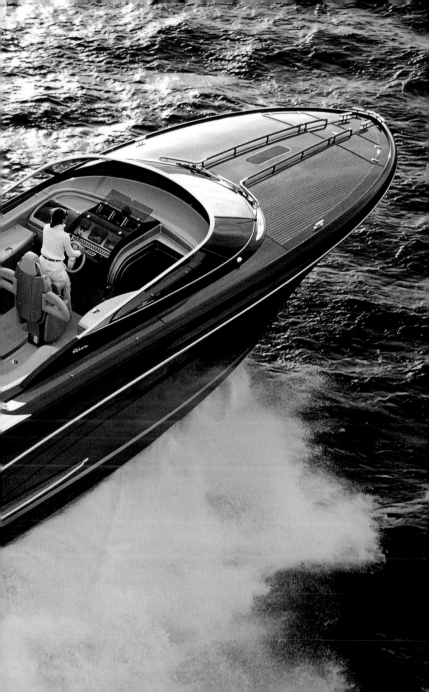

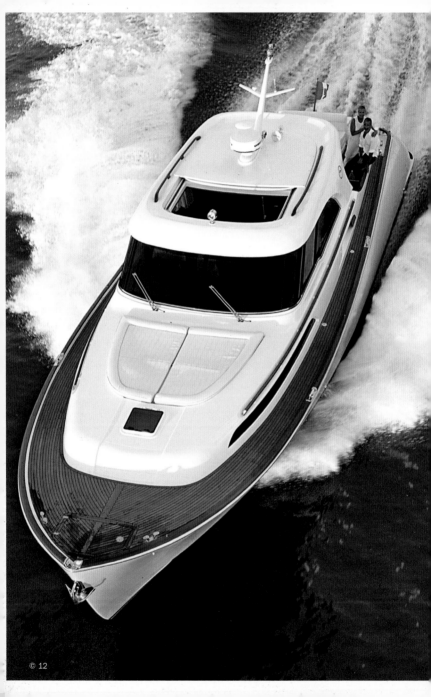

Mochi Craft, Dolphin
I 2004, 51'

Lobster boats: a 2000 Retro trend imported from the US.

Lobster-Boot: wieder ein Retro-Trend, der Anfang 2000 aus den USA kommt.

Le Lobster : encore une tendance rétro en provenance des USA au début 2000.

Embarcación Lobster: Nuevamente una tendencia Retro, que llega de EE.UU. as inicios del 2000.

Quello della Lobster Boat del Maine è un nuovo Retro trend che arriva dagli Stati Uniti.

© 12

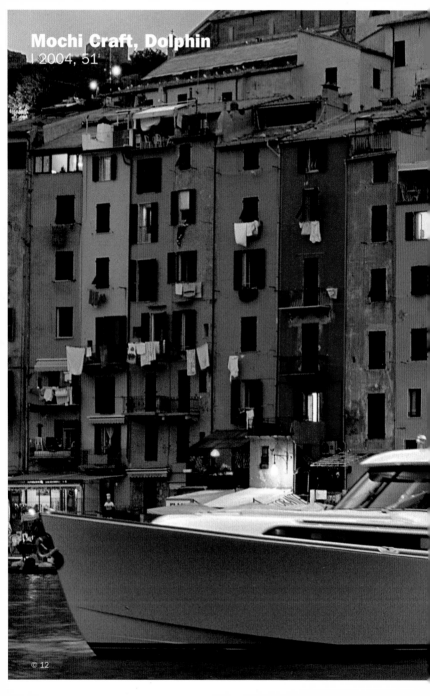

Mochi Craft, Dolphin
I 2004, 51'

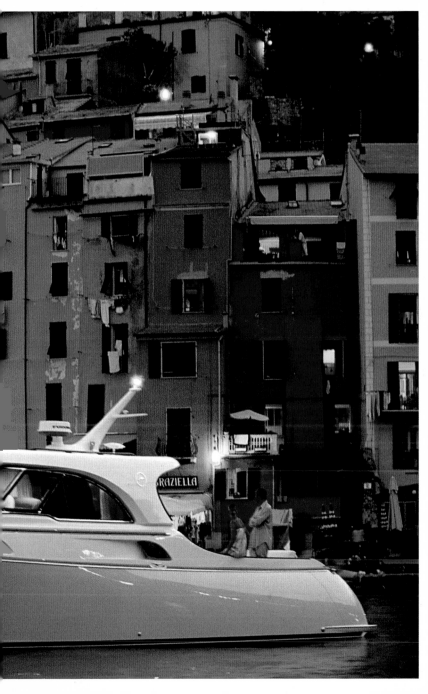

Bertram, 570 Convertible
USA 2000s, 57'

300 **Bertram's Convertible design** concept: outside hi-tech sportiness, inside populuxe comfort.

Bertrams Convertible-Design Konzept: Außen Hi-Tech Sportlichkeit, innen biedere Gemütlichkeit.

Le concept convertible de Bertram : à l'extérieur sportivité Hi-Tech, à l'intérieur confort bourgeois.

Concepto de diseño convertible de Bertram: Exterior deportividad Hi-Tech, interior virtuosa comodidad.

Il concetto del Bertram convertibile: fuori sportivitá hi-tech, dentro comfort borghesissimo.

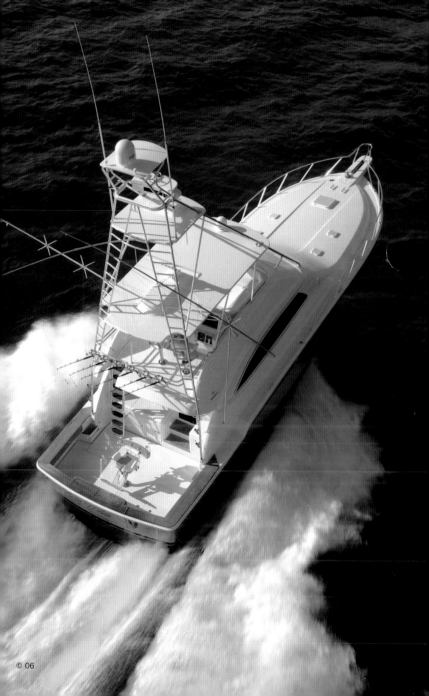

© 06 (all)

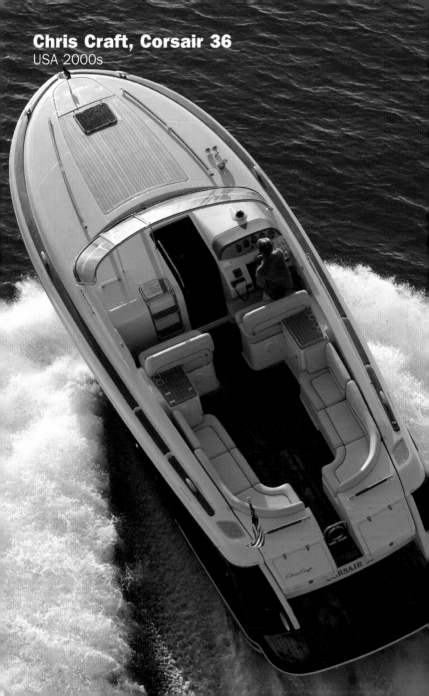

Chris Craft, Corsair 36
USA 2000s

Chris Craft, Roamer 40

USA 2000s

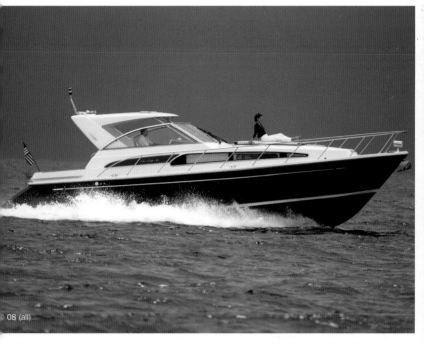

◊ 08 (all)

New classic designs provide the ground for the welcome rebirth of Chris Craft.

Neue Klassiker, die zur Wiederbelebung des Chris-Craft-Geistes tragen.

Nouveaux classiques qui font revivre l'esprit Chris Craft.

Nuevo clásico, que contribuyen a la reactivación del espíritu de Chris Craft.

Un design classico reinterpretato fornisce la base di partenza per la rinascita della Chris Craft.

Chris Craft, Speedster
USA 2005, 20'

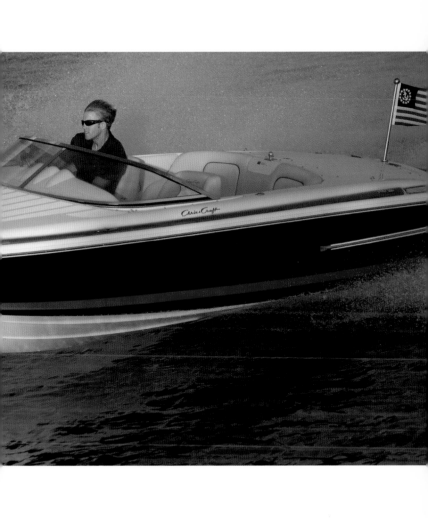

Lambrechtsen & Meijer, Cougar
NL 2005, 9 m

Dutch extravaganza: 100 % aluminum in a retro-tech runabout.

Holländische Extravaganza: 100 % Aluminium im Retro-Tech-Runabout.

L'extravagance hollandaise : 100 % aluminium en hi-tech rétro de Runabout.

Extravagancia holandesa: 100 % de aluminio en el Retro-Tech-Runabout.

Eccentricitá olandese: tutto alluminio per un Runabout in stile retrofuturista.

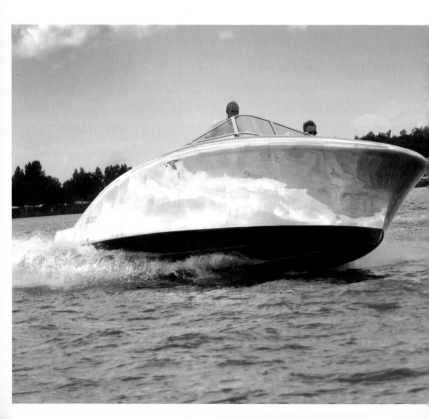

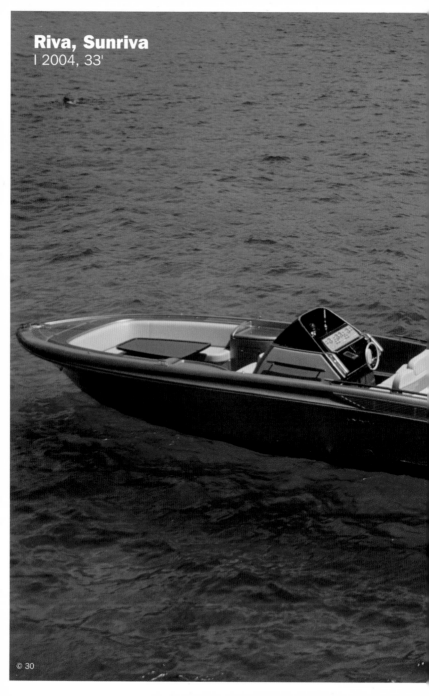

Riva, Sunriva
I 2004, 33'

Wally, Wally Power 118'
F 2003

Provocative and controversial, the Wally Power excites design fans and provides topics of conversation for boat experts. An alien manifestation, this boat clearly opposes the fuzzy language of contemporary boat design.

Provozierend und Kontrovers, die Wally Power begeistert Design-Fans und lässt Boots-Experten diskutieren. Eine außerirdische Erscheinung, die sich gleichzeitig radikal gegen den allgemeingültigen verspielten Formen profiliert.

Provocant et controversé, le Wally Power enthousiasme les amateurs de design et laisse jaser les experts de bateaux. Une apparition extraterrestre qui en même temps combat radicalement les formes enjouées généralement acceptées.

Provocativo y controvertido, el Wally Power entusiasma a aficionados al diseño y deja discutir a los expertos en embarcaciones. Una apariencia extraterrestre, que se perfila a la vez de manera radical contra las formas malogradas generalmente válidas.

Provocante e controverso: il Wally Power affascina i designer e fa discutere gli esperti. Come se provenisse da un altro pianeta, questa barca dal minimalimso espressivo si oppone chiaramente al dilagare di linee pasticciate del design nautico contemporaneo.

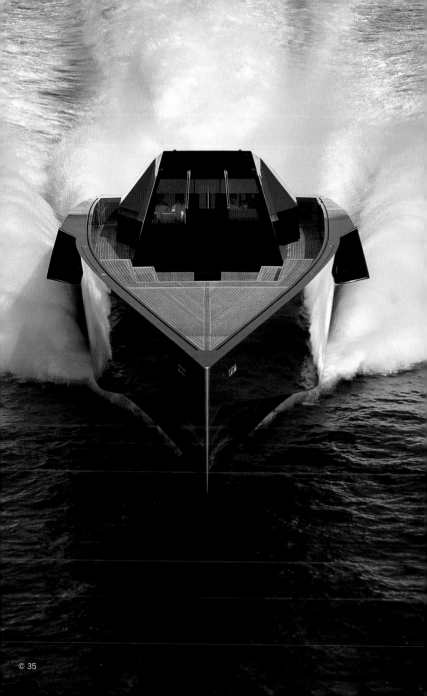

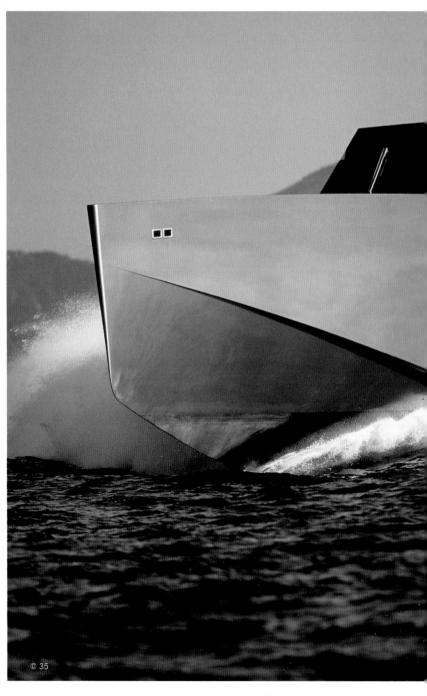

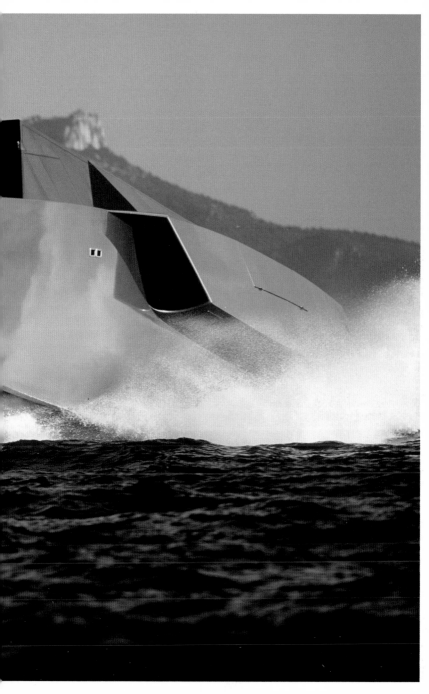

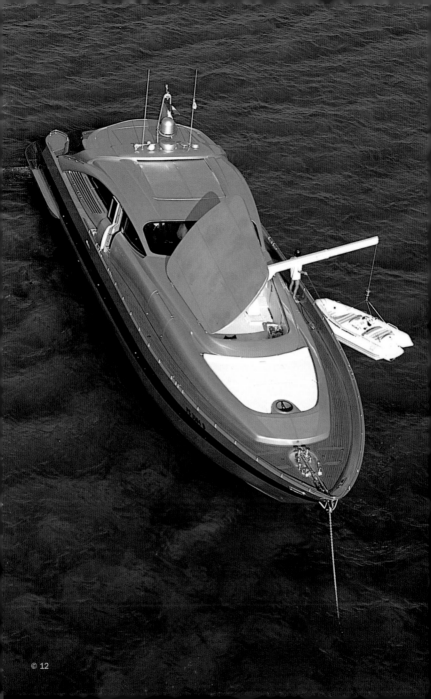

Pershing, 88
l 2000s

Sport yachts are looking for a new identity between the car and the aircraft.

Zwischen Automobil und Flugzeug suchen Sportyachten heute eine neue Identität.

Entre l'automobile et l'avion les Sport Yacht se recherchent aujourd'hui une nouvelle identité.

Entre automóvil y aeronave los Sport Yacht buscan hoy una nueva identidad.

Gli Sport Yacht cercano un'identitá formale a metá strada tra l'automobile e l'aereo.

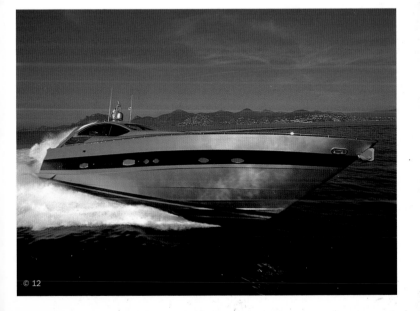

© 12

Riva, 68 Ego

I 2005

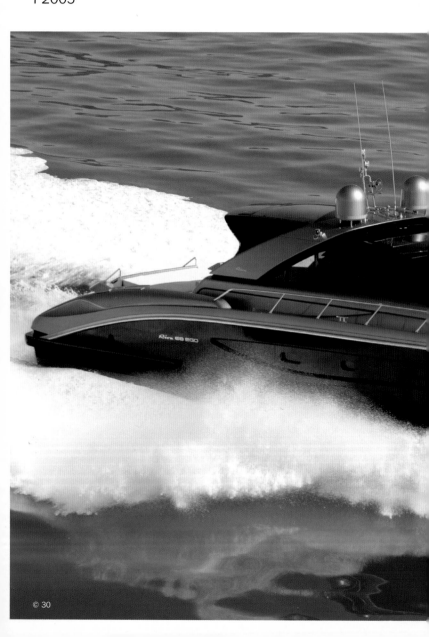

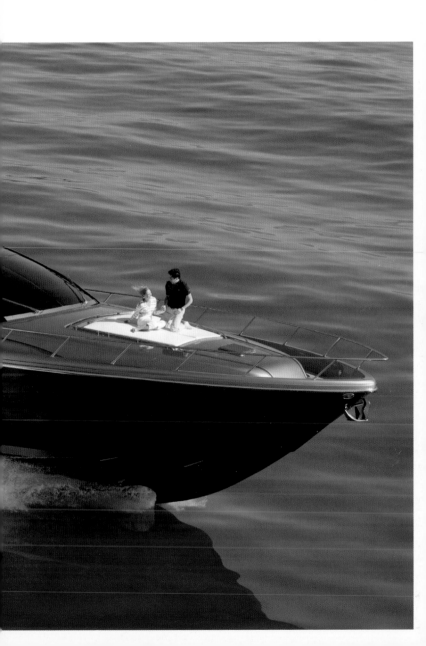

Azimut, AS 68
I.2005

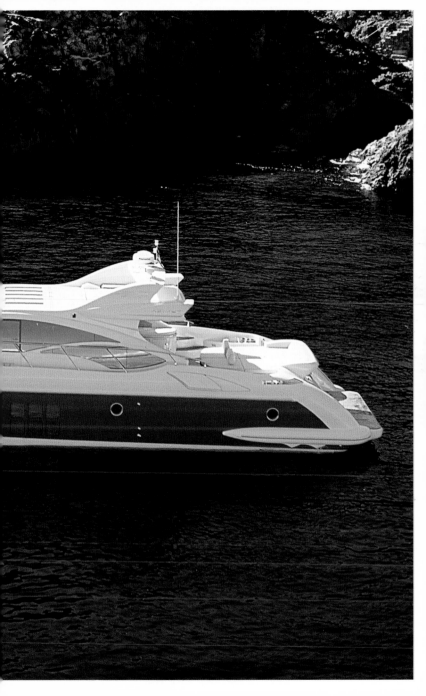

Sea Ray, 415 Motor Yacht
USA 2000s, 41' 1/2

324 **New esthetics in** the 3rd millennium: open to-
wards the sea, as high as a castle, as round as
Barbapapa.

Neue Ästhetik des 3. Jahrtausends: offen zur
Meer, hoch wie eine Burg, rund wie Barbapapa.

La nouvelle esthétique du 3me millénaire :
ouvert à l'arrière, haut comme une forteresse et
rond comme Barbapapa.

Nueva estética del 3º milenio: Abierto hacia
atrás como una fortaleza, redondo como
Barbapapa.

Nuova estetica del terzo millennio: aperto verso
il mare, alto come una torre, cicciotto come
Barbapapá.

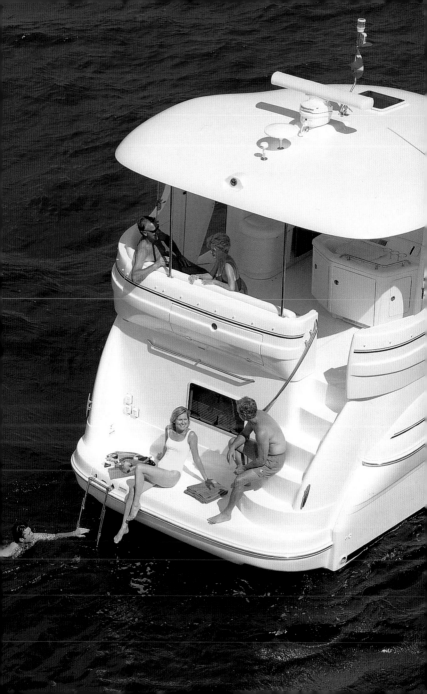

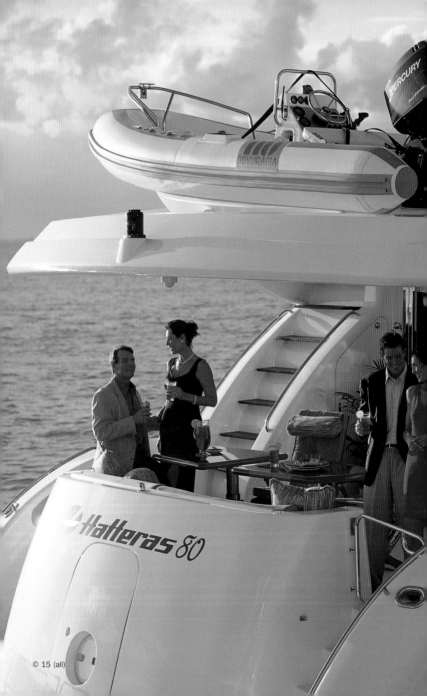

Hatteras, 80 Motor Yacht
USA 2000s

Ferretti, 550
I 2000s, 55'

© 12

Everything works, so long as it's new: a mixture of fantasy and pseudo-functionalism drives modern boat design.

Hauptsache neu: Eine Mischung aus Fantasie und Pseudofunktionalismus treibt das moderne Bootsdesign.

L'important c'est le nouveau : le design moderne est dirigé par un savant mélange d'inspiration et de pseudo fonctionnalité.

Azimut, 75
I 2000s, 75'

© 04

Lo principal que sea nuevo: Una mezcla de fantasía y pseudo funcionalismo pro-
mueve el diseño moderno de embarcaciones.

Tutto va bene purché faccia novitá: un misto di fantasia e pseudofunzionalismo
guida il design contemporaneo.

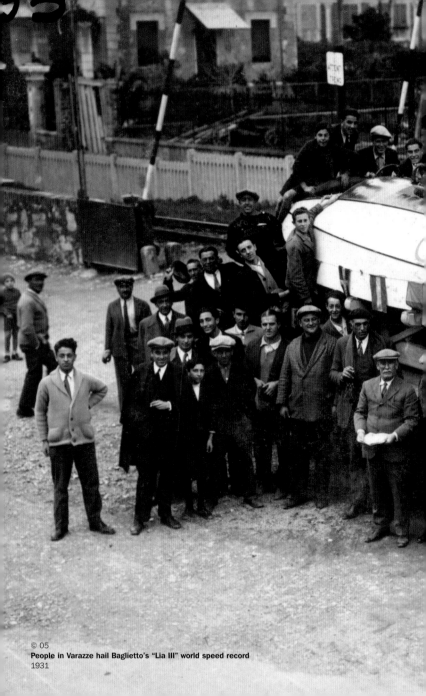

People in Varazze hail Baglietto's "Lia III" world speed record
1931

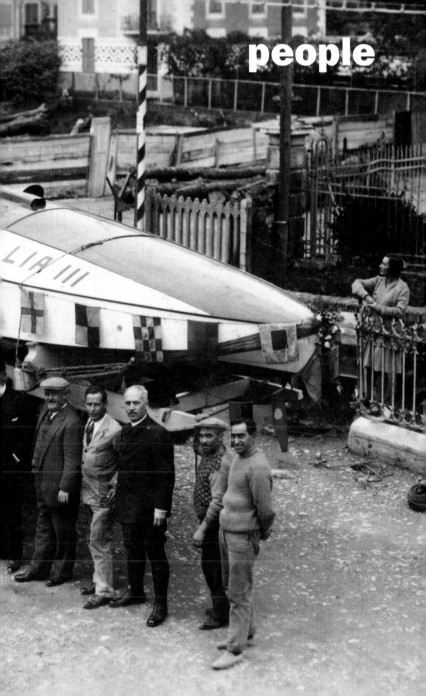

people

334 **The pioneering times** of motor boating never really came to an end. Large corporations have established over the years—some had short life—but there has always been space for new small manufacturers. Using computers and hi-tech facilities or doing everything by hand: with engines available from stock, boatbuilding remains a human job. One made for passionate people: craftsmen like Smith, engineers like Baglietto, inventors like Hunt, racedrivers like Aronow, tasteful entrepreneurs like Ferretti and certainly for the overall genius like Riva. Designers liked boat too: both specialists like Hacker and consultants like Earl left traces. Whichever the background, there are plenty of stories to tell—here are just a few.

Die Pionierzeit der Motorboote ist im Grunde nie zu Ende gegangen. Trotz des Entstehens (zuweilen kurzlebiger) großer Konzerne gab es immer Raum für neue, kleine Hersteller. Ob mit dem Computer, High-Tech-Equipment oder per Handarbeit: Bootsbau bleibt eine Aufgabe für Menschen. Handwerker wie Smith, Ingenieure wie Baglietto, Erfinder wie Hunt, Rennfahrer wie Aronow, geschmackssichere Unternehmer wie Ferretti und komplette Genies wie Riva zeigen, dass es um Leidenschaft geht. Und an den von Spezialisten wie Hacker und Beratern wie Earl hinterlassenen Spuren sieht man, dass auch die Designer mitmischten. Egal vor welchem Hintergrund: es gibt viele Geschichten zu erzählen. Hier sind ein paar davon.

En fait, l'époque des pionniers du bateau à moteur ne s'est jamais achevée. Malgré l'apparition (en partie de courte durée) de grands groupes, il a toujours existé des niches pour de nouveaux petits constructeurs. Que ce soit avec l'ordinateur, les équipements High-Tech ou en travail artisanal : la construction navale reste à la mesure humaine. Les artisans comme Smith, ingénieurs comme Baglietto, inventeurs comme Hunt, pilotes comme Aronow, entreprises au goût sûr comme Ferretti ou des génies complets comme Riva, nous montrent qu'il s'agit d'une passion. Et en se référant à l'empreinte laissée par des spécialistes comme Hacker ou des conseillers comme Earl, ont s'apperçoit que les stylistes sont également de la partie. Peu importe le contexte : il y a de nombreuses histoires à raconter. En voici quelques unes.

La era de los pioneros de embarcaciones a motor en el fondo nunca ha finalizado. A pesar de la creación (a veces de corta vida) de grandes consorcios siempre ha habido espacio para nuevos y pequeños fabricantes. Sea mediante informática, equipamiento de alta tecnología o en trabajo manual: construcción de embarcaciones sigue siendo una tarea para las personas. Artesanos como Smith, ingenieros como Baglietto, inventores como Hunt, corredores como Aronow, empresas seguras del buen gusto como Ferretti y genios completos como Riva, demuestran que se trata de afición. Además, por los rastros dejados por especialistas como Hacker y asesores como Earl, se puede notar, que también los diseñadores realizan sus aportes. Igual cuál sea el trasfondo: hay muchas historias que contar. Aquí están algunas de ellas.

Il pionierismo non ha mai cessato di esistere nella nautica. Anche se si sono creati grandi gruppi industriali – alcuni dei quali hanno avuto vita difficile – c'è sempre stato spazio per nuove idee. Sia usando computer e sistemi di lavorazione hi-tech che facendo tutto a mano: con la meccanica largamente disponibile a catalogo, fare barche è rimasto un mestiere umano. Uno per appassionati soprattutto: artigiani come Smith, ingegneri come Baglietto, inventori come Hunt, piloti come Aronow, architetti come Caliari, imprenditori come Ferretti o semplicemente persone geniali come Riva. Anche i designer si sono cimentati: specialisti come Hacker e consulenti come Pininfarina hanno lasciato traccia. Indipendentemente dall'esperienza, ci sono molte storie da raccontare. Eccone alcune.

Guido Abbate

Following a family tradition, Guido Abbate started his own shipyard by the lake Como in 1946. In the following year, his runabout Pamblo was the worldwide first mono-hull boat with twin surface propellers. Later on Guido contributed to the development of three-point-hull racers—with speeds in excess of 250 km/h—while he at the same time manufactured classic wooden runabouts. Today the Abbate tradition continues in third generation with sons Tullio, a race champion and since 1969 maker of fine "number 5" offshore boats, and Bruno, whose yard launched in 1973 the successful fiberglass Primatist line.

Gemäß der Familientradition gründete Guido Abbate seine eigene Werft nahe dem Comer See 1946. Im darauf folgenden Jahr war sein Runabout „Pamblo" das weltweit erste Monorumpf-Boot mit doppeltem Oberflächenpropeller. Später half er bei der Entwicklung von Racern mit Dreipunktrumpf, die 250 km/h schnell waren. Zur selben Zeit fertigte er aber auch klassische Runabouts aus Holz. Heute geht die Abbate-Tradition in die dritte Generation mit seinen Söhnen Tullio, Rennchampion und seit 1959 der Macher der „Nummer 5" Offshore-Boote, sowie Bruno, dessen Werft 1973 den erfolgreichen „Primatist Range" herausbrachte.

Conformément à la tradition familiale, Guido Abbate fonda, en 1946, son chantier naval à proximité du lac de Côme. L'année suivante il présente son runabout «Pamblo», le premier monocoque au monde à double hélice de surface. Plus tard il aidera au développement de Racer à coque trois points qui atteignaient les 250 km/h. A la même époque il produisait également des runabouts classiques en bois. Aujourd'hui la tradition Abbate entre dans sa troisième génération avec ses fils, Tullio, champion de course et depuis 1959 le constructeur des bateaux Offshore «numéro 5», ainsi que Bruno, dont le chantier naval sortait en 1973 le bateau à grand succès le «Primatist Range».

Conforme la tradición familiar Guido Abbate fundó su propio astillero cerca de Lago Comer en 1946. Al año siguiente su Runabout "Pamblo" ha sido mundialmente la primera embarcación monocasco con doble hélice de superficie. Más tarde contribuyó al desarrollo de Racers con casco de tres puntos, que alcanzaban los 250 km/h. Al mismo tiempo, fabricaba además Runabouts clásicos de madera. Hoy la tradición Abbate pasa a la tercera generación con sus hijos Tullio, campeón de competición y desde 1959 el creador de las embarcaciones Offshore "número 5", así como Bruno, cuyo astillero desde 1973 lanzó la exitosa "Primatist Range".

Seguendo la tradizione di famiglia, Guido Abbate fonda il suo cantiere sul lago di Como nel 1946. L'anno successivo il suo Runabout Pamblo è il primo al mondo con doppie eliche di superficie. Piú avanti Guido contribuisce allo svillupo dei Racer con carena a tre punti la cui velocità supera i 250 km/h mente allo stesso tempo costruisce classici motoscafi in legno. Oggi la tradizione Abbate viene portata avanti dai figli Tullio, un campione sportivo che, partendo dal fortunato "numero 5", fabbrica Offshore dal 1969 e Bruno, che nel 1973 lancia la fortunata serie di barche Primatist.

© 01

The name Amati is directly linked to the Itama shipyard, which Mario founded near Rome in 1969, now a part of the Ferretti group. A man with a feeling for design quality, Amati has been perfecting the concept of large open yachts since the 80s, when he launched the first 38'. Mario himself would spend time scubadiving, his boats cruising upon him, to watch out for design refinements. Over the years, the basic concept never changed: with their timeless, minimalistic design and their fine detailing, blue and white Itamas—now available in sizes between 40' and 76'—are to boats what the Porsche 911 is to cars.

Der Name Amati ist direkt mit der Itama-Werft verbunden, die Mario 1969 nahe Rom gründete und die mittlerweile zur Ferretti-Gruppe gehört. Mit einem guten Gefühl für Designqualität hat Amati das Konzept großer, offener Yachten seit den 80ern, als er die erste 38' auf den Markt brachte, perfektioniert. Er selbst ging tauchen und beobachtete das Design der Boote über ihm, um nach Verbesserungsmöglichkeiten Ausschau zu halten. Über die Jahre hat sich das Grundkonzept nicht geändert: das minimalistische Design und die feinen Details machen die weiß-blauen Itamas zum Porsche 911 unter den Booten.

Le nom d'Amati est directement lié au chantier naval Itama que fonda Mario en 1969 à proximité de Rome et qui maintenant appartient au groupe Ferretti. Avec une grande sensibilité pour la qualité du design, Amati a perfectionné le concept de yachts plus grands et plus ouverts depuis les années 80, en sortant le premier 38' sur le marché. Il plongeait lui-même pour examiner le design des bateaux au-dessus de lui, afin de rechercher des possibilités d'amélioration. Au fil des années le concept de base n'a pas varié : un design minimaliste et des détails de grande finesse ont transformé les Itama bleus et blancs en véritables Porsche 911 parmi les bateaux.

El nombre Amati está directamente relacionado con el astillero Itama, que Mario fundón en 1969 cerca de Roma y que entretanto pertenece al grupo Ferrari. Con una buena percepción para la calidad de diseño, Amati ha perfeccionado desde los años 80' el concepto de yates mayores, más abiertos, que el primer 38' que trajo al mercado. Él mismo durante el submarinismo observaba el diseño de las embarcaciones sobre él, para luego buscar posibilidades de mejoras. A través de los años el concepto básico no se ha modificado: el diseño minimalista y los detalles refinados hacen del Itama azul y blanco, el Porsche 911 entre las embarcaciones.

Il nome Amati é direttamente legato a quello del cantiere Itama, fondato da Mario vicino a Roma nel 1969 ed ora parte del Gruppo Ferretti. Un uomo con una spiccata sensibilità per il design, Amati ha perfezionato il concetto di grande Sport Yacht aperto sin dagli anni 80, quando lanciò il suo primo 38'. Negli anni lo stile Itama non é cambiato: nel loro design senza tempo, minimale e raffinato, gli Itama blu e bianchi, ora disponibili in misure tra i 40' e i 76' sono delle vere e proprie Porsche dell'acqua.

337

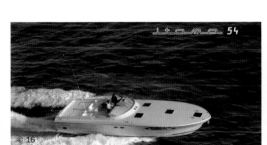

© 16

© 16

338

The "godfather of the powerboat industry" retired to Miami Beach in 1961, aged 34. In 1962 he competed "by chance" in the Miami-Nassau aboard "Claudia", his first 28' wooden racer. Next year, the fiberglass Formula 276 offshore rolls out of a workshop in NE 188th street, later nicknamed Thunderboat Row. Formula Marine was so successful, that in 1964 the proven businessman already had sold the company, which still exists today. A new toy was ready soon: the Sweet Sixteen, known as one of those "damned Donzi boats". Donzi became Aronow's second shipyard. 1966 followed Magnum, a further legendary name, with 27' and 35' offshore, also known as Maltese. In those years, Aronow was racing and winning about with his 32' Cigarette, named after Vannie Higgins's rum-runner, a New Jersey gangster of the prohibition era. Cigarette Racing Team, established 1969, was Aronow's last and probably most famous company. It set a worldwide trend, the name Cigarette being used as a synonymous for offshore boat. The fame of Thunderboat Row was always controversial: on one side the heroic racing years and the sunny side of life, on the other criminals and smugglers among customers, as portrayed in Miami Vice. After winning 350 races, 11 World and 25 US championships, Don Aronow died in 1987 along the same street he made world-famous. Driving his white Mercedes in one of those Florida perfect days, he was shot by five bullets, the motive remaining unknown.

Der „Pate der Rennbootindustrie" zog sich 1961 im Alter von 34 Jahren nach Miami Beach zurück. 1962 fuhr er beim Miami-Nassau-Rennen an Bord der „Claudia" mit, seinem ersten 28'-Racer aus Holz. Im darauf folgendende Jahr fertigt er die Formula 276 Offshore in der NE 188th street, die später „Thunderboat Row" genannt wird. Der Erfolg von Formula war so groß, dass er die Firma – die es immer noch gibt – schon 1964 wieder lukrativ verkaufen konnte. Ein neues Spielzeug stand bald bereit: die Sweet Sixteen, die als eines dieser „damned donzy boats" galt. Donzi wurde Aronows zweite Werft. 1966 folgte Magnum, ein weiterer legendärer Name, mit 27' und 35' Offshores, auch als Maltese bekannt. In diesen Jahren fuhr Aronow die Rennen mit seiner 32' Cigarette, benannt nach dem „Rum-Renner" von Vannie Higgins, einem Gangster aus New Jersey. Das Cigarette Racing Team, gegründet 1969, ist Aronows letzte Firma, deren Name zum Synonym für Offshore wurde. Der Ruhm der Thunderboat Row war stets kontrovers: auf der einen heldenhafte Rennjahre, auf der anderen Seite Kriminelle und Schmuggler à la Miami Vice. Nach dem Gewinn von 350 Rennen, 11 Welt- und 25 US-Meisterschaften starb Aronow 1987 in der von ihm berühmt gemachten Straße. An einem dieser perfekten Tage in Florida wurde er während der Fahrt in seinem weißen Mercedes von fünf Kugeln getroffen. Die Hintergründe sind unbekannt.

© 19

340

Le «Pate de l'industrie des bateaux à moteur» se retira à Miami Beach en 1961 à l'âge de 34 ans. En 1962 il participe à la course Miami-Nassau à bord du «Claudia», son premier Racer de 28' en bois. L'année suivante il construit l'Offshore Formula 276 dans la rue NE 188th street, et qui plus tard se nommera «Thunderboat Row». Le succès du Formula fut si grand, qu'il pu dès 1964 revendre sa société très lucrative déjà en 1964. Un nouveau jouet était déjà prêt : le Sweet Sixteen, qui faisait partie des «damned donzy boats». Donzi fut le deuxième chantier naval d'Aronow. En 1966 suivit le Magnum, un autre nom légendaire, des Offshore de 27' et 35', aussi connu sous le nom de Maltese. Pendant ces années Aronow participa aux courses avec son Cigarette de 32', baptisé d'après le «Rum-Runner» de Vannie Higgins, un gangster du New Jersey. L'écurie de course Cigarette, fondée en 1969, est la dernière société d'Aronow, dont le nom est synonyme de Offshore. La célébrité du Thunderboat Row était certes controversée : d'un côté une année de course héroïque et de l'autre des criminelles et contrebandiers à la Miami Vice. Après avoir gagné 350 courses, dont 11 championnat du monde et 25 championnats US, Aronow décéda en 1987 dans la rue qu'il avait rendue célèbre. L'un de ces jours parfaits en Floride il fut abattu de cinq balles au volant de sa Mercedes blanche. Les raisons en sont encore inconnues.

El "padrino de la industria de embarcaciones de competición" se retiró en 1961 a la edad de 34 años a Miami Beach. 1962 participó en la competición Miami-Nassau a bordo del "Claudia", su primer Racer de madera de 28'. Al año siguiente fabricó la Formula 276 Offshore en la NE 188th street, que más tarde se denominó "Thunderboat Row". El éxito de la fórmula fue tan grande, que ya en 1964 pudo vender nuevamente la empresa –que aún hoy existe– de forma lucrativa. Un nuevo juguete pronto estuvo disponible: la Sweet Sixteen, que valió como una de esos "damned donzy boats". Donzi se transformó en el segundo astillero de Aronow. 1966 le siguió Magnum, otro nombre legendario, con Offshores de 27' y 35', también conocido como Maltese. En este año Aronow participó de la competición con su Cigarette de 32', denominada de acuerdo a "Rum-Runner" de Vannie Higgins, un gangster de New Jersey. El Cigarette Racing Team, fundado en 1969, es la última empresa de Aronows, cuyo nombre se transformó en un sinónimo de Offshore. La fama del Thunderboat Row fue siempre controvertida: por un lado años de competición heroica, por el otro criminales y contrabandistas al estilo Miami Vice. Tras ganar 350 competiciones, 11 campeonatos mundiales y 25 campeonatos americanos, Aronow falleció en 1987 en la calle que él había hecho famosa. En uno de esos días perfectos en Florida durante la conducción de su Mercedes blanco, fue alcanzado por cinco proyectiles. Los motivos permanecen desconocidos.

Nel 1961, a soli 34 anni, "Il padrino" dell'industria motonautica e costruttore benestante si ritira a Miami Beach. L'anno seguente partecipa per caso alla corsa Miami-Nassau a bordo di "Claudia", uno scafo in legno di 28 piedi. Nel 1963 il Formula Marine 276 in vetroresina esce dal capannone della prima azienda di Aronow nella NE 188th street, strada che diverrà famosa come Thunderboat Row. Nel 1964 Aronow vende Formula a prepara un 16 piedi che chiama Sweet Sixteen, riconosciuto dal pubblico come "uno di quei dannati Donzi". Donzi divenne il secondo cantiere di Aronow, cui seguí nel 1966 Magnum, che inzialmente produceva i Maltese, barche veloci di 27 e 35 piedi. In quegli anni, Don correva e vinceva a bordo del suo 32 piedi, chiamato Cigarette in onore della barca usata dal famoso contrabbandiere Vannie Higgins durante il probizionismo. L'ultimo cantiere di Aronow, fondato nel 1969, il nome Cigarette é diventato sinonimo di barca Offshore. La fama di Thunderboat Row è sempre stata controversa: da un lato le imprese eroiche ed il lato bello della vita, dall'altro i contrabbandieri e gli spacciatori rivisitati in Miami Vice. Dopo aver vinto 350 gare, 11 campionati del mondo e 25 campionati americani, in uno di quei giorni di sole perfetti, Don Aronow muore al volante della sua Mercedes lungo la stessa strada che lo aveva reso famoso. Ammazzato con cinque pallottole per un motivo ancora ignoto.

Out of Varazze, a village of the Italian Riviera, father Pietro traded a new sailboat in to let son Vincenzo Vittorio attend the faculty of naval engineering at Glasgow University. Completing his studies after World War I, in 1923 Vittorio is employed in the family shipyard, established 1854 and already well known for having crafted boats of all kinds: from regatta sailboats to a rowboat for the Pope, from a motor cruiser for composer Puccini to several Monaco winning racers, from the world's first hydrofoil down to the famous MAS torpedo boats for the Royal Italian Marine. Vittorio's initial designs are racers such as Baglietto I, the first Italian boat to win a world speed record. While the International Class sailboat production continues, Baglietto develops his racers further. In 1931, Lia III, a stepped-hull racer equipped with a 12 liter engine, holds a world class speed record of 111.18 km/h. In war years, the production focus the military business, the last motor boat before the war being the beautiful 26 meter Millemiglia yacht for the count Mazzotti. After the war, things recovered only slowly, the turnaround coming 1958 with the Ischia, a beautiful, modern 16 m motoryacht which has been produced more than 100 times. Since then, Baglietto concentrated in high-end motoryacht production. Vittorio died 1978, two years before the introduction of the first aluminum-built Ischia 80.

Vater Pietro verkaufte ein Segelboot, um seinen Sohn Vincenzo Vittorio von Varazze an der Riviera an die Glasgow University zum Studium der Schiffstechnik schicken zu können. Nach Ende des Studiums arbeitete er ab 1923 in der Familienwerft, die 1854 gegründet worden und für ihre vielseitige Produktion bekannt war: Von Segelregatten bis zum Ruderboot für den Papst, vom Motor-Cruiser für den Komponisten Puccini bis zu erfolgreichen Racern in Monaco; vom weltweit ersten Wasserfolien-Experimentalboot bis hin zum berühmten MAS für die königliche italienische Marine. Vittorios erste Designs waren Racer wie die Baglietto I – das erste italienische Boot, das den Geschwindigkeitsweltrekord brach. 1931 hält der Lia III, ein Stufengleiter mit 12-Liter-Motor, den Geschwindigkeitsrekord mit 111,18 km/h. Später konzentrierte sich die Produktion aufs Militär; das letzte Motorboot vor dem Krieg war „Millemiglia", die schöne, 26 Meter lange Yacht des Grafen Mazzotti. Nach dem Krieg erholte sich die Auftragslage nur zögerlich, bis 1958 die Wende mit der Ischia kam, einer modernen, 16 Meter langen Motoryacht, von der mehr als hundert Exemplare gebaut wurden. Seit damals konzentriert sich Baglietto auf die Produktion von großen Motoryachten. Vittorio starb 1978, zwei Jahre bevor die aus Aluminium gefertigte Ischia 80 auf dem Markt erschien.

341

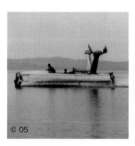

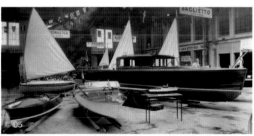

© 05

© 05

342

Père Pietro avait du vendre un voilier pour pouvoir envoyer son fils Vincenzo, de Varazze sur la riviera à l'Université de Glasgow pour y étudier les techniques maritimes. A la fin de ses études, il travaille à partir de 1923 sur le chantier naval familial qui fut fondé en 1854, et qui était célèbre pour ses productions très variées : du voilier de régate jusqu'au canot à rame pour le pape, depuis le Cruiser à moteur pour le compositeur Puccini jusqu'aux Racer victorieux de Monaco; depuis le premier bateau expérimental au monde à feuilles d'eau jusqu'au célèbre MAS pour la marine royale italienne. Les premiers designs de Vittorio furent des Racer, comme le Baglietto I – le premier bateau italien à posséder le record mondial de vitesse. En 1931 il conserve le record avec le Lia III, un glisseur étagé avec un moteur de 12 litres et ses 111,18 km/h. Plus tard il se concentre sur la production militaire; son dernier navire à moteur avant la guerre fut le beau yacht de 26 mètres, le Millemiglia du Comte Mazzotti. Après la guerre, le carnet de commande resta très pauvre, jusqu'en 1958 où le Ischia apporta le renouveau, un yacht à moteur moderne de 16 m, dont il fabriqua plus de 100 exemplaires. Depuis cette époque Baglietto se concentre sur la production de yachts à moteur Hi-End. Vittorio décède en 1978, deux ans avant la sortie sur le marché du Ischia 80 à coque en aluminium.

Pietro padre vendió un velero, para poder enviar a su hijo Vincenzo Vittorio de Varazze en la Riviera a la Glasgow University al estudio de la tecnología naviera. Tras finalizar sus estudios trabajó a partir de 1923 en el astillero de la familia, fundado en 1854 y que era conocido por su producción versátil: desde veleros de regata hasta el bote de remos para el Papa, desde Motor-Cruiser para el compositor Puccini hasta los exitosos Racer en Mónaco; desde la primera embarcación experimental sobre película de agua hasta el famoso MAS para la marina real italiana. Los primeros diseños de Vittorio fueron Racer como el Baglietto I –la primera embarcación italiana que ganó el record mundial de velocidad. En 1931 el Lia III, un deslizador escalonado con motor 12 litros, mantiene el record de velocidad con 111,18 km/h. Más tarde la producción se concentró en lo militar; la última embarcación a motor antes de la guerra fue el bello yate Millemiglia de 26 metros de eslora del Conde Mazzotti. Tras la guerra, sólo lentamente se fue recuperando la situación de pedidos, hasta que en 1958 llegó el cambio con el Ischia, un moderno yate a motor de 16 m de eslora, del cual se construyeron más de cien unidades. Desde aquel entonces, Baglietto se concentra en la producción de yates a motor Hi-End. Vittorio falleció en 1978, dos años antes de ser lanzado al mercado el Ischia 80 fabricado en aluminio.

Pietro Baglietto barattó una barca a vela per pagare le spese di mantenimento del figlio Vincenzo Vittorio agli studi presso l'Universitá di Glasgow. Tornato a Varazze sulla Riviera Ligure nel 1923, egli comincia a lavorare nel cantiere paterno, giá famoso per avere realizzato barche di ogni tipo: da una barchetta per il Papa ad un motorcruiser per il maestro Puccini, dal primo aliscafo per Crocco e Ricaldoni ai famosi MAS per la Regia Marina Italiana. Dall'inizio Vittorio si dedica a Baglietto I, la prima barca italiana ad ottenere un record di velocitá. Mentre la produzione di barche da regata di Classe Internazionale continua, Baglietto progetta altri Racer: nel 1931 il Lia III, un idroplano con carena a redan equipaggiato con un motore di 12 litri, ottiene un record mondiale di velocitá a 111,18 km/h. Negli anni seguenti la produzione si concentra sul settore militare un punto di forza della qualitá Baglietto; l'ultimo Yacht progettato prima della guerra e il bel 26 metri Millemiglia, per il conte Mazzotti. Dopo la guerra il lavoro riprende lentamente, il giro di volta arriva nel 1958 con l'Ischia un elegante Motor Yacht di 16 metri prodotto in serie cui seguono Elba, Capri, Maiorca a Minorca. Dal 1955 Vittorio lascia gradualmente il posto a Pietro Baglietto, che porta il cantiere verso i nuovi materiali, come l'alluminio, per superyacht di alto livello.

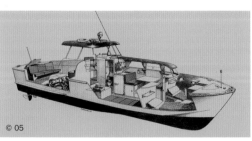

© 05

Giorgio Barilani started his career as freelance illustrator in the early 50s. His first, automobile-like boat design is awarded 50$ in a 1953 US competition for the look of tomorrow's boat. In 1957 Carlo Riva discovered Barilani's "golden hand" and engaged him to design details and fixtures for his boats. Under Riva's guidance, Barilani gradually took over the corporate design of the shipyard. In 1971, Barilani faced responsibility for his first important project: The design of a completely new fiberglass yacht was the occasion to give Riva, whose image was linked to wooden runabouts, a new look. The 42' Super America, launched in 1972, was a brilliant accomplishment to this task. Barilani managed to make his designs stand out of the rather unsexy crowd of early fiberglass boats. A careful study of lines in a mixture of classic elegance and sporty touch, the imaginative use of colour, the beautiful detailing are common to all his projects. The architects' touch can be detected in functional solutions like the round staircase of larger yachts. The 1976 St. Tropez, with her sloping bowline and sculptural transom is a very personal interpretation of the offshore theme. Retiring in 1996, Barilani left behind a portfolio of highly recognizable instant classics.

Giorgio Barilani begann seine Karriere als freier Illustrator in den frühen 50ern. Sein erstes, automobil-ähnliches Bootsdesign gewann 50 $ in einem US-Wettbewerb um das zukünftige Gesicht des Bootes (1953). Carlo Riva entdeckt Barilanis goldenes Händchen 1957 und engagiert ihn als Designer. Unter Rivas Führung bestimmte Barilani bis ins Detail das Corporate Design der Werft. 1971 ist Barilani für sein erstes großes Projekt verantwortlich: Eine völlig neue Fiberglas-Yacht ist die Gelegenheit, um Rivas Image (das v.a. von Runabouts aus Holz geprägt war) zu ändern. Die 42' Super America von 1972 meisterte diese Aufgabe auf brilliante Art und Weise. Barilani schafft es, dass seine Designs aus der Masse der frühen Fiberglasboote herausragen. Eine sorgfältige Linienführung mit einer Mixtur von klassischer Eleganz und Sportlichkeit, der fantasievolle Einsatz von Farben und schönen Details sind all seinen Projekten gemeinsam. Die St. Tropez von 1976 ist mit ihrer abfallenden Bogenlinie und dem skulpturalen Heckspiegel eine äußerst persönliche Interpretation des Offshore-Themas. Als er 1996 in Pension ging, hinterlies Barilani ein Portfolio mit Klassikern von höchstem Wiedererkennungswert.

343

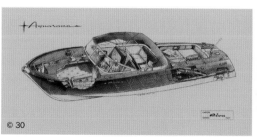

© 30

© 32

344

Giorgio Barilani débuta sa carrière comme illustrateur indépendant dans le début des années 50. Son premier design de bateau se rapprochant des automobiles lui permis de gagner 50 $ dans un concours américain sur la vision futuriste des bateaux (1953). Carlo Riva découvre la main habile de Barilani en 1953, et l'engage comme styliste. Sous la direction de Riva, Barilani détermine jusque dans le détail le design de la marque. En 1971, Barilani devient responsable de son premier grand projet : un yacht en fibres de verre entièrement nouveau, qui lui donne l'occasion de modifier l'image de marque de Riva (qui était principalement marquée par des Runabouts en bois). Le Super America de 42', en 1972, réalisa brillamment cet objectif. Barilani réussit à faire sortir de la masse ses designs parmi les bateaux en fibres de verre en vogue à l'époque. Un dessin soigneux des lignes associé à un mélange d'élégance classique et de sportivité, l'utilisation très imaginative de couleurs et de détails raffinés, sont le point de rencontre de tous ses projets. Le St. Tropez de 1976, constitue avec ses lignes descendantes et son arrière sculptural, une interprétation très personnelle du thème de l'Offshore. Quand il prend sa retraite en 1996, il laisse derrière lui un catalogue de classiques d'une grande valeur de reconnaissance.

Giorgio Barilani comenzó su carrera como diseñador libre a comienzos de los años 50'. Su primer diseño de embarcación similar al de un automóvil ganó 50 $ en un concurso americano sobre el futuro rostro de la embarcación (1953). Carlo Riva descubrió en 1953 la mano de oro de Barilani y lo contrató como diseñador. Bajo la dirección de Riva, Barilani determinó hasta en los detalles, el diseño corporativo del astillero. En 1971 Barilani es responsable de su primer gran proyecto: Un yate de fibra de vidrio completamente nuevo es la oportunidad, para cambiar la imagen de Riva (hasta ese momento marcada por los Runabouts de madera). El Super América de 42' de 1972 dominó esta tarea de manera brillante. Barilani logró, que su diseño sobresalga de la masa de precoces embarcaciones de fibra de vidrio. Un perfil cuidadoso con una mezcla de elegancia clásica y deportividad, el empleo imaginativo de colores y bellos detalles son comunes a todos sus proyectos. El St. Tropez de 1976 es, con su línea curvada descendente y un escultural espejo de popa, una interpretación extremadamente personal del tema Offshore. Cuando se jubila en 1996, Barilani deja atrás un portfolio con clásicos de elevado valor de reconocimiento.

La carriera di Giorgio Barilani comincia nei primi anni 50, quando il suo primo disegno per una barca dal look futuristico vince il premio di 50 dollari bandito da una rivista Americana. Nel 1957 Carlo Riva ne scopre la "mano d'oro". Sotto la sua guida, Barilani prende carico di tutto il Corporate Design del cantiere di Sarnico, dalla bitta ai depliant, dal portachiavi all'architettura. Nel 1971 é la volta del suo primo grande progetto: Il disegno di un Motor Yacht in vetroresina significa dare una nuova immagine a Riva, da sempre legata ai motoscafi di legno. Barilani risolve questo compito con bravura: il Superamerica 42', lanciato nel 1972, si distanzia dalla massa delle altre barche per le sue linee sportive ed eleganti, l'uso inconsueto del colore e la tipica attenzione ai dettagli. Il tocco dell'architetto si ritrova nell'innovativa scala rotonda. Il Riva 2000 ed il St.Tropez sono un'interpretazione molto personale del tema Offshore. Quando Barilani lascia Riva nel 1996 si lascia dietro un portfolio di progetti altamente riconosibili e destinati a diventare dei classici.

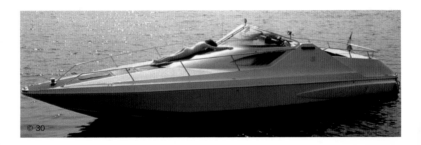

© 30

Luca Bassani Antivari founded Wally in 1994 following a very personal design philosophy: Hi-tech sailing boats that would mix racing performances, family-proof usability and a very individual look. In 2001 Wally entered the motor boat market with the 45' Tender, an open boat whose style lies between 70s retro and a stealth look and a forerunner of the large size sport utility. Her dramatic lines, enhanced by metallic colors, have been a radical breakthrough in boat design. These have been implemented in the 118' Wally Power of 2003, probably the most controversial yacht design ever.

Luca Bassani Antivari gründete 1994 Wally, um einer sehr persönlichen Designphilosophie nachzugehen. Seine Hi-Tech-Segelboote kombinieren Rennleistung, familientaugliche Nützlichkeit und individuelles Äußeres. 2001 betrat Wally den Markt mit dem 45' Tender, einem offenen Boot zwischen 70er-Retro und Stealth-Look – und zudem ein Vorläufer des großen Sport Utility. Die dramatischen Linien waren ein radikaler Bruch im Bootsdesign. Sie wurden auch im 118' Wally Power von 2003 eingesetzt, dem wohlmöglich kontroversesten Yachtdesign, das je realisiert wurde.

Luca Bassani Antivari fonda Wally en 1994, afin de pratiquer sa philosophie très personnelle du stylisme. Ses voiliers Hi-Tech associent les performances de course, les besoins familiaux et l'individualité de l'aspect externe. En 2001 Wally entre sur le marché avec le Tender de 45', un bateau ouvert entre la mode rétro des années 70 et le look Stealth – et d'autre part un prédécesseur des grands Sport Utility. Les lignes dramatiques furent une avancée radicale dans le design des bateaux. Elles furent également mises en oeuvre sur le Wally Power de 118', en 2003, le design de bateau peut-être le plus controversé jamais réalisé.

Luca Bassani Antivari fundó en 1994 Wally, para seguir una filosofía de diseño muy personal. Sus veleros de alta tecnología combinan prestaciones de competición, aptitudes para el uso familiar y una imagen exterior individual. En 2001 Wally accedió al mercado con el Tender de 45', una embarcación abierta entre Retro de los años 70 y Stealth-Look –y además un precursor del gran Sport Utility. Las líneas dramáticas fueron una irrupción radical en el diseño de embarcaciones. El mismo también fue aplicado en el Wally Power de 118' de 2003, el diseño de yate probablemente más controvertido que alguna vez se haya realizado.

Luca Bassani Antivari fonda Wally nel 1994 per dare seguito ad una filosofia di design molto personale: barche a vela che combinino materiali hi-tech, prestazioni da regata, usabilitá familiare ed un look individualistico. Nel 2001 Wally entra nel settore delle barche a motore con il 45' Tender, che combina un Retro anni 70 ad un'estetica stealth. Un precursore degli Sport Utility alto di gamma, con le sue linee squadrate e vigorose messe in risalto dai colori metallizzati, il Tender è stato un taglio radicale con il design corrente. Lo stesso principio è stato applicato al 118' Wally Power, un progetto seducente ma molto controverso.

345

© 35

On a stormy day in 1958, the passionate sailor and yacht broker Dick Bertram saw one of Hunt's first deep-V boats breaking the waves at unthinkable high speed. Bertram immediately contacted Hunt and asked him to design a 30' Utility boat he called Moppie, after his wife's name. The idea to race Moppie between Miami and Nassau in 1960 may have sounded strange, yet the apparently harmful boat won the competition by far, making the name Bertram a myth. News spreading among boaters, a mould was quickly made out of Moppie to become the famous Bertram 31', one of the first large deep-V fiberglass hulls. Miami based Bertram was the first company with facilities designed to professionally manufacture fiberglass boats. Their sporty fishermen, ever engaged in friendly competition with Hatteras, have become world famous and have at times been produced under license by Riva. Although he left the company in the early 60s to concentrate on his brokerage activity, Dick Bertram enjoyed unprecedented popularity for people in the boating industry, being the star in Camel and Rolex advertising.

An einem stürmischen Tag 1958 sah der passionierte Segler und Yachthändler Dick Bertram eines von Hunts ersten Deep-V-Booten mit unglaublicher Geschwindigkeit durch die Wellen brechen. Bertram kontaktierte Hunt sofort und bat ihn, ein 30' Utility Boat zu entwerfen, das er dann nach seiner Frau „Moppie" benannte. Die Idee, Moppie beim Miami-Nassau-Rennen 1960 mitfahren zu lassen, mag seltsam klingen, aber das scheinbar harmlose Boot gewann mit Abstand und machte den Namen Bertram zum Mythos. Als sich die Siegesnachricht verbreitete, wurde von Moppie schnellstmöglich eine Formvorlage gebaut, aus der schließlich die Bertram 31' hervorging – einer der ersten großen Deep-V-Rümpfe. Bertram in Miami war eine der ersten Firmen, die professionell Glasfaserboote fabrizieren konnten. Ihre sportlichen Fishermen, die in ewiger, aber freundlicher Konkurrenz zu Hatteras standen, sind weltberühmt und wurden zeitweise unter Lizenz von Riva produziert. Obwohl er die Firma 1964 verließ, genoss Dick Bertram weiterhin ungebrochene Popularität unter den Bootsleuten und war u. a. Werbefigur von Camel und Rolex.

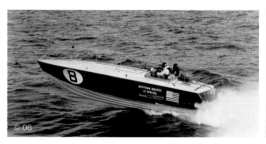
© 06

© 06

© 06

Par une journée de tempête de l'année 1958, le passionné de voiliers et marchand de yachts, Dick Bertram aperçoit les premiers bateaux à Deep-V de Hunt, fendre les vagues avec une vitesse incroyable. Bertram contacte immédiatement Hunt et lui demande de créer un Utility Boat de 30', qu'il nomma «Moppie» du nom de sa femme. L'idée de faire courir le Moppie dans la course Miami-Nassau en 1960, peut sembler étrange, mais ce bateau apparemment anodin gagna avec une grande longueur, et le nom de Bertram devint un mythe. Alors que se répandait le message de la victoire, on a très rapidement construit un modèle de format pour le Moppie, duquel est sorti le Betram de 31' – l'une des premières grandes coques en Deep-V. Bertram était à Miami une des premières entreprises capable de produire industriellement des bateaux en fibres de verre. Son Fisherman sportif qui se trouvait en concurrence constante mais amicale avec les Hattera, est célèbre dans le monde entier, il fut également parfois construit par Riva sous licence. Malgré son départ de l'entreprise en 1964, Dick Bertram continue de jouir d'une popularité indestructible parmi les amateurs de bateaux, il a même été un personnage publicitaire, entre autres, pour Camel et Rolex.

En un día ventoso de 1958, el apasionado aficionado a los deportes náuticos y comerciante de yates Dick Bertram, vio uno de las primeras embarcaciones Deep-V de Hunt, atravesar las olas a una velocidad increíble. Bertram contactó inmediatamente con Hunt y le pidió desarrollar un Utility Boat de 30', que denominó entonces "Moppie" en alusión a su esposa. La idea, de hacer competir a Moppie en la competición Miami-Nassau en 1960, puede parecer extraña, pero la aparente inofensiva embarcación ganó por distancia y convirtió el nombre Bertram en un mito. Cuando se difundió la noticia del triunfo, se construyó con la mayor rapidez un modelo de molde, del cual surgió el Bertram 31' –uno de los primeros cascos grandes Deep-V. Bertram en Miami fue una de las primeras empresas que pudo fabricar profesionalmente, embarcaciones de fibra de vidrio. Sus deportivos Fishermen, que estaban en permanente pero cordial competencia con los Hatteras, son famosos en el mundo entero y fueron producidos un tiempo bajo licencia por Riva. Si bien él abandonó la empresa en 1964, Dick Bertram siguió disfrutando de una popularidad ininterrumpida entre nos aficionados a los deportes náuticos y fue entre otros, modelo de publicidad de Camel y Rolex.

In un giorno di burrasca del 1958, l'appasionato velista Dick Bertram vede una delle prime barchette di Hunt con carene a V profonda tagliare le onde a velocità impensabile. Cerca subito Hunt e gli chiede di costruirgli una barca Utility di 30', che chiamerà Moppie in omaggio a sua moglie. L'idea di partecipare alla Miami-Nassau sarà sembrata sciocca, ma Moppie vince di misura: il nome Bertram diventa un mito. Per accontentare le richieste viene ricavato uno stampo da cui nasce il famoso Bertram 31' in vetroresina. La Bertram di Miami è fra i primi cantieri a trattare professionalmente questo nuovo materiale e i suoi Fishermen sportivi, da sempre in cordiale competizione con Hatteras, famosi al mondo, sono stati prodotti da Riva agli inizi degli anni 70. Pur avendo lasciato l'azienda nei primi anni 60 per concentrarsi sulla sua attività di brokeraggio, Dick Bertram ha goduto di una popolaritá eccezionale, facendo da star in pubblicitá per Rolex e Camel.

Since 1920, the Boeschs are based in swiss Kilchberg, facing the Zurich lake. In 1940 Walter Boesch developed the so called Boesch-Horizon-Gliding principle, whereby his small runabouts enjoyed a perfectly balanced ride and produced a very light wave. Soon after serial production of the 500 series started 1952, Walter noticed a steady order flow from Geneva, then European water ski capital. Boeschs were in fact perfect towing machines and have been used an all world championships between 1963 and 1991. Things have hardly changed in Kilchberg, where the wooden runabouts have been subjected to continuous evolution and are still being manufactured by Walter's son Klaus.

Seit 1920 sind die Boeschs in Kilchberg am Zürcher See in der Schweiz angesiedelt. 1940 entwickelte Walter Boesch das so genannte „Boesch-Horizon-Gliding" Prinzip, dem entsprechend Runabouts perfekt ausbalanciert sind und nur leichte Wellen machen. Kurz nachdem 1952 die Produktion der 500er-Serie begann, nahm Walter die kontinuierlichen Bestellwünsche aus Genf zur Kenntnis, der damaligen europäischen Hauptstadt des Wasserski. Boeschs waren beliebte Schnellschlepper, die bei allen Weltmeisterschaften zwischen 1963 und 1991 eingesetzt wurden. Die Dinge haben sich kaum geändert in Kilchberg, wo Runabouts aus Holz noch immer gefertigt werden – mittlerweile von Walters Sohn Klaus.

Les Boesch sont ancrés depuis 1920 à Kilchberg au bord du lac de Zurich en Suisse. En 1940 Walter Boesch développe le principe nommé «Boesch-Horizon-gliding», qui permet d'équilibrer parfaitement les Runabouts qui ne produisent que de légères vagues. Peu après le démarrage de la production de la série des 500 en 1952, Walter pris en compte les commandes en continuelle croissance provenant de Genève, la capitale européenne du ski nautique de l'époque. Les Boesch étaient des tracteurs rapides très appréciés qui participèrent à tous les championnats du monde entre 1963 et 1991. Les choses ont très peu changé à Kilchberg, où des Runabouts en bois sont encore fabriqués – entre-temps par Klaus, le fils de Walter.

Desde 1920 los Boesch están radicados en Kilchberg junto al lago de Zurich en Suiza. En 1940 Walter Boesch desarrolló el así llamado „Boesch-Horizon-Gliding", bajo los cuales los Runabouts están adecuadamente balanceados de forma perfecta y sólo provocan ligero oleaje. Poco después de que en 1952 se iniciara la producción de la serie 500, Walter tomó conocimiento de los deseos de pedidos continuos desde Ginebra, en aquel entonces la capital europea del esquí acuático. Las de Boesch fueron apreciadas embarcaciones rápidas de arrastre, que fueron empleadas en todas las competiciones mundiales entre 1963 y 1991. Las cosas apenas han cambiado en Kilchberg, donde aún se fabrican Runabouts de madera –entretanto par parte de Klaus, el hijo de Walter.

349

Dal 1920 i Boesch fanno barche a Kilchberg, un paesino affacciato sul lago di Zurigo. Nel 1940 Walter Boesch sviluppa il sistema "Boesch-Horizon-Gliding" che da alla barca un assetto orizzontale e produce poco spostamento d'acqua. Subito dopo l'inizio della produzione della serie 500 nel 1952, Walter si accorge di numerosi ordini in arrivo da Ginevra, allora la capitale dello sci natuco – sport per il quale i motoscafi Boesch erano predestinati. Tutti i campionati del mondo dal 1963 al 1991 si sono tenuti su barche del cantiere svizzero. Le cose non sono cambiate molto a Kilchberg, dove i motoscafi in legno sono stati soggetti ad un continuo processo di aggiornamento che dura tuttora, nelle mani di Klaus Boesch.

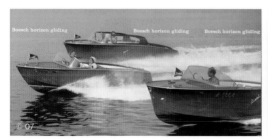

Fabio Buzzi began his offshore competition career in 1960 and in 1971 he graduated from the Turin Polytechnic with a self-constructed vehicle. He then set up FB Design, his own consultancy and boatbuilding facility. Hi-tech composite materials and speed is all that matters in his utterly unconventional creations, be it mono-hull, catamaran or three-points-hull for racing, leisure or military use. In 1992 he set a world record for diesel engines at 252 km/h, in 1999 he recorded an average of 87 knots over the Miami-Nassau-Miami. A "leisure boat", his RIB 38' sport utility can plane in 3 seconds and reach 52 Knots in just under 8 seconds, top speed in 2nd gear being 70 knots.

Fabio Buzzi begann seine Offshore-Karriere 1960 und schloss 1971 sein Studium an der Turiner Politecnico ab. Danach gründete er FB Design, seine eigene Beratungsagentur und Werft. Hi-Tech-Material und Geschwindigkeit sind alles was zählt bei seinen unkonventionellen Kreationen, seien es Monorumpf, Katamaran oder Drei-Punkt-Rumpf für Rennen, Freizeit oder militärischen Einsatz. 1992 stellte er mit 252 km/h einen Weltrekord für Dieselmotoren auf; 1999 registrierte er auf der Strecke Miami-Nassau-Miami eine Durchschnittsgeschwindigkeit von 87 Knoten. Als „Freizeitboot" kann seine RIB 38'

350

Sport Utility nach 3 Sekunden gleiten und erreicht 52 Knoten in weniger als 8 Sekunden – die Höchstgeschwindigkeit im 2. Gang ist 70 Knoten.

Fabio Buzzi débuta sa carrière Offshore en 1960 et termina en 1971 ses études à l'école Politecnico de Turin. Ensuite il créa FB Design, sa propres société de conseil et chantier naval. Des matériaux Hi-Tech et la vitesse, c'est tout ce qui compte dans ses création non conventionnelles, que ce soit des monocoques, catamarans ou des coques trois points pour la course, les loisirs ou des besoins militaires. En 1992 il établit le record du monde de vitesse des moteurs diesel avec 252 km/h; en 1999 il enregistre une moyenne de vitesse de 87 noeuds sur le parcours Miami-Nassau-Miami. En tant que «Bateau de loisir», son Sport Utility RIB de 38', permet en 3 secondes de glisser et d'atteindre 52 noeuds en moins de 8 secondes – la vitesse maximale en 2me vitesse est de 70 noeuds.

Fabio Buzzi inició su carrera de Offshore en 1960 y concluyó sus estudios en 1971 en el Politécnico de Turín. A continuación fundó FB Design, su agencia propia de asesoramiento y astillero. Material de alta tecnología y velocidad son todo lo que cuenta en sus crea-

ciones poco convencionales, ya sea el monocasco, catamarán, o casco de tres puntos para competición, tiempo libre o empleos militares. En 1992 estableció un record mundial para motores diesel con 252 km/h; en 1999 registró en el tramo Miami-Nassau-Miami una velocidad promedio de 87 nudos. Como "embarcación de tiempo libre" su RIB Sport Utility de 38' deslizarse tras 3 segundos y alcanzar 52 nudos en menos de 8 segundos –la velocidad máxima en la 2ª marcha es de 70 nudos.

Fabio Buzzi comincia la sua carriera agonistica nel 1960, nel 1971 si laurea al Politecnico di Torino con un veicolo da lui stesso progettato. È il primo passo per la fondazione di FB Design una società di consulenza con annesso cantiere. I suoi progetti – carene di tutti i tipi per uso sportivo o militare – si concentrano su materiali e lavorazioni a tecnologia avanzata. Nel 1992 una sua barca con motore diesel stabilisce un record di velocitá a 252 km/h, nel 1999 Buzzi tiene una media di 87 nodi sul tragitto Miami-Nassau-Miami. Il suo piccolo RIB 38', una barca "da diporto" raggiunge la planata in tre secondi e I 52 nodi in meno di otto. La velocitá in seconda marcia é di 72 nodi.

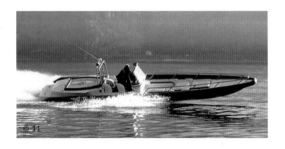

© 11

To design a private yacht for tycoon Gianni Agnelli, carefully made of Mahagony by Cantieri Baglietto, was Paolo Caliari's first task back in 1964. Although this Italian "grand seigneur" of boat design has been mostly dedicated to the upper part of the market, his serially produced designs were both a market success and have set trends the others could not but follow. At the end of the 60s, the Tiger for Cantieri Picchiotti was the forerunner of the so called Z-line, sleek lines with edgy surfaces, that was to become the style for the 70s. Sport yachts—in different configurations—were an intuition of Caliari and are probably his specialty, among them the best-seller C42. Over the years he improved this typology further: faithful to feline names, he has kept improving his Leopard for 30 years: in the late 90s the model 27 sported a flowing roofline that intelligently translated automobile design into a new boating language. The dynamic elegance and the clean geometry of the new Jaguar set this yacht apart from the mad crowd of today's fuzzy-lined yachts. In fact Caliari is and remains foremost an architect, less concerned with the ephemeral showbiz than with timeless quality and human-proof functionality. A well thought design philosophy coupled with an innate good taste make of Caliari a real master of boating arts.

Paolo Caliaris erste Aufgabe war es, 1964 bei Cantieri Baglietto eine Privatyacht aus Mahagoni für den Tycoon Gianni Agnelli zu gestalten. Obwohl der „grand seigneur" des Bootdesigns sich vornehmlich den oberen Segmenten des Markts gewidmet hat, waren auch seine Serienfabrikate Trend setzende Erfolge, denen die anderen nacheiferten. Ende der 60er kam mit dem Tiger für Cantieri Picchiotti der Vorläufer der Z-Linie, deren schlanke Linien und kantigen Oberflächen später den Stil der 70er bilden sollten. Sportyachten unterschiedlichster Ausführung verdanken sich Caliaris Intuition und sind seine Spezialität, wie etwa der Bestseller C42. Den Katzennamen treu bleibend, verbesserte er im Lauf der Jahre seine Typologie. Am Leopard arbeitete er 30 Jahre: in den späten 90ern übersetzte das Model 27 mit fließender Dachkante das Automobildesign in eine neue Bootssprache. Die dynamische Eleganz und klare Geometrie des neuen Jaguar unterscheidet diesen deutlich von den durchgeknallten Kurven-Yachten der Gegenwart. Tatsächlich ist und bleibt Caliari vor allem Architekt, der sich weniger mit flüchtigem Showbiz als mit zeitloser Qualität und anwendungssicherer Funktionalität beschäftigt. Eine gut durchdachte Designphilosophie, gepaart mit eigenem ästhetischen Geschmack, macht Caliari zu einem wahren Meister.

351

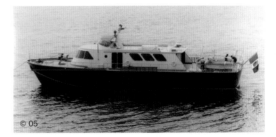

© 05

Le premier travail de Paolo Caliari chez Cantieri Baglietto, en 1964, fut de construire un yacht privé en acajou pour le grand homme d'affaire italien Gianni Agnelli. Bien que le «grand seigneur» du stylisme nautique se consacre principalement au segment haut de gamme du marché, ses modèles de série ont également été des succès qui ont imprimé de nouvelles tendances que les autres stylistes ont copiées. A la fin des années 60, sortit le Tiger pour Cantieri Picchiotti qui devint le précurseur de la ligne Z dont les lignes amincies et les surfaces anguleuses devaient, plus tard, devenir le style des années 70. Des yachts de sport de styles les plus différents doivent remercier l'intuition de Caliari, et ils sont sa spécialité, comme par exemple le C42 qui fut un best-seller. Fidèle aux noms de chats, il améliora leur typologie au fil des années. Il travailla pendant 30 ans sur le Leopard : dans la fin des années 90, le modèle 27 avec son toit à bords de fuite fluide traduisait le design automobile dans une langue nautique nouvelle. L'élégance dynamique et la géométrie simple du nouveau Jaguar sont un contraste violent avec les courbes ahurissantes des yachts actuels. En vérité, Caliari reste avant tout un architecte qui s'occupe moins d'éphémère spectaculaire que de qualité intemporelle et de fonctionnalité sûre adaptée à l'usage. Une philosophie de stylisme mûrement pensée associée à un goût personnel de l'esthétisme font de Caliari un maître véritable.

La primera tarea de Paolo Caliari fue, en 1964 concebir en Cantieri Baglietto un yate privado de caoba para el Tycoon Gianni Agnelli. Si bien el "grand seigneur" del diseño de embarcaciones se dedicó preferentemente al segmento superior del mercado, también sus productos de serie fueron éxitos que crearon tendencias, que los demás siguieron. A fines de los años 60 llegó con el Tiger para Cantieri Picchiotti el predecesor de la línea Z, cuyas líneas esbeltas y superficies angulosas más tarde marcaron el estilo de los años 70. Yates deportivos de diferentes ejecuciones agradecen la intuición de Caliari y son su especialidad, como lo demuestra el éxito de ventas C42. Fiel al nombre del felino, mejoró su tipología con el transcurso de los años. En el Leopard trabajó durante 30 años: a finales de los años 90 adaptó el Model 27 con canto de techo fluente del diseño del automóvil, en un nuevo lenguaje de embarcaciones. Además la elegancia dinámica y la clara geometría del nuevo Jaguar diferencian este notablemente de los alocados yates llenos de curvas de la actualidad. Efectivamente Caliari es y será ante todo arquitecto, que se ocupa menos con el efímero Showbiz que con la calidad intemporal y funcionalidad con seguridad de aplicación. Una filosofía de diseño bien pensada, apareada con un gusto estético propio, hace de Caliari un verdadero maestro.

Il progetto di un Motor Yacht in mogano per l'avvocato Agnelli, realizzato nel 1964 dai Cantieri Baglietto, è il primo lavoro di Paolo Caliari. Anche se questo "gran signore" del design nautico si è spesso dedicato ai super Yacht, le sue barche di serie hanno avuto successo e segnato dei trend importanti. Il suo Tigress per Picchiotti è stato uno dei precursori della linea "Zeta" che ha caratterizzato gli anni 70. Gli Sport Yacht – in svariate configurazioni – sono una delle intuizioni progettuali di Caliari e probabilmente una delle sue specialitá, fra di essi il bestseller C42. Nel corso degli anni egli sviluppa questa tipologia costantemente, per esempio con il Leopard, che nella versione 27 metri degli anni 90 fu tra i primi ad introdurre linee tese di derivazione automobilistica per la sovrastruttura. La dinamica eleganza del suo Jaguar lo fanno risaltare al confronto della maggior parte dei concorrenti plagiati da linee fantasiose e sbilanciate. Di fatto, Caliari è fino in fondo un architetto, poco interessato allo show business e sensibile ad una qualitá a prova di tecnologia e d'uomo. Una solida filosofia progettuale legata ad un innato buon gusto fanno di lui un maestro indiscusso del design nautico.

352

A former racing champion, Giacomo Colombo founded his boatyard by the lake Como in 1962. Initially dealing with Rivas, Colombo moved on to produce his own line of wooden motorboats. In the early 70s there was a shift toward fiberglass, with the first Super Indios and Racing models, followed in the 80s by the Vantage and Antibes. The Riva lesson has been well received by Colombo, whose mentioned boats well interpret the concept of modern sport classics: sober lines and beauty of detail. In 1994, he was one of the first to sense the upcoming retro trend: Colombo's Romance 32' beautifully interpreted the concept of wooden runabouts.

Giacomo, Colombo, ein früherer Rennchampion, gründete seine Werft am Comer See 1962. Nach anfänglichen Geschäften mit Riva begann Colombo mit der Produktion seiner eigenen Motorboote aus Holz. In den frühen 70ern kam die Wende zur Glasfaser mit den ersten Super Indios und Racing, denen in den 80ern Vantage und Antibes folgten. Colombo hat Rivas Lektionen gelernt; seine Boote sind adäquate Interpretationen des modernen Sport Classic-Konzeptes: nüchterne Linien und schöne Details. 1994 erspürte er als erster den sich anbahnenden Retro-Trend. Seine Romance 32' bediente sich erfolgreich beim frühen Runabout aus Holz.

Giacomo, Colombo, un ancien champion, fonda son chantier naval sur le lac de Côme en 1962. Après des affaires en collaboration avec Riva, Colombo commence la production de ses propres bateaux à moteur en bois. Dans le début des années 70 arrive le tournant des fibres de verre avec les premiers Super Indio et Racing, auxquels suivirent les Vantage et Antibes dans les années 80. Colombo a retenu les leçons de Riva; ses bateaux sont des interprétations idéales du concept moderne de Sport Classic : des lignes sobres et de jolis détails. En 1994 il est le premier à sentir l'approche de la tendance rétro. Son Romance de 32' utilise avec succès les avantages des anciens Runabouts en bois.

Giacomo Colombo, un antiguo campeón de competiciones, fundó su astillero junto al lago Comer en 1962. Tras unos negocios iniciales con Riva, Colombo comenzó con la producción de sus propias embarcaciones a motor de madera. En los inicios de los años 70 llegó el cambio a la fibra de vidrio con los primeros Super Indios y Racing, a los que siguieron en los años 80, Vantage y Antibes. Colombo ha aprendido la lección de Riva; sus embarcaciones son adecuadas interpretaciones del moderno concepto Sport Classic: líneas sensatas y bellos detalles. En 1994 percibió como primero la tendencia Retro que se avecinaba. Para su Romance 32' se sirvió de su antiguo y exitoso Runabout de madera.

Affiancando una carriera dedicata all'agonismo motonautico, Giacomo Colombo fonda il suo cantiere sul lago di Como nel 1962. Cominciando a commercializzare barche Riva, egli si muove verso la produzione in proprio di classici motoscafi in legno. Negli anni 70 Colombo passa alla vetroresina con i primi modelli Super Indios e Racing 29', seguiti negli anni 80 dalla serie Vantage ed Antibes. Colombo ha ben ricevuto la lezione di Riva, le sue barche intepretano perfettamente il concetto di moderno Sport Classic: linee sobrie e qualitá nel dettaglio. Nel 1994 Colombo fu tra i primi a presentire le tendenze Retro: il 32' Romance intepreta poeticamente il concetto della classica barca in mogano.

353

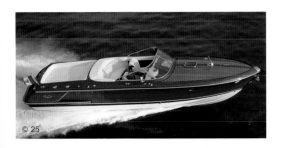

© 25

George Crouch

The father of concave V-bottom, George Crouch constructed his first racer already in 1901. In 1905 he joined the Webb Institute of naval architecture in Long Island, which he was going to head in 1920. In 1924 he was hired as vice president of the Dodge Boat Works. He had to oversee the design and production of their standardized Watercars while still developing racers for the Gold Cup, two tasks which he skillfully mastered. Resisting only two years to Horace Dodge's Jr. erratic management style, he moved to New York to work as a consultant. Still, the fine Watercars testimony of Crouch's design quality—They were among the first to feature the modern flush deck design in 1928.

George Crouch, Vater des konkaven V-Bodens, konstruierte seinen ersten Racer bereits 1901. 1905 trat er dem Webb-Institut für Schiffsarchitektur in Long Island bei, das er ab 1920 leitete. Von den Dodge Boat Works wurde er 1920 als Vizepräsident angestellt. Noch während er Racer für den Gold Cup entwickelte, musste er dort das Design und die Produktion der Standard-Watercars überwachen. Da er Horace Dodge's Jr. seltsames Management jedoch nur zwei Jahre aushielt, ging er schließlich nach New York um als Berater zu arbeiten. Die Qualität von Crouchs Design bezeugen Dodges Watercars dennoch – sie waren 1928 unter den ersten Modellen, die die moderne, glatte Deckgestaltung aufwiesen.

George Crouch, le père du fond en V concave, construisait son premier Racer, déjà en 1901. En 1905 il entre au Webb-Institut pour l'architecture navale à Long Island, qu'il dirigea à partir de 1920. En 1920 il est nommé vice président de la Dodge Boat Works. Tout en dévelopant des Racer pour la Gold Cup, il devait surveiller le design et la production des Watercar standard. Mais comme il ne pu résister que deux ans à l'étrange gestion pratiquée par Horace Dodge Jr., il partit finalement à New York pour travailler en tant que conseiller. La qualité du design de Crouch est attestée par les Watercar de Dodges, et de plus – ce furent, en 1928, les premiers modèles à présenter l'aménagement moderne de pont entièrement plat.

George Crouch, padre del fondo-V cóncavo, construyó su primer Racer ya en 1901. 1905 se incorporó al Webb-Institut para arquitectura naviera en Long Island, que dirigió a partir de 1920. Fue contratado por la Dodge Boat Works como vicepresidente en 1920. Aún mientras el desarrollaba Racer para la Gold Cup, tuvo que supervisar allí el diseño y la producción de los Standard-Watercars. Debido a que el pudo soportar solamente dos años la curiosa gestión de Horace Dodge's Jr., finalmente se trasladó a Nueva York para trabajar como asesor. La calidad del diseño de Crouch la certifican aún los Dodges Watercars –ellos han estado en 1928 entre los primeros modelos, que presentaron la moderna concepción lisa de la cubierta.

Considerato il padre della carena a V concava, George Coruch costruisce il suo primo Racer giá nel 1901. Nel 1905 si iscrive al Webb Institute die Architettura Navale di cui diventa direttore nel 1920. Nel 1924 gli viene fatta un'offerta dalla Dodge Boat Works: egli riceve il compito di supervisionare la produzione delle famose Watercars e di sviluppare una serie di barche da corsa. Pur essendo bravissimo in ció, egli resiste solo due anni allo stile manageriale di Horace Dodge Jr. e si trasferisce a New York per lavorare come consulente. Le raffinate Watercars testimoniano in ogni modo la sua grande qualitá progettuale.

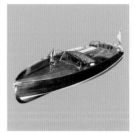

© 20

354

When his father died of flu in 1920, Horace Elgine Dodge jr. was 20 years old and the heir of an automobile fortune. Not being allowed to run the family business, he decided to try with motor boats, his vision being that of an affordable standardized Watercar with high manufacturing quality, that would eventually overwhelm the Chris Craft market dominance. He even thought of selling car-and-boat packages through the Dodge dealers. Dodge Motor Works was founded 1923 and lasted until 1935, cut down by the depression and by Horace's rather uncontrollable personality: his rich young man's interests being rather racing, drinking and love affairs than managing a business.

Als sein Vater 1920 an einer Grippe starb, war Horace Elgine Dodge jr. 20 Jahre alt und der Erbe eines Automobilvermögens. Da er das Familiengeschäft aber nicht leiten durfte, versuchte er es mit Motorbooten. Seine Vision war ein erschwingliches Modell von hoher Qualität, das Chris Crafts Marktdominanz brechen sollte. Er dachte sogar daran, Autos und Boote als Paket bei den Dodge-Händlern anzubieten. Die Dodge Motor Works wurden 1923 gegründet und hielten sich bis 1935, als sie an der ökonomischen Depression und Horaces eher unkontrollierter Persönlichkeit zu Grunde gingen. Der junge Mann war eher an Rennen, Drinks und Affären als am Management interessiert.

Quand son père décéda d'une grippe en 1920, Horace Elgine Dodge jr. avait 20 ans, et était l'héritier d'une immense fortune constituée dans l'industrie automobile. Mais comme il n'avait pas le droit de diriger l'empire familial, il se retourna vers les bateaux à moteur. Sa vision était de concevoir un modèle bon marché de très haute qualité qui devait briser la dominance du marché par Chris Craft. Il pensait même à proposer ensemble la voiture et le bateau chez les concessionnaires Dodge. La Dodge Motor Works fut fondée en 1923 et s'est maintenue jusqu'en 1935, avant de succomber à la dépression économique et à la personnalité plutôt incontrôlée d'Horace. Le jeune homme était plus intéressé par la course, les boissons et les femmes que par la gestion.

Cuando en 1920 su padre falleció a consecuencia de una gripe, Horace Elgine Dodge jr. tenía 20 años de edad y era el heredero de una de las fortunas del automóvil. Debido a que no podría dirigir los negocios familiares, lo intentó con embarcaciones a motor. Su visión era un modelo, al alcance de todos, de alta calidad, que debía romper el dominio de mercado de Chris Craft. Él incluso pensó ofrecer automóvil y embarcación como paquete en los concesionarios Dodge. La Dodge Motor Works fue fundada en 1923 y se mantuvo hasta 1935, cuando se hundieron debido a la depresión económica y la personalidad mas bien incontrolada de Horace. El joven estaba más interesado en competiciones, bebidas y aventuras que de la gestión.

Quando suo padre muore di influenza nel 1920, Horace Elgine Dodge Jr. ha 20 anni ed é l'erede di una fortuna automobilistica. Non essendo autorizzato ad amministrarla, decide di provarsi nella nautica con la visione di produrre affidabili ed economiche Watercars con cui attaccare il dominio assoluto di Chris Craft. Fra le sue idee, quella di vendere pacchetti di macchina-con-barca attraverso i concesionari Dodge. Dodge Motor Works viene fondata nel 1923 e dura, attraverso molte peripezie, fino al 1935, sfinita dalla depressione e dalla personalità incontrollabile di Dodge stesso: i suoi interessi da ricco giovanotto sembravano piuttosto rivolti all'alcol e alle donne che alla direzione aziendale.

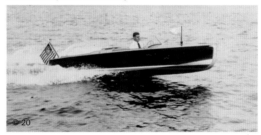

© 20

356

The founder and dominative boss of the Art & Color General Motors department, Hollywood born Harley Earl was the many behind Cadillac's fins, the Corvette and most designs of the American Dream. Leaving is post in 1958, Earl founded his design consultancy firm and entered the boating industry at a time, when fiberglass called for new shapes and lines. There is no doubt about Earls indirect influence in the new automobile-look of smaller craft across the 50s and 60s. In 1964 he was called in as a consultant by Sea Ray, which would become one of the largest leisure boat manufacturers worldwide.

Als Gründer und autoritärer Boss des General Motors Styling Department war der in Hollywood geborene Harley Earl der Mann hinter Cadillacs Flossen, der Corvette und weiteren Designs des American Dream. Er verließ GM 1958, gründete eine Design-Beratungsagentur und betrat die Bühne der Boote zu einer Zeit, als Glasfasern neue Formen und Linien verlangten. Earls indirekter Einfluss auf den auto-ähnlichen Look der kleineren Boote der 50er und 60er ist unbestritten. 1964 wurde er als Berater zu Sea Ray geholt, einer Firma, die später zu einem der weltweit größten Hersteller von Freizeitbooten wurde.

En tant que fondateur et directeur autoritaire du département stylisme de la société General Motors, Harley Earl, né à Hollywood, fut l'homme des ailes de Cadillac, des Corvette et d'autres designs du rêve américain. Il quitta la GM en 1958, pour fonder une agence conseil en stylisme et parvint sur la scène des bateaux à une époque où les fibres de verre réclamaient de nouvelles formes et de nouvelles lignes. L'influence indirecte d'Earl sur le look plutôt automobile des canots à moteur des années 50 et 60 est incontestable. En 1964 il devient conseiller de Sea Ray, une société qui deviendra plus tard le plus grand constructeur mondial de bateaux de loisir.

Como fundador y jefe autoritario del General Motors Styling Department, Harley Eral nacido den Hollywood fue el hombre detrás de las aletas del Cadillac, el Corvette y otros diseños del American Dream. El abandonó GM en 1958, fundó su agentes de asesoramiento de diseño y accedió a la escena de as embarcaciones en un momento en que la fibra de vidrio requería nuevas formas y líneas. La influencia indirecta de Earl sobre el Look automovilísico de las pequeñas embarcaciones de los años 50 y 60 es controvertida. En 1964 fue contratado como asesor por Sea Ray, una empresa, que más tarde se transformó en uno de los mayores fabricantes del mundo de embarcaciones para tiempo libre.

Fondatore del centro stile della General Motors e dotato di carattere dominante, l'hollywoodiano Harley Earl è la persona cui si devono le pinne della Cadillac, la Corvette e molti dei design che hanno costituito il sogno americano. Lasciando il suo posto nel 1958 a Bill Mitchell, Earl fonda uno studio di consulenza ed entra nell'industria nautica in un momento in cui la vetroresina domanda nuove forme. Non c'è dubbio sull'influenza delle idee di Earl osservando il look automobilstico dei piccoli motoscafi degli anni 50 e 60. Nel 1964 eglis viene chiamato a progettare per Sea ray, che non a caso diventa uno dei piú grandi produttori mondiali.

© 13

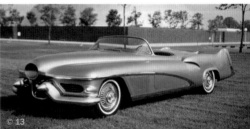
© 13

First committed to the family's automobile business—to sell Lancia, Lamborghini and Maserati in Bologna—Norberto Ferretti decided at the age of 22 to expand his horizons by starting to trade Chris Craft motor boats. This was 1968: two years later he built and sold his first motor sailor. Ten years later Ferretti Craft were serially producing their first open 38' motor yacht, later they specialized in flybridge boats. Himself a class 1 offshore champion and a passionate sailor, Ferretti dedicated time and attention to design features: standard features like to stern platform are among his inventions. In 1998 the company starts a diversification campaign by acquiring prestigious shipyards. Doing so, the Ferretti Group now owns among the best brands in the most important market segments: between 7 to 70 meters, from Riva to Bertram, Apreamare, Itama or Pershing, there's a boat for any taste. Doing so, Norberto Ferretti has become to the boating industry what William Durant, the founder of General Motors, has been to the car industry one century ago.

Nachdem er sich zunächst dem familiären Autogeschäft widmete, indem er Lancia, Lamborghini und Maserati in Bologna verkaufte, entschied sich Norberto Ferretti mit 22 dafür, seinen Horizont durch den Verkauf von Chris Crafts Motorbooten zu erweitern. Das war 1968; zwei Jahre später baute und verkaufte er seinen ersten Motorsegler. Nach weiteren 10 Jahren ging Ferrettis erste offene 38' Motoryacht in Serie; später spezialisierten sie sich auf Flybridge-Boote. Er selbst Class 1 Offshore-Rennmeister und ein passionierter Segler, der Zeit und Aufmerksamkeit dem Design schenkt – Standards wie die Heckplattform gehören zu seinen Erfindungen. 1998 beginnt die Firma eine Diversifizierung, indem sie renommierte Werften erwirbt. Der Ferretti-Gruppe gehören mittlerweile einige der besten Marken in den wichtigsten Segmenten. Zwischen 7 und 70 Metern, von Riva bis Bertram, Apreamare, Itama oder Pershing, für jeden Geschmack gibt es ein Boot. Dadurch ist Norberto Ferretti für die Bootsindustrie das geworden, was William Durant hundert Jahre zuvor mit General Motors für die Automobilbranche war.

357

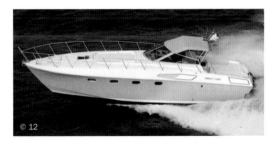

© 12

Après s'être consacré en premier lieu aux affaires automobiles familiales, en vendant des Lancia, Lamborghini et Maserati à Bologne, Norberto Ferretti décide à 22 ans de changer d'horizon en vendant des bateaux à moteur de Chris Craft. C'était en 1968; deux ans plus tard il construit et vend son premier voilier à moteur. Après 10 années, son premier yacht à moteur ouvert de 38' entre en série; plus tard il se spécialise dans les bateaux Flybridge. Lui-même champion des Offshore de classe 1 et un passionné de voile qui offre son temps et son attention au design – les standards comme la plateforme arrière sont de son invention. En 1998 la société débute une diversification en achetant divers chantiers navals réputés. Le groupe Ferretti possède entre-temps quelques unes des meilleures marques dans les segments les plus importants. De 7 à 70 mètres, de Riva à Bertram, Apreamare, Itama ou Pershing, des bateaux pour tous les goûts. Ainsi Norberto Ferretti est devenu pour l'industrie nautique ce que William Durant avec General Motors était pour le secteur automobile il y a un siècle.

Después de que en principio se dedicó al negocio familiar de de automóviles, vendiendo Lancia, Lamborghini y Maserati en Bologna, Norberto Ferretti con 22 años se decidió a ampliar su horizonte a través de la venta de embarcaciones a motor de Chris Craft. Esto era en 1968; dos años más tarde construyó y vendió su primer velero a motor. Tras otros 10 años entró en serie el primer yate a motor abierto de 38' de Ferretti; más tarde se especializó en embarcaciones Flybridge. Él mismo es campeón mundial Offshore Clase 1 y un apasionado velerista, que dedica tiempo y atención al diseño –estándares como la plataforma de popa pertenecen a sus invenciones. En 1998 la empresa comenzó una diversificación, adquiriendo astilleros de renombre. Al grupo Ferretti entretanto pertenecen algunas de las mejores marcas en los segmentos más importantes. Entre 7 y 70 metros, de Riva hasta Bertram, Apreamare, Itama o Pershing, para cada gusto se dispone de una embarcación. De esta manera Norberto Ferretti se ha convertido para la industria náutica, lo que William Durant de General Motors ha sido cien años antes para el ramo del automotor.

Inizialmente dedito al business di famiglia – la vendita di automobili Lancia, Lamborghini e Maserati a Bologna – Norberto Ferretti decide a 22 anni di espandere i suoi orizzonti e comincia a vendere barche Chris Craft. Siamo nel 1968: due anni dopo costruisce e vende il suo primo motorsailer. Dieci anni più tardi Ferretti Craft produce in serie il primo open di 38 piedi, specializzandosi successivamente in Yacht con flybridge. Egli stesso campione di Offshore in Classe 1 e velista appassionato, Ferretti dedica tempo ed attenzione al design delle imbarcazioni che produce. Nel 1998 comincia una campagna di diversificazione della sua azienda, che comincia ad acquisire marchi perstigiosi in ogni segmento di mercato: da 7 a 70 metri, da Riva a Bertram, Apreamare, Itama o Pershing, c'é una barca per ogni gusto. facendo ció, Ferretti é diventato per l'industria nautica ció che per l'automobile é stato all'inizio del secolo scorso William Durant, fondatore della General Motors.

359

Richard Fisher
Boston Whaler

The Harvard graduate Richard T. Fisher used to run his own electric company when, in 1954, he came across with a new material, a polyurethane foam which, injected between two thin fiberglass shells, he thought would be perfect to make lightweight boats. His friend C. Raymond Hunt stood behind the decision to produce a small craft with outboard engine. Hunt designed a wholly new three-point hull and in 1958 the Boston Whaler myth of the unsinkable boat was born.

Der Harvardabsolvent Robert T. Fisher betrieb eine eigene Elektrofirma, als er 1954 einem neuen Material begegnete. Polyurethan-Schaum hielt er für bestens geeignet, um in Kombination mit Glasfasern extrem leichte Boote zu bauen. Sein Freund C. Raymond Hunt unterstützte ihn in der Entscheidung, einen kleinen Außenborder zu produzieren. Hunt entwarf einen völlig neuen Drei-Punkt-Rumpf, und mit dem Boston Whaler wurde 1958 der Mythos des unsinkbaren Bootes geboren.

Le lauréat de Harvard, Robert T. Fisher gérait sa propre société électrique quand, en 1954, il fait la connaissance d'un matériau tout nouveau. Il trouva la mousse de polyuréthane parfaitement adaptée pour la construction de bateaux extrêmement légers, en l'associant à des fibres de verre. Son ami C. Raymond Hunt l'assista dans sa décision de construire un petit hors-bord. Hunt créa une toute nouvelle coque à trois points, et ainsi avec le Boston Whaler naquit en 1958 le mythe du bateau insubmersible.

El graduado de Harward Robert T. Fisher gestionó una empresa propia de productos eléctricos, cuando en 1954 entró en contacto con un material nuevo. Él consideró que la espuma de poliuretano se adaptaba perfectamente, para en combinación con fibra de vidrio, construir embarcaciones extremadamente ligeras. Su amigo C. Raymond Hunt le brindó apoyo en su decisión, de producir un pequeño fuera de borda. Hunt desarrolló un casco de tres puntos completamente nuevo y con el Boston Whaler se convirtió en 1958 en el mito de las embarcaciones insumergibles.

Dopo essersi laureato ad Harvard, Richard T. Fisher si occupa della sua azienda di componenti elettrici quando, nel 1954, scopre una schiuma di poliuretano che, se iniettata attraverso due sottili lastre di vetroresina, ritiene ideale per produrre barche a vela leggere. È il suo amico Hunt a suggerigli di concentrarsi sulle barche a motore fuoribordo, che stavano diventando di gran moda a quel tempo. Hunt gli disegna una carena a 3 punti che rivoluzionerà le prestazioni di barche piccole: cosí nasce nel 1958 il mito dell'inaffondabile Boston Whaler.

the boats to see in '63

JET-SMOOTH RIDE
SPACE AGE STYLING

64's

A Texan boat dealer, Bill Gaston engaged with designer Bob Hammond in the launch one of the very first fiberglass boat companies. One evening of 1956 Bill's wife Bettye came out with the idea of combining "glas" for fiberglass and "tron", which sounded high tech, into Glastron, a name that would become a worldwide famous trademark. Business boomed: already in 1957 Glastron delivered 900 boats, among them the fancy SurfFlite and FireFlite, advertised of as "tomorrow's boat today". They sported tailfins, panorama windshield and a car-like cockpit. In 1958 followed the first 17' inboard appeared, available in two-tone colors of such appealing names as Matador Red, Bimini Blue, Tahitian Coral or Polished Ebony over a Cascade White hull. In 1961 the first stern-drive models were presented, in 1962 The deep-V hull was marketed under the promising name Aqua Lift. In 1967 Aqua Lift II followed, in itself Glastron's version of a three-point hull. In 1968 the Hi-performance Glastron-Carlson range was launched. By 1970, the 100 000ᵗʰ Glastron was built, making the company to the largest boat manufacturer worldwide. In 1973, the GT-150 performed in James Bond "Live and Let Die" and set a world record for the longest jump. Those were the days of jet boats and swingers in metalflake colors.

Der texanische Bootshändler Bill Gaston tat sich mit Bob Hammond zusammen, um eine der ersten Firmen für Glasfaserbooten aufzumachen. 1956 hatte Bills Frau Betty die Idee, das „Glas" der Glasfaser mit „tron" (was nach Hi-Tech klang) zu „Glastron" zu verschmelzen – eine Name, der zum weltweit berühmten Markenzeichen wurde. Das Geschäft brummte: schon 1957 lieferte Glastron 900 Boote aus, unter ihnen die SurfFlite und FireFlite, die als „Boote von morgen" beworben wurden. Sie hatten Schwanzflossen, Panoramascheiben und ein autoähnliches Cockpit. 1958 erschien der erste 17' Inboard und war in Zweifarben mit Namen wie Matador Rot, Bimini Blau, tahitianscher Koralle oder poliertem Ebenholz erhältlich. 1961 wurden die ersten Modelle mit Heckantrieb präsentiert, und der Deep-V-Rumpf firmierte 1962 unter dem viel versprechenden Namen „Aqua Lift". Der Aqua Lift II, Glastrons Version eines Drei-Punkt-Rumpfes, folgte 1967. Die Hi-Performance Glastron-Carlson-Linie wurde 1968 herausgebracht. Bis 1970 war das 100.000 Glastron-Boot gebaut und die Firma eine der größten weltweit. Der GT-150 spielte 1973 im James Bond-Film „Leben und sterben lassen" mit, in dem er den Weltrekord für den weitesten Sprung aufstellte. Es waren die Zeiten der Jet Boats und Swinger, mit poppigen Metallik-farben.

361

© 24 (all)

362

Le marchand de bottes texan Bill Gaston, s'associa à Bob Hammond pour créer la première société de bateaux en fibres de verre. En 1956, la femme de Bill, Betty eut l'idée d'associer le nom de «Glas» des fibres de verre à «tron» (ce qui avait un côté Hi-Tech) pour former «Glastron» – un nom devenu une célèbre marque mondiale. Les affaires marchaient bien : dès 1957 Glastron livrait 900 bateaux, parmi eux le SurfFlite et le FireFlite, qui était qualifiés de «Bateaux de demain». Ils avaient des ailerons de queue, des vitres panoramiques et un cockpit rappelant celui des voitures. En 1958 apparaît le premier Inboard de 17', dans des coloris bicolores portant des noms comme rouge matador, bleu Bimini, corail tahitien ou ébène poli. En 1961 furent présenté les premiers modèles avec entraînement à l'arrière, et la coque Deep-V fut utilisée par la société en 1962 sous le nom très prometteur d'Aqua Lift. L'Aqua Lift II, une version Glastron de la coque à trois points, suivit en 1967. Les hautes performances de la ligne Glastron-Carlson est sortie en 1968. Dès 1970 le 100.000ème bateau Glastron avait été produit et la société était devenue une des plus grandes au niveau mondial. Le GT-150 participa en 1973 au film de James Bond «Vivre et laisser mourir», où il établit le record mondial du saut en longueur. C'était l'époque des Jet Boat et Swinger, à coloris métalliques.

El comerciante tejano de embarcaciones Bill Gaston se asoció con Bob Hammond, para abrir una de las primeras empresas para embarcaciones de fibra de vidrio. En 1956 la esposa de Bill, Betty tuvo la idea, de fusionar el "Glas" de la fibra de vidrio con "tron" (lo que sonaba a alta tecnología) en "Glastron" –un nombre, que se transformó a nivel mundial en una marca registrada famosa. Los negocios florecieron: ya en 1957 Glastron suministró 900 embarcaciones, entre ellas la SurfFlite y FireFlite, que fueron promocionadas como las "embarcaciones del mañana". Las mismas tenían aletas finales, cristales panorámicos y una cabina similar a la de un automóvil. En 1958 apareció en primer Inboard de 17' y podía ser adquirido en dos tonalidades de color con nombres como rojo Matador, azul Bimini, coral tahitiano o madera de ébano pulida. En 1961 se presentaron los primeros modelos con propulsión trasera, y el casco Deep-V firmaba en 1962 bajo el nombre muy prometedor de "Aqua Lift". El Aqua Lift II, versión de Glastron de un casco de tres puntos, le siguió en 1967. La línea Hi-Performance Glastron-Carlson fue lanzada en 1968. Hasta 1970 había sido construida la embarcación 100.000 de Glastron. El GT-150 actuó en 1973 en la película de James Bond "Vivir y dejar morir", donde logró el record mundial por el mayor salto. Eran los tiempos de los Jet Boats y Swinger, el colores metálicos flocados.

Un commerciante di barche texano, Bill Gaston decide assieme al progettista Bob Hammond di cimentarsi in uno dei primissimi cantieri specializzati in vetroresina. Una sera del 1956 a sua moglie Bettye viene l'idea di combinare la parola "Glas" da vetroresina con "tron", che le sembra molto hi-tech, in Glastron, un nome che diventerá uno dei piú famosi brand della nautica popolare. Il business esplode, nel 1957 si vendono 900 barche dei tipi SurfFlite a FireFlite, pubblicizzate come "la barca del futuro oggi" a caratterizzate da un design automobilistico. Nel 1958 segue il primo entrobordo da 17 piedi disponibile in colori sgargianti dai nomi esotici come Rosso Matador, Blu Bimini, Corallo di Tahiti o Ebano lucido sopra una carena in tinta Bianco Cascata. Nel 1961 seguono i primi entrofuoribordo, nel 1962 gli Aqua Lift con carena a V profonda. Nel 1967 è la volta di Aqua Lift II, una versione Glastron della carena a tre punti di Hunt. Nel 1968 nasce la serie ad alte prestazioni Glastron-Carlson. Nel 1970, viene prodotto il centomillesimo Glastron, allora disponibile in colori pazzeschi con finitura "fiocco metallico": Glastron è il piú grande costruttore al mondo. Nel 1973 il GT-150 fa la sua figura in "vivi e lascia morire" di James Bond, dove ottiene il record per il salto piú lungo.

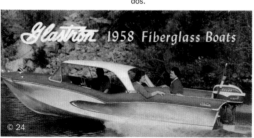

© 24

Edgar Gregory and his Detroit based Belle Isle Boats are credited with the first standardized runabout with forward cockpit. It was launched in 1920 as the Bearcat, the reference to the famous Stutz roadster car being not casual. The boat was in fact Gregory's ingenious evolution of a design by John Hacker and it was to set the market standard for years to come. In 1924 Gregory merged operations with Hacker and in 1925 the 30' Super Bearcat was launched. Nevertheless, by 1928 the desirable Bercats had almost disappeared from the market.

Edgar Gregory und seinen in Detroit beheimateten Belle Isle Boats werden die ersten serienmäßigen Runabouts mit Vordercockpit zugeschrieben. 1920 als „Bearcat" vorgestellt, war die Referenz zum Stutz Roadster-Auto kein Zufall. Das Boot war tatsächlich eine Weiterentwicklung des Designs von John Hacker, und setzte den Marktstandard für die kommenden Jahre. 1924 tat sich Gregory dann mit Hacker zusammen, so dass 1925 die 30' Super Bearcat erschien. Nichtsdestotrotz waren die begehrenswerten Bearcats bis 1928 fast ganz vom Markt verschwunden.

On attribue à Edgar Gregory et à sa société Belle Isle Boats située à Detroit, les premiers runabouts de série avec cockpit à l'avant. En 1920, présenté comme «Bearcat», la référence aux voitures Roadster Stutz n'était pas un hasard. Le bateau était effectivement un développement ultérieur du design de John Hacker, et détermina le standard du marché pour les années suivantes. En 1924 Gregory s'associa à Hacker, et en 1925 sortit le Super Bearcat de 30'. Malgré tout, les très demandés Bearcat avaient presque disparu du marché en 1928.

A Edgar Gregory y su Belle Isle Boats originaria de Detroit se le adjudican los primeros Runabouts de serie con cabina delantera. En 1920 cuando presentó "Bearcat", la referencia al automóvil roadster Stutz no era una casualidad. La embarcación fue realmente un desarrollo mundial del diseño de John Hacker, y puso las normas en el mercado para los años siguientes. En 1924 Gregory se asoció entonces con Hacker, de manera tal que en 1925 apareció la Super Bearcat de 30'. Muy a pesar de ello los cotizados Bearcats hasta 1928 casi habían desaparecido del mercado.

Ad Edgar Gregory ed al suo Belle Isle Boat di Detroit viene accreditata la produzione in serie del primo Runabout di stampo moderno con cockpit anteriore frontale e motore centrale, lanciato nel 1920 come Bearcat in onore del famoso roadster della Stutz. La barca era in realtá l'evoluzione di Gregory sulla base di un disegno di Hacker ed avrebbe fatto tendenza per gli anni a venire. Nel 1924 Gregory si unisce ad Hacker e nel 1925 nasce il Super Bearcat di 30 piedi. Come spesso succede, nel 1928 il marchio, travolto dalla concorrenza, scompare dal mercato.

363

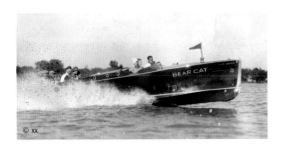

364

John Ludwig Hacker—born 1877—studied speedboat design by correspondence and by 1911 had already constructed his first boat, a stepped-hull capable of 50 mph. In 1914 he founded the Hacker Boat Company in Detroit, being credited for the basic layout of the Bearcat, the first modern standardized Runabout. Among Hacker's refinement, the adoption of a windshield in the 1923 Dolphin and of the flush deck design in 1928. A believer in the principles of standardized mass production, inspired to him by friend Henry Ford, Hacker was capable to grow his business considerably down to 1930 but the effects of the great depression were to be felt soon. In 1935 Hacker sold his interest in the company and started working as a consultant again. Not only found he a worthwhile niche in the military industry, but he also started adopting streamline design into his one-off creations. Noteworthy are the 55' commuter Thunderbird of 1939, whose flowing cabin top was made of polished stainless steel, and the exceptional Pardon Me of 1953. At 48' and with a top speed of up to 80 mph, this is probably the largest wooden speedboat ever built. One of the most talented and prolific boat designers, with a record of 1000 projects realized, Hacker continued to design until his death in 1961.

John Ludwig Hacker, geboren 1877, hatte Bootsdesign per Briefwechsel studiert und konstruierte bereits 1911 sein erstes Boot, einen Stufenrumpf mit 50 mph Geschwindigkeit. 1914 gründete er die Hacker Boat Company in Detroit und zeichnete für den Grundriss des Bearcat verantwortlich, dem ersten modernen Serien-Runabout. Zu Hackers Verfeinerungen zählen die Frontscheibe im 1923er Dolphin und das glatte Deckdesign von 1928. Als Freund der Massenproduktion, zu der ihn sein Freund Henry Ford anregte, konnte Hacker bis in die 30er Jahre hinein expandieren, bis auch er die Auswirkungen der großen Depression spürte. 1935 verkaufte er seinen Firmenanteil und begann wieder als Berater zu arbeiten. Er fand nicht nur eine hübsche Nische in der Militärindustrie, sondern integrierte auch das Stromliniendesign in seine Einzelanfertigungen. Erwähnenswert sind sein 55' Commuter Thunderbird von 1939, dessen fließendes Kabinendach aus poliertem, rostfreien Stahl bestand, sowie sein außergewöhnlicher Pardon Me von 1953. Mit 48' Länge und einer Höchstgeschwindigkeit von bis zu 80 mph ist dies womöglich das größte jemals gebaute Speedboat aus Holz. Hacker war einer der talentiertesten und mit 1000 realisierten Projekten auch einer der produktivsten. Er arbeitete bis zu seinem Tod 1961.

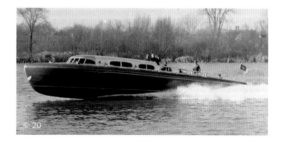

John Ludwig Hacker, né en 1877, avait étudié le design nautique par échange de courrier, et il construit dès 1911 son premier bateau, une coque tronquée avec une vitesse de 50 mph. En 1914 il fonde la Hacker Boat Company à Detroit et dessine l'esquisse du Bearcat, le premier Runabout moderne de série. Parmi les améliorations créées par Hacker, on compte le pare-brise frontal, en 1923 le Dolphin et le design du pont plat en 1928. En tant qu'amateur de la production de masse, conseillée par son ami Henry Ford, Hacker a pu s'agrandir jusque dans le milieu des années 30, jusqu'à ce que lui aussi ressente les effets de la crise de 1929. En 1935 il revend sa participation et recommence à travailler comme conseiller. Il ne trouva pas simplement une niche intéressante dans l'industrie militaire, mais il introduisit aussi son design de lignes fluides dans ses constructions individuelles. Ce qu'il faut retenir c'est son Commuter Thunderbird de 55' en 1939, dont le toit de cabine aux lignes fluides et en acier inoxydable poli, ainsi que son extraordinaire Pardon Me de 1953. Avec une longueur de 48' et une vitesse maximale de jusqu'à 80 mph, c'est probablement le plus grand bateau rapide en bois jamais construit. Hacker fut l'un des stylistes les plus talentueux et avec ses 1000 projets réalisés, aussi l'un des plus productifs. Il travailla jusqu'à sa mort en 1961.

John Ludwig Hacker, nacido en 1877, estudió diseño d embarcaciones por correspondencia y construyó ya en 1911 su primera embarcación, un casco escalonado con 50 mph de velocidad. En 1914 fundó la Hacker Boat Company en Detroit y fue el responsable del diseño básico del Bearcat, el primer Runabout moderno de serie. Entre los refinamientos de Hacker contaron la luna delantera en el Dophin de 1923 y el diseño de cubierta liso de 1928. Como amigo de la producción masiva, a lo que estimuló su amigo Henry Ford, Hacker consiguió expandir hasta entrados los años 30, hasta que también sintió los efectos de la gran depresión. En 1935 vendió su parte de la empresa y comenzó nuevamente a trabajar como asesor. Él no sólo encontró un buen hueco de mercado en la industria militar, sino integró también el diseño aerodinámico en sus fabricaciones individuales. Dignos de mención son sus Commuter Thunderbird de 55' de 1939, cuyo techo de cabina fluente estaba constituido de acero inoxidable pulido, así como su extraordinaria Pardon Me de 1953. Con 48' de eslora y una velocidad máxima de hasta 80 mph este es posiblemente el Speedboat de madera más grande que se haya construido alguna vez. Hacker fue uno de los diseñadores más talentosos y con 1.000 proyectos realizados también uno de los más productivos. Él continuó trabajando hasta su fallecimiento en 1961.

John Ludwig Hacker, nato nel 1877, studia design nautico per corrispondenza e nel 1911 costruisce la sua prima barca con carena a redan, capace di 50 miglia orarie. Nel 1914 fonda la Hacker Boat Company a Detroit e disegna il Bearcat, primo moderno Runabout. Tra le idee di Hacker, l'adozione del parabrezza sul Dolphin del 1923 e la coperta a filo disegnata nel 1928. Convinto assertore dei principi della standardizzazione ispiratigli dall'amico Henry Ford, Hacker è in grado di far crescere il suo business considerevolmente fino al 1930, ma la grande depressione lo colpisce ineosorabilmente. Nel 1935 vende la sua quota e ricomincia a lavorare come consulente, annoverando tra i suoi clienti la Marina Militare. Affascinato dallo streamline, lo applica a due creazioni strepitose: il Thunderbird del 1939, un Fast Commuter con la sovrastruttura di acciaio inox lucidato, ed il Pardon Me del 1953. Con una lunghezza di 48 piedi ed una velocitá di 80 miglia questo è probabilmente il piú grande Runabout mai costruito. Alla sua morte nel 1961, Hacker lascia un eredità intellettuale fatta di almeno mille progetti.

365

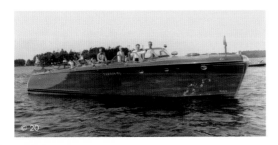

© 20

366

Robert R. Hammond may be considered the king of popular boats. Having begun his career as an advanced material researcher soon after the war, he initially sought employment at Lone Star, makers of small aluminum fishing boats, with the aim to apply his knowledge of plastics to mass boat production. Between 1952 and 1956 he developed a fully new fiberglass range for Lone Star, among them the Meteor, a small outboard craft that looked like a swimming automobile, half Studebaker and half Cadillac. Hammond's big chance when he and Bill Gaston teamed to found Glastron of which he was to become the president. For over 17 years, Hamond was credited with the most shrill, yet extremely successful boats and a very creative, often provocative approach to boat design. Bob was to leave Glastron in 1974, by then the world's largest boat manufacturer, to set up Hammond Boats, where he would be more free to experiment. Hammond ran his company down to the mid 80s.

Robert R. Hammond kann als König des populären Bootes angesehen werden. Nach dem Krieg begann er seine Karriere als Materialforscher und suchte anfangs eine Beschäftigung bei Lone Star, einem Hersteller von Fischerbooten aus Aluminium, um seine Kunststoffkenntnisse in die serielle Bootsproduktion einzubringen. Zwischen 1952 und 1965 entwickelte er dann eine komplett neue Lone Star Serie aus Glasfasern. Unter ihnen war der Meteor: ein Außenborder, der als Kreuzung von Studebaker und Cadillac wie ein schwimmendes Auto aussah. Hammonds große Chance kam, als er mit Bill Gaston Glastron gründete, dessen Präsident er später wurde. Mehr als 17 Jahre lang entwarf Hammond äußerst schrille Boote mit einem sehr kreativen und oft provokativen Ansatz, der dem Erfolg jedoch nicht abträglich war. Bob verließ Glastron 1974, als sie der weltgrößte Hersteller waren. Seine neu gegründete Firma Hammond Boats, die er bis in die 80er leitete, gab ihm mehr Raum für Experimente.

Robert R. Hammond peut être désigné comme le roi du bateau populaire. Après la guerre il commence sa carrière comme chercheur sur les matériaux et cherchait au départ un emploi chez Lone Star, un constructeur de bateaux de pêche de série en aluminium, afin d'y investir ses connaissances dans les matières synthétiques. Entre 1952 et 1965 il développe une gamme entièrement nouvelle de Lone Star en fibres de verre. Parmi eux le Meteor : un hors-bord qui ressemblait à une auto flottante qui serait un croisement de Studebaker et de Cadillac. La grande chance d'Hammond arriva lorsqu'il fonda la Glastron en association avec Bill Gaston, dont il devint plus tard le président. Pendant plus de 17 ans, Hammond créa des bateaux extravagants avec des équipements très créatifs et souvent provocants qui toutefois n'empêchèrent pas le succès. Bob quitta Glastron en 1974, alors qu'ils étaient devenus les plus grands constructeurs mondiaux. La nouvelle société qu'il fonda Hammond Boats et qu'il dirigea jusque dans les années 80, lui offrit plus de latitude pour l'expérimentation.

Robert R. Hammond puede ser considerado como el rey de la embarcación popular. Después de la guerra comenzó su carrera como investigador de materiales y buscó de inicio una ocupación en Lone Star, un fabricante de embarcaciones de pesca de aluminio, para introducir sus conocimientos sobre materiales plásticos en la producción en serie de embarcaciones. Entre 1952 y 1965 desarrolló entonces una serie Lone Star completamente nueva de fibra de vidrio. Entre ellas estaba la Meteor: un fuera de borda, que parecía una cruza entre Studebaker y Cadillac como automóvil anfibio. La gran oportunidad de Hammond se presentó, cuando fundó junto con Bill Gaston la empresa Glastron cuyo presidente fue más adelante. Más de 17 años Hammond desarrolló embarcaciones con un toque extremadamente estridentes y frecuentemente provocativo, cuyo suceso sin embargo no fue contraproducente. Bob abandonó Glastron en 1974, cuando era el mayor fabricante mundial. La nueva empresa por él creada, la Hammond Boats, que dirigió hasta los años 80, le abrió más espacio para experimentaciones.

Robert R. Hammond puó essere considerato il re del motoscafo di massa. Avendo cominciato la sua carriera come ricercatore di materiali avanzati, subito dopo la seconda guerra mondiale cerca lavoro presso Lone Star, un fabbricante di piccole barche da pesca in alluminio, con l'obbiettivo di trovare un'applicazione per il suo sapere nel campo delle plastiche. Tra il 1952 ed il 1956 sviluppa una nuova serie di barche in vetroresina, tra di essi il Meteor, un piccolo scafo che sembra un'automobile galleggiante, a metà tra Studebaker e Cadillac. La sua grande chance arriva quando lui e Bill Gaston si uniscono per fondare Glastron, azienda della quale Hammond diventerá presidente. Durante piú di 17 anni, Hammond ha realizzato una sbalorditiva serie di modelli dalle forme e dai colori incredibili, dimostrando un approccio molto creativo e spesso provocatorio rispetto al design nautico corrente. Hammond lascia Glastron nel 1974 per fondare Hammond Boats, una nuova societá nella quale essere piú libero di sperimentare. L'esperienza si conclude alla metá degli anni 80.

367

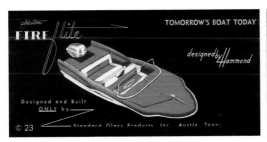

Born 1908 with a genial mind and little sense for business, Charles Raymond Hunt is the one man the whole motor boating community should be for ever grateful to. A self-taught engineer, he started his own consultancy to build and broker boats in 1932. Although he was a skilled helmsman and his design credentials ranged from sailboat to powerboat design, success came rather late. Hunt's name is linked with the perfection and first application of the deep-V, high-deadrise hull—with longitudinal strips to ease planing and prevent water spray. First tested in 1949, the validity of Hunt's concept became finally apparent to Dick Bertram in 1958. The series of successful Moppie racers was the final demonstration deep-V was just perfect for the new fiberglass technology. Unfortunately, due to the high publicity given to his design, Hunt was unable to patent it. Too good for the market: even now, not only is Hunt's design widely applied, but there has been hardly space for any improvement. Less concerned with ambitions and fame, Hunt, who also largely contributed to the design of the unsinkable Boston Whaler, kept sailing until his death in 1978.

Mit genialem Verstand und armseligem Geschäftssinn 1908 geboren, ist Charles Raymond Hunt einer der Männer, dem die Branche ewig dankbar sein sollte. Als autodidaktischer Ingenieur startete er 1932 seine Firma für den Bau und Verkauf von Booten. Obwohl er ein versierter Steuermann war und seine gestalterischen Referenzen vom Segel- bis zum Motorboot reichten, kam der Erfolg relativ spät. Hunts Name ist mit der Perfektionierung und ersten Anwendung des Deep-V-Rumpfes verbunden, der mit längs laufenden Streifen für erleichtertes Gleiten sowie Spritzwasservermeidung sorgt. Nach den ersten Tests 1949 wurde Hunts Konzept 1958 von Dick Bertram gesichtet. Die erfolgreichen Moppie-Racer bewiesen endgültig, dass das Deep-V für die neue Glasfasertechnologie perfekt war. Leider gelang es Hunt wegen des großen öffentlichen Interesses für sein Design nicht, ein Patent darauf anzumelden. Ohnehin war es zu gut für den Markt: Hunts Design ist nicht nur weit verbreitet, sondern ließ auch kaum Spielraum für Verbesserungen. Hunt, der beim unsinkbaren Boston Whaler ebenfalls kräftig mitmischte, war an Ruhm kaum interessiert und segelte weiter bis zu seinem Tod 1978.

Né en 1908, avec un esprit génial et un sens des affaires déplorable, Charles Raymond Hunt est l'un des hommes dont le secteur devrait toujours être redevable. En tant qu'ingénieur autodidacte il fonda sa société en 1932 pour la construction et la vente de bateaux. Malgré ses grandes aptitudes de barreur et ses références de stylisme pour les voiliers comme pour les bateaux à moteur, la réussite lui vint relativement tard. Le nom de Hunt est associé au perfectionnement et à la première application de la coque Deep-V qui assure un glissage facilité par des lattes longitudinales, ainsi que la réduction des projections d'eau. Après les premiers tests en 1949, le concept de Hunt a été appréhendé en 1958 par Dick Bertram. Le succès des Racer Moppie a prouvé sans équivoque que le Deep-V était parfait pour la technologie des fibres de verre. En raison du grand intérêt public provoqué par son design, Hunt n'a jamais pu déposé un brevet à ce sujet. C'était de toute façon trop bien pour le marché : le design de Hunt n'est pas seulement largement répandu mais il laisse très peu de place pour des améliorations. Hunt qui participa activement à l'insubmersible Boston Whaler, était très peu intéressé par la renommée et il continua à pratiquer la voile jusqu'à sa mort en 1978.

Con criterio genial y un pobre sentido comercial nacido en 1908, Charles Raymond Hunt es uno de los hombres al que el ramo debería estar eternamente agradecido. Como ingeniero autodidacta inició en 1932 su empresa para la construcción y venta de embarcaciones. Si bien él era un versado timonel y sus referencias creativas alcanzaban desde los veleros hasta las embarcaciones a motor, el éxito llegó relativamente tarde. El nombre de Hunt está ligado al perfeccionamiento y primera aplicación del casco Deep-V, que cuidó con sus tiras desarrolladas longitudinalmente un deslizamiento facilitado así como de evitar salpicaduras de agua. Tras las primeras pruebas en 1949 el concepto de Hunt fue asegurado por Dick Bertram. Los exitosos Moppie-Racer demostraron finalmente, que el Deep-V era perfecto para la nueva tecnología de fibra de vidrio. Lamentablemente, debido al gran interés público por el diseño, no logró registrar una patente. Así y todo era demasiado bueno para el mercado: el diseño de Hunt no sólo está difundido mundialmente, sino deja tras de sí apenas margen para perfeccionamientos. Hunt, que participó también intensamente en la Boston Whaler, apenas si estaba interesado en la fama y continuó su travesía hasta que la muerte lo sorprendió en 1978.

Nato nel 1908 con una mente geniale e scarso senso degli affari, Charles Raymond Hunt è l'uomo a cui tutto il mondo della nautica deve essere eternamente riconoscente. Ingegnere autodidatta, egli progetta e realizza barche a partire dal 1932. Pur essendo un esperto timoniere ed accumulando credenziali nel campo delle imbarcazioni a vela ed a motore, il riconoscimento ufficiale arriva tardi. Il suo nome è legato al perfezionamento ed alla prima applicazione della carena a V profonda, con pattini laterali per facilitare la planata ed evitare gli spruzzi. Testata dal 1949, la validità del suo progetto diventa evidente a Dick Bertram nel 1958. La serie di barche da corsa Moppie ed i primi Bertram dimostrano che la carena di Hunt è perfetta per gli scafi in vetroresina e tutti la vogliono. Sfortunatamente, a causa dell'elevata pubblicità data all'idea, Hunt non riesce a patentarla. Cosa buona per il mercato: non solo il design di Hunt è ora uno standard riconosciuto, ma in quasi 50 anni non c'è stato nemmeno bisogno di grandi evoluzioni. Poco ambizioso, Hunt, che tra l'altro ha ampiamente contribuito alla nascita del Boston Whaler, continua a veleggiare fino alla sua morte, avvenuta nel 1978.

369

OWNER'S MANUAL
© 26

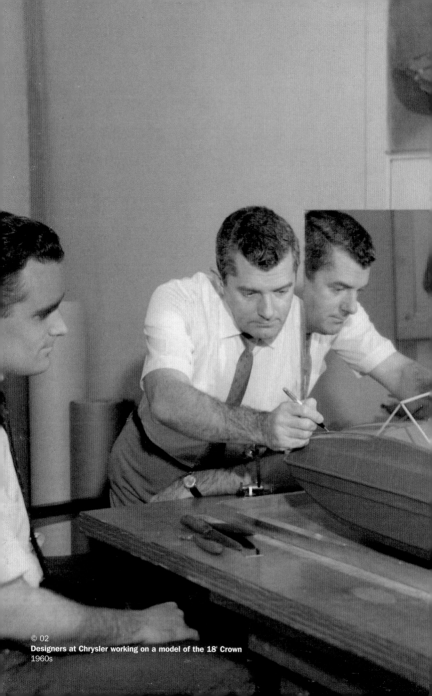

Designers at Chrysler working on a model of the 18' Crown
1960s

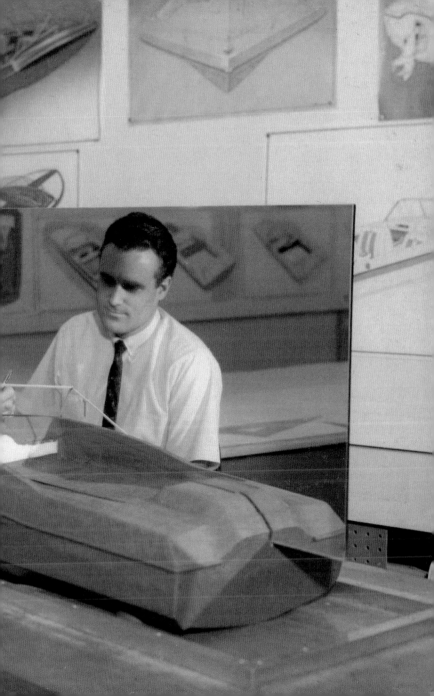

Renato Levi

After having studied aeronautical engineering in England, back in the late 40s India, Renato "Sonny" Levi was among the pioneers of deep-V hull development. In 1961 he moved to Europe and started racing, winning the 1963 Cowes-Torquay with his A Speranziella. In the same year he designed the Corsair 27', a "cabin cruiser with which one would win races too". Since 1965 he enforced his consulting business and became an expert in transmission and propulsion systems—specially surface propellers—working for, among others, Riva. In 1987 he was conferred the title of Royal Designer for the Industry by the Royal Society of Arts.

372

Nach einem Studium zum Flugzeugingenieur in England war Renato „Sonny" Levi am Ende der 40er einer der Pioniere der Deep-V-Entwicklung in Indien. 1961 zog er nach Europa, begann Rennen zu fahren und gewann den 1963er Cowes-Torquay mit seiner A Speranziella. Im selben Jahr entwarf er die Corsair 27', ein „Cabin Cruiser, der auch Rennen gewinnen soll". Ab 1965 verstärkte er seine Beratertätigkeit und wurde Experte für Transmissions- und Antriebssysteme mit Schwerpunkt Propelleroberflächen. Er arbeitete u. a. für Riva. 1987 erhielt er den Titel „Royal Designer for the Industry" von der Royal Society of Arts.

Après ses études d'ingénieur aéronautique en Angleterre, Renato « Sonny » Levi était, dans les années 40, un des pionniers du développement du Deep-V en Inde. En 1961 il émigre vers l'Europe, et commence à participer à des courses, et gagne en 1963 la Cowes-Torquay avec son A Speranziella. Dans la même année il conçoit le Corsair de 27', un « Cabin Cruiser, qui devait aussi gagner des courses ». A partir de 1965 il renforce ses activités de conseil et devient expert des systèmes de transmissions et d'entraînement, avec une spécialisation dans les surfaces d'hélices. Il a travaillé entre autres pour Riva. En 1987 La Royal Society of Arts lui décerne le titre de « Styliste Royal de l'industrie ».

Tras sus estudios como ingeniero aeronáutico en Inglaterra Renato "Sonny" Levi fue a fines de los años 40 uno de los pioneros del desarrollo Deep-V en India. 1961 se mudó a Europa, comenzó a participar en competiciones y ganó en 1963 la Cowes-Torquay con su A Speranziella. En el mismo año desarrolló el Corsair 27', un "Cabin Cruiser, que también tiene que ganar competiciones". A partir de 1965 reforzó su tarea de asesor y se convirtió en experto de sistemas de propulsión y transmisión con punto esencial en superficies de hélices. Él trabajó entre otros para Riva. En 1987 recibió el título de "Royal Designer for the Industry" de la Royal Society of Arts.

Dopo aver studiato ingegneria aeronautica in Inghilterra, tornato in India nei tardi anni 40, Renato "Sonny" Levi è tra i pionieri nello sviluppo della carena a V profonda. Nel 1961 si trasferisce in Europa e comincia a gareggiare, vincendo la Cowes-Torquay nel 1963 a bordo del suo scafo A Speranziella. Nello stesso anno disegna il Corsair 27', un "cabin cruiser con cui si possono vincere le gare" per il cantiere Viking. Dal 1965 si dedica all'attività di consulenza e matura esperienza in sistemi di trasmissione, in particolar modo le eliche di superficie. Lavora, tra gli altri, per Riva. Nel 1987 gli viene conferito il titolo di Royal Designer for the Industry da parte della Royal Society of Arts.

Napoleon "Nap" Lisee was the design mastermind behind Chris Craft, Gar Wood and many of the Gold Cup winning racers of the roaring age of motor boating. He began his career working for Chris Smith and Sons but left the company to join Gar Wood between 1927 and 1928 with the task to oversee both racing and production boats. Lisee is credited with more than 30 of the world's finest race boats, including all Miss Americas and Miss Detroits and many Baby Gars, Baby Americas and Gar Jrs.

Napoleon „Nap" Lisee war das Designgenie bei Chris Craft, Gar Wood und vielen anderen Gewinnern des Gold-Cup-Rennens während der wildesten Zeit des Motorsports. Er begann seine Karriere bei Chris Smith and Sons, verließ diese aber, um zwischen 1927 und 1928 bei Gar Wood die Produktion von Renn- und Serienbooten zu überwachen. Lisee hat mehr als 30 der schönsten Rennboote entworfen, darunter alle Miss Americas und Miss Detroits, viele Baby Gars, Baby Americas und Gar jrs.

Napoleon «Nap» Lisee était le styliste de génie de Chris Craft, Gar Wood et de nombreux autres gagnants de la Gold Cup à l'époque la plus sauvage des sports motorisés. Il débuta sa carrière chez Chris Smith and Sons qu'il quitta pour aller surveiller la production de bateaux de course et de série, entre 1927 et 1928, chez Gar Wood. Lisee a créé plus de 30 des plus beaux bateaux de course, parmi eux tous les Miss America et Miss Detroit, de nombreux Baby Gar, Baby America et Gar jrs.

Napoleon "Nap" Lisee fue el genio diseñador de Chris Craft, Gar Wood y muchos otros ganadores de la competencia Gold Cup durante los tiempos más intensos del deporte del motor. Él comenzó su carrera en Chris Smith and Sons, abandonó esta sin embargo, para supervisar entre 1927 y 1928 en Gar Wood la producción de botes de serie y de competición. Lisee ha desarrollado más de 30 de las más bellas embarcaciones de competición, entre ellas Miss America y Miss Detroit, muchas Baby Gar, Baby America y Gar jr.

Napoleone "Nap" Lisee è la mente progettuale alla base del successo di Chris Craft, Gar Wood e molti dei Racer che hanno vinto la Gold Cup. Comincia la sua carriera lavorando per Chris Smith and Sons, che abbandona per seguire Gar Wood tra il 1927 ed il 1928 con il compito di supervisionare sia la produzione di barche da corsa che quelle di produzione. Lisee è accreditato con piú di 30 dei migliori Racer, comprese tutte le Miss America e Miss Detroit e molti Baby Gar, Baby America a Gar Jr.

373

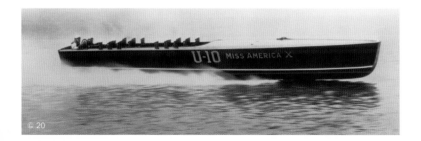

© 20

Bernard Lyman

Cabinetmaker Bernard E. Lyman turned to boatbuilding in the early 1890s, soon concentrating his production on power launches with clinker construction. Clinker suited well the big waters of lake Erie and became a Lyman trademark, being later applied to utilities, runabout and cruisers. At Bernard's death in 1934 son Bill took over, introducing the famous Islander range. Lyman Boat Works remained faithful to his design principles—like the windshield with wooden frame—and to clinker style, which was eventually updated with laminated wood. The company resisted the fiberglass attraction down to the very end of the yard in the 70s.

Der Tischler Bernard E. Lyman wandte sich dem Bootsbau Ende der 1890er zu und konzentrierte sich bald auf kraftvolle Modelle in Klinkerbauweise. Klinker passten gut in die weiten Wasser des Eriesees und gerieten zu Lymans Markenzeichen, das später auf Utilities, Runabouts und Cruisern angebracht wurde. Nach seinem Tod 1934 übernahm Sohn Bill, der die berühmte Islander-Reihe einführte. Die Lyman Boat Works blieben seinen Designprinzipien treu, so z. B. mit der Frontscheibe mit Holzrahmen und dem Klinkerstil, der durch laminiertes Holz aufgefrischt wurde. Die Firma widerstand bis zum Ende der 70er (das denn auch ihr eigenes war) dem Glasfasertrend.

L'ébéniste Bernard E. Lyman se tourna vers la construction de bateaux à la fin des années 1890, et se concentra rapidement sur des modèles puissants de construction à chevauchement. Les coques à chevauchement étaient bien adaptées aux vastes eaux du lac Erié et devinrent l'image de marque de Lyman, qui plus tard furent adaptées aux Utilities, Runabouts et Cruisers. Après sa mort en 1934, son fils Bill prit le relais et développa la gamme célèbre des Islander. La Societé Lyman Boat Works resta fidèle à ses principes, ainsi par exemple le pare-brise à cadre de bois et le style à chevauchement qui a été rajeuni par l'utilisation de bois laminé. La société a résisté jusqu'à la fin des années 70 (dont ils avaient la propriété) à la tendance des fibres de verre.

El carpintero Bernard E. Lyman se inclinó por la construcción de embarcaciones a fines de 1890 y se concentró rápidamente en modelos potentes de modo de construcción de tingladillo. Los tingladillos se adaptaban bien en las amplias aguas del lago Erie y se convirtieron en la marca registrada de Lyman, que más tarde se aplicó a Utilities, Runabouts y Cruisers. Tras su fallecimiento en 1934 su hijo Bill, asumió a quien introdujo de famosa serie Islander. La Lyman Boat Works permaneció fiel a sus principios de diseño, de manera que p.ej. con el cristal delantero con marco de madera y el estilo tingladillo, que fue renovado mediante madera laminada. La firma resistió hasta fines de los años 70 la tendencia a la fibra de vidrio (que entonces también se hizo propia).

Di professione mobiliere, Bernard E. Lyman si dedica alla nautica nei primi anni del 1890, concentrandosi subito sulla produzione di lance col sistema a clinker, che ben si adatta alle acque mosse del lago Erie e diventa il marchio di fabbrica di Lyman, essendo applicato sui suoi Utility, Cruiser e perfino Runabout. Alla morte die Bernard gli succede nel 1934 il figlio Bill, a cui si deve la fortunata serie Islander. Lyman Boat Works rimane fedele ai suoi principi di design – tra cui il parabrezza dallo spesso profilo in legno – ad alla costruzione a clinker – che si evolve poi con l'uso di laminato invece del legno massello. Resistendo alla tentazione della vetroresina fino all'ultimo, la Lyman chiude i battenti negli anni 70.

374

© 18

© 18

Arnold William MacKerer tried it hard in at least ten boatyards until he finally got a job at Chris Craft in 1922, where he became known as Bill, Mac or later "the Boss". To the world outside he simply was "Mr. Chris Craft". Except for a short break due to a disagreement with Nap Lisee, he would work for the company until 1965, starting as a designer, taking gradually control of production—which he straightened up according to Taylor's principles—and retiring as their vice president. He is the acknowledged driving force behind Chris Craft's success, de facto leading the company from the Cadet runabout range down to the fiberglass era, his last project being the 1964 38' Commander Express.

Arnold William MacKerer klopfte bei wenigstens zehn Werften an, bis er 1922 schließlich einen Job bei Chris Craft bekam, wo er als Bill, Mac oder später als „Der Chef" bekannt war. Für die Außenwelt hieß er schlicht „Mr. Chris Craft". Außer einer kleinen Unterbrechung wegen Streitigkeiten mit Nap Lisee arbeitete er dort bis 1965. Zuerst war er Designer, übernahm dann allmählich die Produktionskontrolle – die er nach Taylors Prinzipien verschlankte – und ging als Vizepräsident in Rente. Er ist die anerkannte Kraft hinter Chris Crafts Erfolg und führte das Unternehmen de facto von der Cadet Runabout-Reihe in die Glasfaser-Àra. Sein letztes Projekt war der 38' Commander Express von 1964.

Arnold William MacKerer a frappé à la porte d'au moins dix chantiers navals, avant de trouver finalement un travail, en 1922, chez Chris Craft, où il fut connu sous les noms de Bill, Mac ou plus tard «Le chef». Pour le monde extérieur il s'appelait tout simplement «M. Chris Craft». En dehors d'une petite interruption en raison d'un différent avec Nap Lisee, il travailla là jusqu'en 1965. En premier il travailla comme styliste, puis progressivement il passa au contrôle de la production – qu'il amincit selon les principes du taylorisme – et partit à la retraite en tant que vice président. Il est la force reconnue derrière le succès de Chris Craft et dirigea de facto l'entreprise depuis la gamme Cadet runabout dans l'ère des fibres de verre. Son dernier projet fut le Commander Express de 38' en 1964.

Arnold William MacKerer llamó a la puerta de por lo menos 10 artilleros, hasta que en 1922 consiguió finalmente un empleo en Chris Craft, donde fue conocido como Bill, Mac o más tarde "el jefe". Para el mundo exterior se llamaba sencillamente "Mr. Chris Craft". Exceptuando una pequeña interrupción debido a entredichos con Nap Lisee, él trabajó allí hasta 1965. Primero fue diseñador, asumió entonces paso a paso el control de la producción –que refinó de acuerdo a los principios de Taylor– y se jubiló como vicepresidente. El es la fuerza conocida detrás del éxito de Chris Craf y condujo la empresa de hecho desde la serie Runabout Cadet a la era de la fibra de vidrio. Su último proyecto fue el Commander Express de 38' de 1964.

Arnold William MacKerer tenta la fortuna in almeno dieci cantieri prima di trovare lavoro alla Chris Craft nel 1922, dove lo chiamano Bill, Mac o piú tardi, Boss. Nel resto del mondo egli é semplicemente noto come "Mr. Chris Craft". Eccezione fatta per una breve interruzione dovuta a dissapori con Nap Lisee, Mac lavora alla Chris Craft fino al 1965, cominciando come progettista, prendendo gradualmente controllo della produzione – che egli organizza secondo i prinicpi tayloristici – e diventandone infine vicepresidente. É la forza riconosciuta dietro il successo industriale della Chris Craft, di fatto guidando l'azienda dal primo Runabout Cadet fino al passaggio alla vetroresina. Il suo ultimo progetto è il Commander Express 38' del 1964.

375

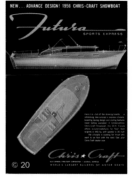

376

Dedicating their life to outboard raceboats, the lake Como based Molinaris—father Angelo and son Renato—have been both designers and professional racers. They are considered among the driving forces of both the OPC Throphy and of the 80s F1 boat racing, with Renato an unbeaten 11 times world champion. Back in the 60s, their tunnel-hull designed was so performing and Angelo's fame so high, that Carlson signed an agreement to produce Molinari's outboards in the US. (Seen here is a 2+2 version of the early 70s).

Die Molinaris vom Comer See – Vater Angelo und Sohn Renato – waren sowohl Designer als auch professionelle Rennfahrer, die ihr Leben den Außenbordern widmeten. Sie werden als treibende Kraft hinter der OPC Trophy und den F1 Bootsrennen der 80er gesehen, mit Renato als ungeschlagenem elfmaligen Weltmeister. In den 60ern war ihr Tunnelrumpf so leistungsstark und Angelos Ruhm so groß, dass Carlson einen Vertrag zur Produktion ihrer Außenborder in den USA unterzeichnete. (Dies hier ist eine 2+2-Version aus den frühen 70ern).

Le Molinari du lac de Côme – le père Angelo et le fils Renato – étaient aussi bien stylistes que pilotes de course professionnels qui ont consacré leur vie aux hors-bord. Ils sont considérés comme les force agissantes derrière le trophée OPC et les courses de bateaux de F1 des années 80, avec Renato 11 fois champion du monde encore invaincu. Dans les années 60 leur coque à tunnel était si performante et la gloire d'Angelo si importante, que Carlson signa un contrat pour la construction aux USA de leurs hors-bord. (On voit ici une version 2+2 du début des années 70).

Los Molinari del lago Comer –padre Angelo e hijo Renato– fueron tanto diseñadores como también profesionales de competición, que dedicaron su vida a los fuera de borda. Ellos son vistos como la fuerza impulsora detrás del OPC Trophy y la competiciones de embarcaciones F1 de los años 80, con Renato como imbatible campeón mundial en once oportunidades. En los años 60 su casco de túnel era tan potente y la fama de Angelo tan grande, que Carlson firmó un contrato para la producción de sus fuera de borda en los EE.UU. (Esta aquí es una versión 2+2 de los comienzos de los años 70).

8Dedicando la loro vita alle gare fuoribordo, padre Angelo e figlio Renato Molinari sono sia designer che piloti professionisti. Sono considerati la forza trainante del Trofeo OPC e della Formula 1 nautica, con Renato che vanta un record imbattuto di 11 titoli mondiali. Negli anni 60, la carena a tunnel e la fama di Angelo Molinari sono cosí irresistibili che la Carlson firma un accordo di produzione negli USA di barche su design Molinari. (Qui si vede una versione 2+2 degi primi anni 70).

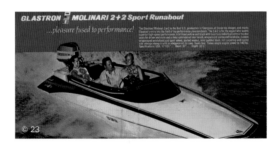

GLASTRON MOLINARI 2+2 Sport Runabout
...pleasure fused to performance!

© 23

The well known gentleman racer —and 1999 Daytona 24 hours winner—Gianpiero Moretti is not only linked to the boating industry through his sporty Momo steering wheels, which have been equipping luxury cars as well es hi-end motorboats since the 60s. A design oriented entrepreneur, boating enthusiast and the former owner of the Cantieri Baglietto, with his own boat and yacht projects Dr. Moretti has over time inspired design innovation. (Seen here is his fine Momo Design Open of the 80s).

Gianpiero Moretti, bekannter Gentleman unter den Rennfahrern und Gewinner von unter anderem der Daytona 24 Hours 1999, steht nicht nur mit dem Motorsport in Verbindung – seine Momo-Lenkräder wurden in Luxusautos wie -booten eingesetzt. Als designorientierter Unternehmer, Bootsenthusiast und ehemaliger Besitzer der Cantieri Baglietto hat Moretti über Jahre hinweg, direkt oder indirekt, Innovationen im Bootdesign vorangetrieben. (Dies hier ist die feine Momo Design Open aus den 80ern).

Le nom de Gianpiero Moretti, un gentleman parmi les pilotes de course et vainqueur des 24 heures de Daytona, n'est pas uniquement connu en relation avec les sports motorisés – ses volants Momo ont été montés dans les automobiles comme dans les bateaux de luxe. En tant qu'entrepreneur orienté sur le design, passionné de bateaux et ancien propriétaire de la Cantieri Baglietto, a fait progressé au cours des années, directement ou indirectement, l'innovation en matière de stylisme pour les bateaux. (On voit ici le Momo Design Open des années 80).

Gianpiero Moretti, el caballero entre los corredores y ganador de las 24 horas de Daytona, no sólo está ligado al deporte del motor –sus volantes Momo fueron instalados en automóviles de lujo así como embarcaciones. Como empresario orientado en el diseño, entusiasta de las embarcaciones y antiguo propietario de Cantieri Baglietto, Moretti ha promovido a través de los años, directa o indirectamente, innovaciones en el diseño de embarcaciones. (Esta aquí es el Momo Design Open de los años 80).

Gentlemen driver da sempre e vincitore tra l'altro della 24 di Daytona nel 1999, Gianpiero Moretti non é legato alla nautica solo attraverso i suoi volanti sportivi Momo, che dagli anni 60 equipaggiano sia auto che barche di prestigio. Industriale con un infallibile senso per il design, grande appassionato di barche e giá proprietario dei Cantieri Baglietto, Moretti ha al suo attivo progetti innovativi nel campo della nautica, che continuano a fare tendenza. Come il suo Momo Design Open degli anni 80.

377

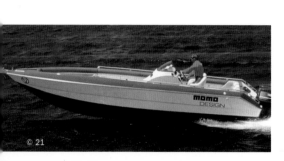

© 21

© 22

Don Mortrude

A fan of streamlining, Donald Mortrude may not have been the most famous of US designers, still he worked as a freelance on one of the most striking prewar automobiles, the Nash Airflyte of the early 40s. During the war he published numerous futuristic ideas in Motor Boating, among them an aerodynamic "bull nose" which must have caught the attention of Chris Craft, for whom he would be occasionally consulting. Though interesting, Mortrudes attempt to "cast" wood into softer and rounded surfaces did not meet everybody's taste. His innovations —including the Cobra's fin—gradually faded out by the end of the 50s, as Chris Craft's design would become sleeker and somehow more conservative. Motrude himself would later contribute to the design of Chrysler boats.

Donald Mortrude, ein Fan der Stromlinie, war vielleicht keiner der bekanntesten US-Designer. Als Freier arbeitete er jedoch an einem der wichtigsten Vorkriegsautos mit, dem Nash Airflyte der frühen 40er. Während des Krieges veröffentlichte er zahlreiche futuristische Ideen für Motorboote. Darunter war auch eine aerodynamische „Bullennase", die Chris Crafts Aufmerksamkeit auf sich zog, so dass er beratend für sie tätig wurde. Obwohl interessant, traf Mortrudes Versuch, Holz in weicheren und runden Oberflächen einzusetzen, nicht jedermanns Geschmack. Seine Inno-

vationen wie die Flosse der Cobra verschwanden bis zum Ende der 50er, als Chris Crafts Design schlanker und auch konservativer wurde. Er selbst designte weiterhin für Chrysler.

Donald Mortrude, un fanatique des lignes fluides, il ne fut peut-être pas l'un des stylistes américains les plus connus. Il travailla toutefois en indépendant sur l'une des automobiles les plus importantes de l'avant-guerre, la Nash Airflyte du début des années 40. Pendant la guerre il publie un grand nombre d'idées futuristes de bateaux à moteur. Parmi elles également un «bull nose» aérodynamique qui retint l'attention de Chris Craft, de telle sorte qu'il devint un de leur conseillers. Malgré l'aspect intéressant, la tentative de Mortrude d'introduire du bois dans les surfaces arrondies et plus douces, ne rencontra pas le goût de tout un chacun. Ses innovations comme l'aileron de la Cobra disparurent jusqu'à la fin des années 50, lorsque le design de Chris Craft devint plus aminci et plus conservateur.

Donald Mortrude, un aficionado de la línea aerodinámica, quizás no haya sido uno de los más conocidos diseñadores americanos. Como autónomo sin embargo, trabajó en uno de los autos de preguerra más importantes, el Nash Airflyte de comienzos de los años 40. Durante

la guerra publicó una serie de ideas futuristas para embarcaciones a motor. Entre ellas estaba también una "bull nose" aerodinámica, que llamó la atención de Chris Craft, de manera que se convirtió en asesor para ellos. Si bien interesante, el intento de Mortrude de emplear madera en superficies más blandas y redondas, no acertó en el gusto de todos. Sus innovaciones como la aleta del Cobra desaparecieron hasta fines de los años 50, cuando el diseño Chris Craft se tornó más esbelto y también más conservador.

Un seguace dello streamline, Donald Mortrude non è passato alla storia tra i piú grandi del design americano, eppure ha lavorato ad alcuni dei progetti piú significativi dell'anteguerra, come la Nash Airflyte dei primi anni 40. Durante la guerra pubblica numerose idee futuristiche sulla rivista Motor Boating, fra di esse un "bull nose" aerodinamico che attira l'attenzione di Chris Craft, per la quale ha spesso occasione di lavorare. Per quanto interessanti, i suoi tentativi di modellare il legno in forme morbide ed arrotondate non sempre incontrano il gusto del pubblico e sono difficili da realizzare. Le sue innovazioni – ivi inclusa la pinna del Cobra – scompaiono gradualmente verso la fine degli anni 50, quando il design Chris Craft diventa piú tranquillo e tradizionalista.

378

© 23

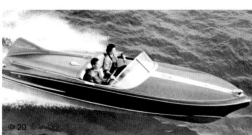
© 20

In 1959 **Connie Ray** bought a small Detroit company whose main asset – beside a 17' runabout mould – was Jerry Michalak, one of the fathers of fiberglass construction. C. Ray changed the company name into Sea Ray (get it?) and in the early 60s he called in Harley Earl, probably the most influential US designer, as a consultant. The three immediately saw the need to adopt Hunt's deep-V hull, which happened in 1966 with the 230 runabout. Together with the 240 weekender of 1971, this boat set the company out to become today's largest manufacturer worldwide.

1959 kaufte Connie Ray eine kleine Detroiter Firma, deren Kapital neben einer 17'-Form für einen Runabout vor allem aus Jerry Michalak bestand, einem der Väter der Glasfaserkonstruktion. C. Ray änderte den Firmennamen in Sea Ray (ecco) und engagierte in den 60ern den wohl einflussreichsten US-Designer Harley Earl als Berater. Die drei erkannten sofort, dass man Hunts Deep-V Rumpf adaptieren musste, was dann auch 1966 mit dem 230 Runabout geschah. Zusammen mit dem 240 Weekender von 1971 machte dieses Boot die Firma zur derzeit größten auf der Welt.

En 1959 **Connie Ray** achetait une petite entreprise de Detroit dont le capital, en dehors d'un modèle de 17' pour un Runabout, était constitué essentiellement de Jerry Michalak, l'un des pères de la construction en fibres de verre. C. Ray modifia le nom de la société en Sea Ray (ecco) et engagea dans les années 60 le styliste américain dont l'influence était la plus grande Harley Earl en tant que conseiller. Les trois partenaires ont tout de suite vu l'importance d'adapter la coque Deep-V de Hunt, ce qui se produisit en 1966 avec le 230 Runabout. Ensemble avec le 240 Weekender de 1971, ce bateau fit de la société la plus grande au monde à cette époque.

En 1959 **Connie Ray** adquirió una pequeña empresa en Detroit, cuyo capital, junto a un molde de 17' para un Runabout ante todo provenía de Jerry Michalak, uno de los padres de la construcción de fibra de vidrio. C. Ray cambió el nombre de la empresa en Sea Ray (ecco) y contrató en los años 60 al probablemente el diseñador americano más influyente Harley Earl como asesor. Los tres reconocieron inmediatamente que debían adaptar el casco Deep-V de Hunt, lo que también se produjo en 1966 con el 230 Runabout . Junto con el 240 Weekender de 1971 esta embarcación llevó a la empresa a ser en este momento la mayor del mundo.

Nel 1959 **Connie Ray** compra un piccolo cantiere di Detroit il cui unico pregio – oltre allo stampo per un Runabout di 17 piedi – si chiama Jerry Michalak, uno dei padri delle costruzioni in vetroresina. C.Ray cambia il nome in Sea Ray (semplice, no?) e, negli anni 60, chiama Harley Earl, probabilmente il designer americano più influente, come consulente. I tre si mettono all'opera per realizzare una barca con carena a V profonda, il 230 Runabout del 1966. Insieme al 240 Weekender del 1971, questi progetti avviano la Sea Ray sulla strada del successo. L'azienda è oggi il più grande produttore al mondo.

379

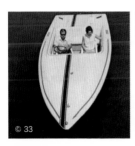

© 33

© 33

380

A lot has been written about the genius of Carlo Riva, a man who between 1950 and 1971 was to transform his father Serafino's yard by the small lake Iseo into the finest of all boat brands. Fascinated by Chris Craft, Carlo got to know their production systems and started importing their engines to Italy. His quest for total quality has become legendary, the style of his wooden boats—down to the smallest detail—unsurpassed. What is most striking though, is his visionary understanding for branding, both as product quality and as image and experience. Not only were his boats constructed to be eternal—which accounts for the high number of survivors. To attract customers, he designed sales catalogues that looked like artwork and opened showrooms downtown Milan and New York. To keep customers happy, he started an international network of conveniently based dealers and service units: Monaco, St. Tropez and the likes. Largely inspired by US classic designs, Riva wooden boats never revolutionized the market, but they certainly have been the most perfect interpretation of the finest of all boats: the runabout. Carlo sold Riva when social problems were making it too hard to run a luxury manufacturing business. He left in time to see Riva's first fiberglass boats, themselves outstanding designs, entering production. Through his Yacht Corporation and his Rapallo harbor, he remains a presence in the boating business. And the Riva legend lives on.

Es wurde viel geschrieben über das Genie von Carlo Riva, der zwischen 1950 und 1971 die Werft seines Vaters Serafino am See Iseo zur erlesensten Marke unter den Booten machte. Fasziniert von Chris Craft, eignete sich Carlo ihr Produktionssystem an und importierte ihre Motoren nach Italien. Seine Suche nach perfekter Qualität ist legendär und der Stil seiner Boote bis ins kleinste Detail unübertroffen. Was aber am meisten auffällt, ist sein Verständnis für Branding, sowohl hinsichtlich Produktqualität, als auch im Sinne von Image und Erlebnis. Seine Boote waren nicht nur für die Ewigkeit gemacht (was sich an der hohen Zahl der Überlebenden zeigte). Er gestaltete auch Verkaufskataloge, die wie Kunstwerke aussahen und eröffnete Showrooms in den Herzen Mailands und New Yorks. Um die Kundschaft bei Laune zu halten, spannte er ein internationales Netzwerk von gut gelegenen Händlern und Werkstätten auf: in Monaco, St. Tropez u.v.m. Da stark vom klassisch-amerikanischen Design inspiriert, revolutionierten Rivas Holzboote zwar nie den Markt, boten aber die beste Version des schönsten aller Schiffstypen: dem Runabout. Carlo verkaufte Riva als große soziale Probleme die Fortsetzung des Luxusgeschäfts allzu schwierig machten. Er ging rechtzeitig und sah, wie die ebenfalls schönen Glasfaserboote in Produktion gingen. Wegen seiner Yachtfirma und des Rapallo-Hafens bleibt er aber präsent. Die Legende Riva lebt weiter.

© 31

On a beaucoup écrit sur le génie de Carlo Riva qui entre 1950 et 1971 qui fit du chantier naval de son père Serafino, sur les bords du lac de Iseo, une des marques les plus nobles parmi les entreprises navales. Fasciné par Chris Craft, Carlo intégra leur système de production et importa leurs moteurs vers l'Italie. Sa recherche de la qualité absolue est exemplaire et le style de ses bateaux jusque dans le moindre détail reste inégalé. Ce qui pourtant se détache le plus, c'est sa compréhension de la marque, aussi bien dans le sens de la qualité que dans le sens de l'image de marque et du vécu. Ses bateaux n'étaient pas seulement fabriqués pour l'éternité (ce qui est prouvé par le grand nombre des rescapés). Il réalisait également des catalogues qui étaient de vrais petits chef-d'oeuvre, et il ouvrit des salons d'exposition au coeur de Milan et de New York. Afin de fidéliser sa clientèle, il tissa un réseau international de concessionnaires et d'ateliers bien situés : à Monaco, St. Tropez, et bien d'autres lieux. Etant fortement inspirés du design américain classique, les bateaux de Riva ne révolutionnèrent jamais le marché mais ils offraient les meilleures versions du plus beau type de bateaux : le Runabout. Carlo vendit Riva, car de grands problèmes sociaux apportaient de grandes difficultés dans la continuation de ce commerce de luxe. Il se retira à temps, et pu observer les beaux navires en fibres de verre arriver en production. En raison de sa société de yachts et du port de Rapallo il reste présent. La légende Riva continue de vivre.

Mucho se ha escrito sobre el genio de Carlo Riva, que entre 1950 y 1971 llevó al astillero de su padre Serafino en el lago Iseo a la marca más exclusiva entre las embarcaciones. Fascinado por Chris Craft, Carlo se agenció de sus sistema de producción e importó sus motores a Italia. Su búsqueda de la perfecta calidad es legendaria y el estilo de sus embarcaciones insuperable hasta en los mínimos detalles. Lo que sin embargo le llama la atención a la mayoría, son sus conocimientos sobre Branding, tanto con relación a la calidad de producto, como también en el sentido de la imagen y la vivencia. Sus embarcaciones no sólo fueron hechas para la eternidad (lo que se demuestra por la elevada cantidad de sobrevivientes). Él también concebía los catálogos de ventas, que parecían obras de arte y abrió Showrooms en el centro de Milán y Nueva York. Para mantener el interés de la clientela, montó una red internacional de revendedores y talleres bien ubicados: en Mónaco, St. Tropez y muchos más. Debido a que estaba inspirado intensamente en el diseño americano clásico, si bien las embarcaciones de madera de Riva nunca revolucionaron el mercado, sin embargo ofrecían la mejor versión de los más bellos de todos los tipos de embarcaciones: el Runabout. Carlo vendió Riva cuando grandes problemas sociales tornaron demasiado difícil la continuidad de los negocios de lujo. El se fue a tiempo y vio como asimismo entraban en producción bellas embarcaciones de fibra de vidrio. Sin embargo él permanece presente debido a su empresa de yates y al puerto de Rapallo. La leyenda Riva continúa viva.

Fra il 1950 ed il 1971, il genio imprenditoriale di Carlo Riva trasforma il cantiere di papà Serafino sul piccolo lago d'Iseo nel piú raffinato marchio della nautica mondiale. Affascinato dal colosso Chris Craft, Carlo ne osserva attentamente i prodotti e i sistemi di produzione e ne importa i motori in Italia. La sua ricerca della qualitá totale é leggendaria, lo stile dei suoi motoscafi in legno – fin nell'ultimo dettaglio – insorpassato. L'aspetto piú importante peró, é la sua concezione, visionaria per i tempi, di un branding che si estende dal prodotto all'immagine all'esperienza. Non solo produce le sue barche per durare un'eternitá – il che spiega l'elevato numero di esemplari esistenti. Per invogliare i clienti, realizza cataloghi che sembrano opere d'arte e apre showroom al Rockefeller Center e nel centro di Milano e per mantenerli felici apre una serie di centri di vendita ed assistenza nei posti giusti: Gardone Riviera, Monaco, St.Tropez… Largamente ispirati ai classici modelli americani, i motoscafi di Carlo Riva non rivoluzionano ma semmai portano il concetto di Runabout alla perfezione estetica e funzionale. Carlo vende l'azienda in un momento in cui problemi sociali rendono difficile la gestione di una fabbrica di lusso, ma in tempo per vedere le prime barche in vetroresina, anch'esse destinate a diventare dei classici, uscire dai cantieri. Attraverso la Carlo Riva Yacht Corporation ed il suo porto di Rapallo, egli rimane una presenta costante nel mondo della nautica. E la leggenda continua.

What would have come out of motor boating without Christopher Columbus Smith? The Algonac based young boy saw the birth of motor boating, mated with Gar Wood, Nap Lisee and the likes to contribute to the Gold Cup, followed Ford's principles to introduce mass production systems for standardized runabouts, sold boats on credit and kit boats. Doing so he succeeded into making motor boating popular. When he died in 1939, the name Chris Craft stood overall for leisure motorboats, his company being by far the world's largest manufacturer—a Ford without General Motors to compete with. This was probably the major drawback in the company's strategy. Content with their leadership role, Chris's grandson Harsen expanded the wooden range beyond imagination, new names being so inspiring as Freedom Fleet or Futura. Attempts like the Cobra and the Silver Arrow, with their automobile style, did not really suit fine wooden boats. In fact, one may think that the Smiths misjudged the upcoming fiberglass revolution. Truth is that the conversion of Chris Craft to fiberglass would have been a major investment and risk. As early as 1960, the family preferred to sell to National Automotive Fibers Inc. Fiberglass was introduced, not without success. Although by 1972 the 100 000th boat was built, Chris Craft were way behind their previous leadership. Operations were to be closed down in the 80s, but the brand's appeal never really ceased to be. Chris Craft revives now in the hands of Stephen Julius, former owner of Cantieri Riva.

Was wäre aus Motorbooten geworden ohne Christopher Columbus Smith? Der Junge aus Algonac sah die Geburt der Motorboote und tat sich mit Gar Wood, Nap Lisee und anderen zusammen, um dem Gold Cup auf die Sprünge zu helfen. Gemäß Fords Philosophie der Massenproduktion führte er Serien-Runabouts ein, verkaufte Boote auf Kredit und sogar zum Selberbauen: er schaffte es, Motorboote populär zu machen. Als Smith 1939 starb, stand der Name Chris Craft als Synonym für Freizeitboote, deren weltweit größter Hersteller sie waren. Wie Ford in der Automobilbranche – jedoch ohne einen Konkurrenten wie GM, was vielleicht der Anfang vom Ende war. Zufrieden mit der Marktführerschaft, erweiterte Smiths Enkel Harsen die Holzserie mit neuen Booten wie der Freedom Fleet oder der Futura ins Unvorstellbare. An Autos angelehnte Versuche wie die Cobra oder der Silver Arrow passten aber nicht wirklich zu den feinen Booten aus Holz. Tatsächlich mag man davon ausgehen, dass die Smiths die sich anbahnende Glasfaserrevolution falsch einschätzten. Die Umstellung auf Fiberglas wäre eine große Investition und ein hohes Risiko gewesen. Statt dieses einzugehen, verkaufte die Familie ihre National Automotive Fiberglas Inc. schon in den frühen 60ern. Obwohl bis 1972 100.000. Boot gebaut war, fielen Chris Craft auf dem Markt weit zurück. 1980 wurde das Geschäft eingestellt, doch der Reiz der Marke hält nach wie vor an. Stephen Julius, vormaliger Besitzer von Cantieri Riva, unternimmt derzeit Revitalisierungsversuche.

383

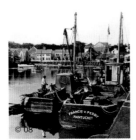

© 08

384

Que seraient devenus les bateaux à moteur sans Christopher Columbus Smith ? Le jeune d'Algonac assista à la naissance des bateaux à moteur et s'associa à Gar Wood, Nap Lisee et d'autres, pour faire vivre la Gold Cup. Conformément à la philosophie de Ford de la production de masse il produisit des runabouts de série, vendit des bateaux à crédit et même à construire soi-même : il arriva à rendre populaire le bateau à moteur. Quand Smith décéda en 1939, le nom de Chris Craft était devenu synonyme de bateaux de loisir dont ils étaient les plus grands constructeurs mondiaux. Comme Ford dans le secteur automobile – toutefois sans un concurrent comme GM, ce qui peut-être a signifié le début de la fin. Satisfait de son leadership sur le marché, le petit fils de Smith, Harsen poursuivit et agrandit la gamme de bateaux en bois comme le Freedom Fleet ou le Futura jusqu'à l'extrême. Les études basées sur les automobiles comme le Cobra ou la Silver Arrow n'harmonisaient pas vraiment avec les fins bateaux en bois. En réalité on peut supposer que les Smith n'ont pas reconnu l'importance de la révolution apportée par les fibres de verre. La conversion vers les fibres de verre réclamait de gros investissements et la prise de grands risques. Au lieu de s'y engager, la famille revendit sa société National Automotive Fiberglas Inc. précocement dans les années 60. Malgré, en 1972 la construction du 100.000me bateau, Chris Craft recula très loin sur le marché. En 1980 le commerce s'arrêta, mais l'engouement pour la marque est resté. Stephen Julius, anciennement propriétaire de Cantieri Riva, entreprend actuellement une tentative de revitalisation.

¿Qué sería de las embarcaciones a motor sin Christopher Columbus Smith? El joven de Algonac vivió el nacimiento de las embarcaciones a motor y se asoció con Gar Wood, Nap Lisee y otros, para ayudar en la concreción de la Gold Cup. Él introdujo el Runabouts de serie, de acuerdo a la filosofía de Ford de la producción masiva, vendió embarcaciones a crédito e incluso para aficionados del bricolaje: él es el que logró hacer populares las embarcaciones a motor. Cuando Smith fallece en 1939, el nombre Chris Craft figuraba como sinónimo de embarcaciones de tiempo libre, de los que ellos eran los mayores fabricantes del mundo. Como Ford en el ramo automotriz —sin embargo sin un competidor como GM, lo que fue quizás el principio del fin. Conforme con el liderazgo de mercado, el nieto de Smith Harsen expandió la serie de madera con ampliaciones como el Freedom Fleet o el Futura hasta lo inimaginable. Ensayos basados en el automóvil como el Cobra o el Silver Arrow sin embargo no se adecuaban verdaderamente a las finas embarcaciones de madera. Efectivamente parte de allí, que los Smith evaluaron erróneamente la revolución de la fibra de vidrio que se avecinaba. La conversión a fibra de vidrio hubiese supuesto una gran inversión y un elevado riesgo. En lugar de abordarlo, la familia vendió su National Automotive Fiberglas Inc. ya en los comienzos de los años 60. Si bien hasta 1972 había sido construida la embarcación 100.000, Chris Craft retrocedió ampliamente en el mercado. En 1980 fueron cesados los negocios, sin embargo la atracción de la marca se mantiene hasta hoy. Stephen Julius, antiguo propietario de Cantieri Riva, realiza en este momento intentos de revitalización.

Il mondo della nautica non sarebbe lo stesso senza Christopher Columbus Smith. Il giovanotto di Algonac assiste alla nascita dei primi motoscafi, contribuisce assieme a Gar Wood e Nap Lisee al successo della Gold Cup, segue i principi di Ford per introdurre la produzione standardizzata seriale per i Runabout, vende barche a rate e persino in scatola di montaggio pur di aumentarne la popolaritá. Quando muore nel 1939, il nome Chris Craft viene comunemente usato per indicare i motoscafi e la sua azienda e di gran lunga il piú grande produttore al mondo – una Ford senza General Motors con cui competere. Questo é probabilmente anche il suo punto debole. Soddisfatto del proprio ruolo di leader, il nipote Harsen espande la flotta oltre l'immaginabile, con progetti di grande portata come la Freedom Fleet del 1955 o lo show-boat Futura. Tentativi di ammodernarsi falsificano la natura del prodotto come con il Cobra e il Silver Arrow in stile automobilstico non fanno peró bene all'immagine del cantiere. In realtá sarebbe sbagliato pensare che gli Smith abbiano sottovalutato la rivoluzione della vetroresina, semmai se hanno previsto gli effetti sconvolgenti su una fabbrica fortemente legata, anche produttivamente, al legno. Nel 1960 la famiglia vende alla National Automotive Fibers Inc. e Chris Craft si lancia, non senza successo, nella vetroresina. Anche se nel 1972 la centomillesima barca viene prodotta, il cantiere perde la sua leadership. Lentamente, la forza motrice di Chris Craft si spegne negli anni 80 per rivivere ora una nuova giovinezza nelle mani di Stephen Julius, che é giá stato a capo della Riva.

386

An architect, designer and professor at the University of Florence, Pierluigi Spadolini (1922–2000) can hardly be remembered for his achievements in the boating industry alone. While his architectural projects translated the complexity of classical styles, his industrial designs were rather innovative and—to say so—modern. Among them the legendary Akhir 18 for Cantieri di Pisa, back to 1972 a radical cut with formal tradition. Its wedge shape, tense geometrical lines and strong black & white graphic touch constitute a recognized trademark. As the only drawback, its less-good imitators led the way to flat-iron design of the 70s and 80s. Son Tommaso Spadolini and former scholar Francesco Paszkowski have carried on his design legacy.

An Pierluigi Spadolini (1922–2000), Architekt, Designer und Professor an der Universität von Florenz, wird man sich kaum nur wegen seiner Verdienste im Bootsbereich erinnern. Während seine Architektur-Projekte die Komplexität klassischer Stile übersetzten, war sein Industriedesign innovativer und moderner – so z. B. seine legendäre Akhir 18 für Cantieri di Pisa, die 1972 einen radikalen Bruch mit der formalen Tradition darstellte. Ihre Keilform, die spannungsvollen geometrischen Linien sowie der drastische Schwarzweiß-Einschlag bildeten ein Markenzeichen. Einziger Nachteil war, dass die weniger talentierten Imitatoren von dort zum Bügeleisendesign der 70er und 80er kamen. Sohn Tommaso und der frühere Schüler Francesco Paszkowski führen das Erbe fort.

On se souviendra très peu de Pierluigi Spadolini (1922–2000), en tant qu'architecte, styliste et professeur à l'université de Florence, mais beaucoup plus pour ses apports dans le domaine des bateaux. Alors que ses projets d'architecture traduisent la complexité des styles classiques, son design industriel, lui, était innovant et moderne – ainsi par exemple son légendaire Akhir 18, pour Cantieri di Pisa, qui en 1972 représentait une véritable rupture avec les formes traditionnelles. Sa forme anguleuse, les lignes géométriques pleines de tension ainsi qu'un noir et blanc drastique ont contribué à en faire une image de marque. Le seul désavantage fut que de pales imitateurs, moins talentueux, sont passés ainsi au style fer à repasser des années 70 à 80. Son fils Tommaso et son ancien élève Francesco Paszkowski poursuivent son oeuvre.

De Pierluigi Spadolini (1922–2000), arquitecto, diseñador y profesor de la Universidad de Florencia, apenas alguien se recordará por sus logros en el área de las embarcaciones. Mientras que sus proyectos de arquitectura traducían la complejidad de los estilos clásicos, fue su diseño industrial innovador y moderno –así su legendario Akhir 18 para Cantieri di Pisa, que en 1972 representó un ruptura radical con la conformación tradicional. Su forma de cuña, las líneas geométricas llenas de tensión así como la irrupción dramática del blanco y negro crearon una seña de identidad. La única desventaja era, que los menos talentosos imitadores de allí llegaron al diseño de plancha de los años 70 y 80. Su hijo Tommaso y el antiguo estudiante Francesco Paszkowski dan continuidad a la herencia.

Architetto, designer e professore all'Universitá di Firenze, Pierluigi Spadolini (1922–2000) non puó solo essere ricordato per il suo contributo nel campo della nautica. Mentre i suoi progetti di architettura interpretano tutta la complessitá degli stili classici, quelli di industrial design sono piuttosto innovativi e "moderni". Tra di essi, l'Akhir 18 per i Cantieri di Pisa, che nel 1972 rappresenta un taglio radicale con la tradizione formale. La sua linea a cuneo geometrica e la sua grafica forte giocata sul bianco e nero costituiscono da un lato un segno di riconoscimento di una serie fortunata. Dall'altro, nelle mani di imitatori poco attenti, essa ha portato allo stile "ferro da stiro" dilagante negli anni 80. La sua ereditá intellettuale prosegue nelle mani del figlio Tommaso e dell'ex-allievo Francesco Paszkowski, designer fra l'altro dei moderni Baglietto.

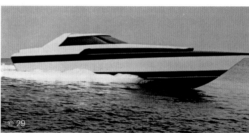

Marchese **Filippo Theodoli** and his wife Katrin moved from Italy to Miami in 1976 with a dream in mind: To manufacture a boat that would be as large as a yacht and as quick and fun to drive as runabouts had been. A boat for individuals that didn't need a crew. They took over Aronow's Magnum Marine and, after just one year, the impressive Maltese 53' was out there. One could hardly believe these large open boats were true. When Filippo suddenly died in 1990, Katrin took over. Things didn't change though: 60', 70', 80'...the Magnums and their legend grew on.

Der Marchese Filippo Theodoli und seine Frau Katrin zogen 1976 von Italien nach Miami mit einem Traum im Kopf: ein Boot für Individualisten, so groß wie eine Yacht und so schnell und angenehm zu fahren wie die alten Runabouts. Sie übernahmen Aronows Magnum Marine und nach nur einem Jahr war die eindrucksvolle Maltese 53' draußen. Man konnte kaum glauben, dass es diese offenen, großen Boote wirklich gab. Als Filippo 1990 plötzlich starb, machte Katrin weiter, ohne dass sich Grundlegendes änderte: 60', 70', 80'...die Magnums und ihre Legende wuchsen weiter.

Le Marquis Filippo Theodoli et son épouse Katrin quittèrent l'Italie en 1976 pour s'installer à Miami, avec en tête un rêve : un bateau pour individualistes, aussi grand qu'un yacht et aussi rapide et agréable à conduire que les anciens Runabouts. Ils reprirent la société d'Aronow, Magnum Marine, et après seulement une année, l'impressionnant Maltese de 53' était construit. Il était à peine croyable que ces grands bateaux ouverts existaient vraiment. Quand Filippo décéda soudainement en 1990, Katrin continua, sans changer fondamentalement de cap : 60', 70', 80'... les Magnum et leur légende continuent.

El marqués Filippo Theodoli y su esposa Katrin se mudaron en 1976 de Italia a Miami con un sueño en la cabeza: una embarcación para individualistas, tan grande como un yate y tan rápida y cómoda de conducir como los viejos Runabout. Ellos se hicieron cargo de Aronows Magnum Marine y sólo tras un año estaba fuera en imponente Maltese 53'. Apenas se podía creer, que esta embarcación grande abierta realmente existiese. Cuando Filippo 1990 sorpresivamente murió , continuó Katrin, sin modificar nada de los fundamentos: 60', 70', 80'...los Magnums y su leyenda continuaron creciendo.

Il Marchese Filippo Theodoli e sua moglie Kathrin si trasferisono dall'Italia a Miami nel 1976 con un sogno nel cassetto: costruire una barca che sia grande come uno Yacht ma facile e divertente da guidare come lo erano stati i Runabout; una barca per gente che non ha bisogno di equipaggio. Dopo aver rilevato il cantiere Magnum fondato da Aronow, i Theodoli presentano lo sbalorditivo Magnum 53': difficile credere che questa nave in forma di motoscafo sia vera! Quando Filippo muore improvvisamente nel 1990, la moglie Kathrin prende il timone e i Magnum continuano a crescere, fino a 80 piedi e nelle mani di Pininfarina.

387

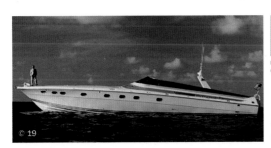

© 19

© 19

John Isaac Thornycroft

Born in the Vatican State 1843, the english engineer Sir John Isaac Thornycroft built his first steam launch on the river Thames aged 21. His shipyard designed and built the first Torpedo boats, sold to the Italian and British Navy in 1876–77. During the transition from steam to gasoline engines he became one of the experts in Torpedo and speed boat design. He tested and perfected V-hull shapes using redan steps and hydrofoil techniques. Sir John died in 1929, his company survives up to today.

1843 im Vatikan geboren, mit 21 baute der englische Ingenieur Sir John Isaac Thornycroft seinen ersten Dampfer auf der Themse. Seine Firma gestaltete und baute die ersten Torpedoboote, die 1876/77 an die italienische und britische Flotte verkauft wurden. Während der Umstellung von Dampf auf Benzin wurde er Experte für Torpedo- und Speedboatdesigns. Er testete und perfektionierte V-Rumpfformen mittels Stufengleiter und Wasserfolientechnik. Sir John starb 1929, seine Firma gibt es immer noch.

Né au Vatican en 1843, l'ingénieur anglais Sir John Isaac Thornycroft construisit son premier vapeur en 1921 sur la Tamise. Sa société imagina et construisit les premiers torpilleurs qui furent vendus à la flotte britannique et italienne en 1876/77. Pendant la reconversion de la vapeur à l'essence, il devint expert en design de torpilles et bateaux rapides. Il testa et améliora des coques en V par le truchement de glisseurs étagés et de la technique à feuilles d'eau. Sir John décéda en 1929, sa société existe encore.

Nacido en 1843 en El Vaticano, el ingeniero inglés Sir John Isaac Thornycroft construyó su primer vapor en 1921 sobre el Támesis. Su empresa concibió y construyó los primeras embarcaciones torpederas, que en 1876/77 fueron vendidos a la flota italiana y británica. Durante la conversión de vapor a gasolina se hizo experto en diseño de embarcaciones torpederas y Speedboat. Él probó y perfeccionó las formas de caso en V mediante deslizadores escalonados y tecnología de película de agua. Sir John falleció en 1929, su empresa perdura hasta el día de hoy.

Uno dei padri fondatori della nautica a motore, nato in Vaticano nel 1843, l'ingegnere inglese Sir John Isaac Thornycroft costruisce la sua prima lancia a vapore sul Tamigi all'età di 21 anni. Da quel momento, il suo cantiere disegna e costruisce le prime torpediniere militari per la Marina Italiana e Britannica già nel 1876–77. Nel passaggio dal vapore ai motori a ciclo otto Thornycroft si specializza in barche veloci testando e perfezionando la carena a V con aggiunta di redan e di pattini da aliscafo. Sir John muore nel 1929, il suo studio é cresciuto nel gruppo aziendale Vosper Thornycroft.

Although his passion were the alpine mountains, Paolo Vitelli was only 22 when he founded a small brokerage firm for sailboats named Azimut, which then turned to import-export of yachts. In 1974 he ventures into production with an industrial serial production in mind. With sales growing, by 1985 Vitelli had acquired Benetti, a Name in naval history and the makers of glamorous custom made yachts like the 86 meter Nabila of 1980. In 1999 Azimut opens the world's largest boat factory in Avigliana, near Turin. Azimut-Benetti is now the world leading mega-yacht yard and the most important European motoryacht builder.

Obwohl seine Leidenschaft die Alpen waren, gründete Paolo Vitelli mit 22 eine kleine Handelsfirma mit dem Namen Azimut, die sich dem Im- und Export von Yachten zuwandte. 1974 steigt er in die Produktion ein, die serielle Fertigung bereits im Kopf. Mit steigenden Verkäufen konnte er sich 1985 Benetti einverleiben, einen großen Namen in der Schiffsgeschichte: Benetti führte glamouröse, maßgeschneiderte Yachten wie die 86 Meter Nabila von 1980. Azimut eröffnete 1999 die weltweit größte Bootsfabrik in Avigliana bei Turin. Azimut-Benetti ist derzeit der führende Megayacht-Produzent der Welt und Europas wichtigste Werft für Motoryachten.

Malgré sa passion pour les Alpes, Paolo Vitelli fonda à 22 ans une petite société commerciale du nom d'Azimut qui s'occupait de l'import-export de yachts. En 1974 il commence la production, avec déjà dans l'idée la production en série. Avec des ventes croissantes, il peut racheter Benetti en 1985, un grand nom de l'histoire des navires : Benetti construisait des yachts romantiques et sur mesure, comme le Nabila de 86 m en 1980. Azimut ouvrit en 1999 la plus grande usine de bateaux au monde à Avigliana près de Turin. Azimut-Benetti est actuellement le producteur leader mondial de yachts géants et le plus grand chantier naval européen de yachts à moteur.

Si bien su afición eran los Alpes, Paolo Vitelli fundó con 22 años una pequeña empresa de comercialización con el nombre de Azimut, que se inclinó por la importación y exportación de yates. En 1974 se inicia en la producción, con la fabricación en serie ya en la mente. Con las crecientes ventas en 1985 consiguió incorporar a Benetti, uno de los grandes nombres en la historia de la náutica: Benetti se dedicaba a yates construidos a medida como el Nabila de 86 m de 1980. Azimut abrió en 1999 la mayor fábrica de embarcaciones del mundo en Avigliana cerca de Turín. Azimut-Benetti es en este momento el productor de megayates líder en el mundo y el astillero más importante de Europa para yates a motor.

Anche se la sua passione sono le Alpi, a soli 22 anni Paolo Vitelli fonda una piccola società di brokeraggio di barche a vela che chiama Azimut. Dopo essersi dedicato all'import-export di Yacht, nel 1974 Vitelli si avventura nella produzione con in mente la produzione seriale. Grazie ad un giro d'affari crescente, nel 1985 Vitelli acquista Benetti, un grande nome della cantieristica, già produttore di favolosi mega-yacht come il Nabila di 80 metri del 1980. Nel 1999 Azimut apre il più grande stabilimento del mondo ad Avigliana, presso Torino. Azimut Benetti (alla quale apprtiene anche Gobbi) è ora il più grande produttore mondiale nel settore dei megayacht ed il più importante costruttore europeo di Motor Yacht.

389

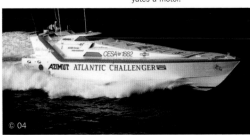

© 04

© 04

Garfield Arthur Wood embodied both the myth of speed and that of the self made man. The invention of the hydraulic hoist made him a multimillionaire by 40, his hunger for racing made him an everlasting legend. He challenged Chris Smith, whose company he actually owned between 1916 and 1923, into building the most performing racers, winning the Gold Cup 5 times in a row and two Harmsworth trophies. His delirious imagination seemed to have no limits: in 1932 he had his Miss America X equipped with four 12-cylinder engines achieving the crazy speed of 125 mph. His fortune as boat builder is mainly connected with the lucky Baby Gar runabout. Started with the famous triple cockpit 33', the range extended to 28' in 1927 and to 22' in 1930. In 1934 Gar Wood opened with the 16' Speedster a niche for smaller, sportier runabouts. The boat version of the Europeans sports car, Speedsters were given challenging names like "Miss Behave", "Miss Adventure" or "Miss Chief". Successively entering the utility and cruiser market, Gar Wood's business, backed up by an industrial empire, flourished. With Wood thinking about retiring to Florida, the 1946 postwar production featured a new style by star designer Norman Bel Geddes. All 1947 boats sported bright colors instead of varnished mahogany. Maybe a premonition, in the same year the Gar Wood yard ceased to be. Wood died in Miami aged 90 in 1971. His spirit is still present in his vintage runabouts, probably the most desirable of all.

Garfield Arthur Wood verkörperte den Mythos der Geschwindigkeit und den des Selfmademan. Die Erfindung des hydraulischen Zugs machte ihn mit 40 zum Multimillionär, sein Hunger nach Rennen zur unsterblichen Legende. Er brachte Chris Smith – dessen Firma er übrigens zwischen 1916 und 1923 besaß – dazu, die leistungsstärksten Racer zu bauen und gewann so den Gold Cup fünfmal hintereinander sowie zwei Harmsworth Trophies. Seine Vorstellungskraft schien keine Grenzen zu kennen: 1932 verpasste er der Miss America X vier 12-Zylinder-Motoren und erreichte unglaubliche 125 mph. Seine Erfolge als Bootsbauer sind hauptsächlich mit dem Baby Gar Runabout verbunden. Beginnend mit dem berühmten Triple Cockpit 33', wurde die Reihe 1927 durch ein 28'- und 1930 mit einem 22'-Modell erweitert. 1934 öffnete er mit dem 16'-Speedster eine Nische für kleine, sportlichere Runabouts. Als Bootsversion des europäischen Sportautos bekamen Speedster herausfordernde Namen wie „Miss Behave", „Miss Adventure" oder „Miss Chief". Die Firma wuchs mit dem schrittweisen Eintritt in den Utility- und Cruiser-Markt weiter. Noch während Wood über seine baldigen Rentnertage in Florida nachdachte, bekam die 1946er Nachkriegsproduktion einen neuen Stil von Norman Bel Geddes. Alle Boote von 1947 hatten nun grelle Farben statt lackiertem Mahagoni. Wahrscheinlich ein Fehler, denn im gleichen Jahr war alles vorbei. Wood starb 1971 mit 90 Jahren; in seinen klassischen Runabouts ist sein Geist aber weiterhin präsent.

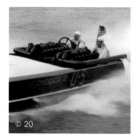

© 20

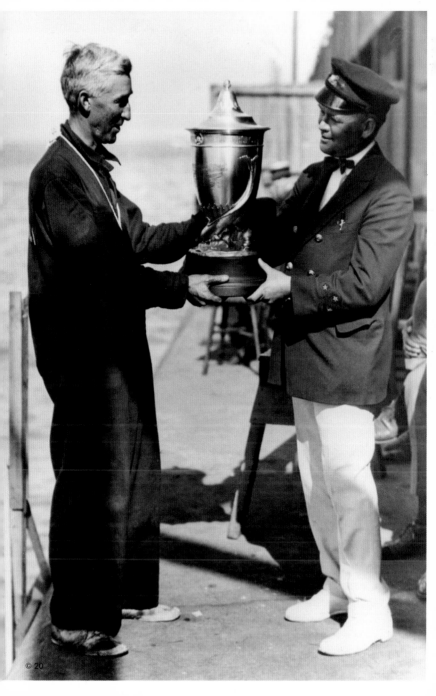

Garfield Arthur Wood incarnait le mythe de la vitesse et de l'autodidacte. L'invention de la traction hydraulique le transforma à 40 ans en multimillionnaire, et sa faim de course en légende impérissable. Il incita Chris Smith – dont il posséda la société entre 1916 et 1923 – à construire le racer le plus performant du monde, et gagna ainsi la Gold Cup cinq fois de suite ainsi que deux trophées Harmsworth. Son imagination délirante semblait n'avoir pas de limite : en 1932 il monte sur le Miss America X quatre moteurs 12 cylindres et atteignit la vitesse incroyable de 125 mph. Ses succès dans le domaine de la construction de bateaux sont principalement liés au Runabout Baby Gar. A commencer par le fameux «triple cockpit» de 33', la série a été agencée en 1927 par un 28' et en 1930 par un 22'. En 1934 il ouvre avec le Speedster de 16' une niche pour petits Runabouts sportifs. En tant que version bateau des voitures de sport européennes le Speedster reçu des noms prometteurs comme «Miss Behave», «Miss Adventure» ou «Miss Chief». La société grandit avec l'entrée progressive sur le marché des Utility et Cruiser. Alors que Wood pensait déjà à prendre sa retraite en Floride, la production d'après-guerre de 1946 gagna un nouveau style apporté par Norman Bel Geddes. Tous les bateaux de 1947 reçurent des couleurs criardes pour remplacer l'habituel acajou laqué. Probablement une erreur, car la même année tout était terminé. Wood décéda en 1971 à l'âge de 90 ans; mais son esprit reste présent dans ses Runabouts classiques.

Garfield Arthur Wood materializó el mito de la velocidad y del Self-made-man. La invención de la tracción hidráulica lo transformó con 40 años en multimillonario, su afición a las competiciones en una leyenda inmortal. Él convenció a Chris Smith –cuya empresa por lo demás poseía entre 1916 y 1923–, da construir los potentes Racer y ganó de esta manera cinco veces consecutivas la Gold Cup así como dos Harmsworth Trophies. Su delirante imaginación parecía no conocer ningún límite: en 1932 equipó el Miss America X de cuatro motores de 12 cilindros y alcanzó increíbles 125 mph. Sus éxitos como constructor de embarcaciones están ligados principalmente con el Baby Gar Runabout. Comenzando con el famoso "triple cockpit" 33', la serie fue ampliada en 1927 con un modelo de 28' y en 1930 con uno de 22'. En 1934 con el Speedster de 16' abrió un hueco para pequeños y deportivos Runabouts. Como versión de embarcación del automóvil deportivo europeo los Speedster recibieron nombres provocativos como "Miss Behave", "Miss Adventure" o "Miss Chief". La empresa creció con el acceso paso a paso en el mercado de Utility y Cruiser. Aún mientras Wood pensaba en sus próximos días como jubilado en Florida, la producción de posguerra a partir de 1946 recibió un nuevo estilo por parte de Norman Bel Geddes. Todas las embarcaciones de 1947 tenían ahora colores estridentes en lugar de caoba barnizada. Probablemente un error, por que en el mismo año todo había acabado. Wood falleció en 1971 con 90 años de edad; sin embargo en sus clásicos Runabouts su alma continua presente.

La figura di Garfield Arthur Wood incorpora il mito della velocitá e quello del self-made man: con l'invenzione del pistone idraulico diventa multimilionario a 40 anni, la sua grinta nelle corse fanno di lui una leggenda. Gar Wood sfida Chris Smith, di cui finanzia il cantiere fra il 1916 ed il 1923, a costruire i migliori Racer, vincendo la Gold Cup cinque volte di fila e due trofei Harmsworth. La sua immaginazione delirante lo porta nel 1932 a far equipaggiare Miss America X con quattro motori a 12 cilindri raggiungendo cosí la pazza velocitá di 125 miglia orarie. La sua fortuna di costruttore é legata alla fortunata serie dei Runabout Baby Gar, che comincia col famoso 33 piedi "triple cockpit" per finire con il 22 piedi del 1930. Nel 1934 Wood apre con lo Speedster di 16 piedi una nuova nicchia per barche piccole, agili e velocissime, quasi una versione nautica dei roadster europei, che portano nomi divertenti come "Miss Behave" (screanzato), "Miss Adventure" (disavventura) o "Miss Chief" (maldicente). Entrato successivamente nel mercato degli Utility e Cruiser, il business di Wood, supportato da un impero finanziario, fiorisce anche in anni di crisi. Ma mentre Wood pensa a ritirarsi in Florida, nel 1946 i manager dell'azienda chiamano il famoso designer Norman bel Geddes a disegnare nuove linee, che non incontrano il successo del pubblico. Nel 1947 l'azienda chiude, Wood muore felice a Miami nel 1971 all'etá di 90 anni. I suoi Runabout d'epoca sono probabilmente tra i piú desiderabili.

In the mid 50s, James R. Wynne was chief test engineer for Kiekhaefer Corp, the company that produced the famous Mercury outboard engines, and a friend and colleague of Charles Strang, the company VP. Both are part of a plot at the base of which lies one of the breakthrough inventions in motor boating industry: the stern-drive transmission. It was in fact Strang to have the idea of an inboard-outboard engine, back in 1949, but Mr. Kiekhaefer would not show interest. When Jim heard of it, he and Charles decided to go on together. After Jim left Mercury in 1958, he moved on to patent and market the invention, finally finding a partner in Swedish Volvo Penta. It appears that Charles, enjoying his executive post at Mercury, did not want to enter discussion with Kiekhaefer—in fact the old man never knew—and let Jim officially do. The Aquamatic was launched at the New York fair in 1959 and, in spite of a rather chilly welcome, it would eventually write a very successful story. Mercury soon felt the need to enter competition, and Kiekhaefer asked Strang to design "their" stern-drive system, which was called the MerCruiser. The two main competitors in the market were in fact invented by the same man. Being granted patent in 1968, Wynne found time to dedicate to new challenges: after designing the first turbine-powered Thunderbird, he followed Don Aronow to work on the first Formula and Magnum. Overall, Wynne has been acclaimed as one of the most influential designers in the boating world.

Mitte der 50er war James R. Wynne der oberste Testingenieur bei der Kiekhaefer Corp., die die berühmten Mercury-Außenbordmotoren herstellte, und Freund des Vizepräsidenten Charles Strang. Beide sind Teil einer Geschichte, deren Anfang eine bahnbrechende Erfindung in der Motorbootindustrie bildete: die Stern-Drive Transmission. Eigentlich war es Strang, der 1949 die Idee eines Innen-/Außenbordmotors hatte – aber Herr Kiekhaefer zeigte kein Interesse. Als Jim davon hörte, beschlossen er und Charles, von nun an gemeinsame Sache zu machen. Nachdem Jim Mercury 1958 adieu sagte, ließ er sich die Erfindung patentieren, vermarktete sie und fand schließlich einen Partner in der schwedischen Volvo Penta. Charles, dem sein Posten bei Mercury offensichtlich behagte, vermied Diskussionen mit Kiekhaefer (tatsächlich erfuhr dieser nie davon) und ließ Jim offiziell freie Hand. Der Aquamatic wurde bei der New Yorker Messe 1959 vorgestellt und schrieb trotz kühlem Empfang eine Erfolgsgeschichte. Mercury wollte natürlich in den Wettbewerb einsteigen, so dass Kiekhaefer Strang darum bat, nun doch bitteschön „ihren" Heckantrieb zu bauen – er wurde als MerCruiser bekannt. Die zwei größten Konkurrenten des Marktes wurden also letztlich vom selben Mann erfunden. Im Jahr 1968, mit dem Patent in der Tasche, fand Wynne Zeit, sich neuen Aufgaben zu widmen: Nach dem Entwurf des ersten Turbinen getriebenen Thunderbirds arbeitete er mit Don Aronow an den Formulas und Magnums.

393

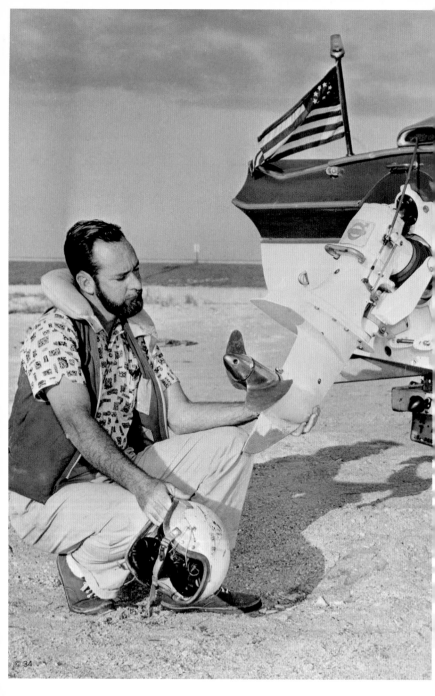

Dans le milieu des années 50, James R. Wynne était l'ingénieur d'essai principal de la société Kiekhaefer Corp., qui construisait les fameux moteurs hors-bord Mercury, et il était l'ami du vice président Charles Strang. Tous deux font partie d'une même histoire dont les débuts produisirent une invention révolutionnaire dans l'industrie des moteurs : la transmission Stern-Drive. En fait ce fut Strang qui en 1949 eut l'idée d'un moteur in / hors-bord – mais Monsieur Kiekhaefer ne montra aucun intérêt. Quand Jim en entendit parler, lui et Charles décidèrent de faire dorénavant cause commune. Après que Jim ait remercié la société, en 1958, il fit breveter son invention, la mis sur le marché et finalement trouva un partenaire auprès de la société suédoise Volvo Penta. Charles, qui apparemment appréciait son poste chez Mercury, évita les discussions avec Kiekhaefer (effectivement ce dernier n'eut jamais vent de rien) et donna officiellement à Jim carte blanche. L'Aquamatic fut présenté au salon de New York de 1959, et devint l'histoire d'un succès malgré une réception au départ quelque peu froide. Mercury a voulu naturellement entrer en concurrence, et ainsi Kiekhaefer pria Strang de construire «leur» entraînement hors-bord – il fut connu sous le nom de MerCruiser. Les deux concurrents sur le marché ont été finalement inventés par le même homme. En 1968, avec son brevet dans la poche, Wynne avait maintenant le temps de se consacrer à d'autres tâches : après l'étude du premier Thunderbirds à propulsion par turbine, il travailla avec Don Aronow sur les Formula et Magnum.

A mediados de los años 50 James R. Wynne era el mayor ingeniero de ensayos en la Kiekhaefer Corp., que fabricaba los famosos motores fuera de borda Mercury, y amigo del vicepresidente Charles Strang. Ambos son parte de una historia, en cuyos comienzos generaron una invención revolucionaria en la industria de las embarcaciones a motor: la Stern-Drive Transmission. En realidad fue Strang, que en 1949 tuvo la idea de un motor interior/fuera de borda –pero el Señor Kiekhaefer no mostró ningún interés. Cuando Jim escuchó de ello, resolvieron Charles y él, hacer de ello un tema común. Después de que Jim Mercury dijera adiós en 1958, dejó patentar su invención, la comercializó y finalmente encontró un socio en la empresa sueca Volvo Penta. Charles, quien evidentemente le gustaba su cargo en Mercury, evitó discusiones con Kiekhaefer (efectivamente nunca supo de ello) y le dejó oficialmente las manos libres a Jim. El Aquamatic fue presentado en la feria de Nueva York en 1959 y a pesar de su fría acogida consiguió escribir una historia de éxito. Mercury naturalmente quería acceder a la competencia, ahora sí a construir "su" propulsión trasera –que se hizo conocido bajo el nombre de MerCruiser. Los dos mayores competidores del mercado finalmente fuero inventados por la misma persona. En el año 1968, con la patente en el bolsillo, Wynne encontró tiempo para dedicarse a nuevas tareas: Tras el proyecto del primer Thunderbird propulsado con turbina, trabajó con Don Aronow en los Formulas y Magnums.

Negli anni 50, James R. Wynne é capo collaudatore di Kiekhaefer Corp., il gruppo che produce i famosi motori fuoribordo Mercury, ed amico di Charles Strang, vicepresidente dell'azienda. Enrambi sono parte di una trama che sta alla base di un'invenzione rivoluzionaria, quella del motore entrofuoribordo. In realtá é Strang ad avere l'idea nel 1949, ma il signor Kiekhaefer non ne vuol sapere. Quando Jim ne viene a conoscenza, lui e Charles decidono di portare avanti l'idea insieme. Jim lascia la Mercury nel 1958 e si affretta a patentare e commercializzare l'invenzione, per la quale trova un partner nella svedese Volvo Penta. Sembra che Charles, contento del suo lavoro e non volendo entrare in discussione con Kiekhaefer, faccia buon viso a cattivo gioco. Il sistema Aquamatic viene lanciato alla Fiera di New York nel 1959 e, dopo un'accoglienza fredda, diventa un sueccesso strepitoso. A quel punto, anche la Mercury vuole entrare nel mercato e Kiekhaefer chiede a Streng di sviluppare il "suo" motore entrofuoribordo, che viene chiamato MerCruiser. Dietro ai due piú grandi concorrenti si nasconde in realtá la stessa persona. Jim Wynne trova il tempo per dedicarsi ad altre cose: dopo aver progettato il primo Thundebrird alimentato a turbina, egli segue Don Aronow per lavorare sul primo Formula e sul Magnum. Alla fine dei conti, Wynne viene acclamato come uno dei piú influenti progettisti della nautica moderna.

395

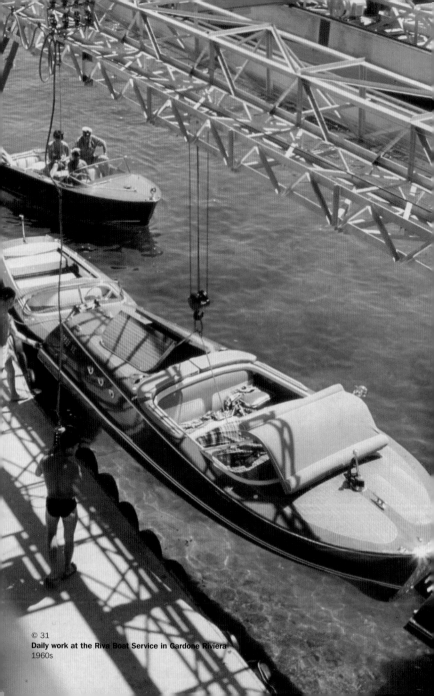

Daily work at the Riva Boat Service in Gardone Riviera
1960s

Paolo Tumminelli

... studied architecture and design direction in Milan. Today, he is the chief executive officer of the consulting company goodbrands® and Professor for Design Concepts at the Köln International School of Design. Tumminelli has worked as a design critic for Domus and Form, now he writes for the business newspaper Handelsblatt. In 2004 he published the book "Car Design".

... studierte Architektur und Design Direction in Mailand. Heute ist er gesellschaftlicher Geschäftsführer des Beratungsunternehmens goodbrands® und Professor für Design Konzepte an der Köln International School of Design. Tumminelli hat als Designkritiker für Domus und Form gearbeitet; derzeit schreibt er für die Wirtschaftszeitung Handelsblatt. 2004 veröffentlichte sein Buch „Car Design".

... a étudié l'architecture et la Direction Design á Milan. Il est actuellement PDG social de l'entreprise conseil goodbrands® et professeur pour concepts de design à la Köln International School of Design. Tumminelli a travaillé comme critique de design pour Domus et Form; il écrit actuellement pour le journal économique Handelsblatt. Il a publié en 2004 «Car Design».

... estudió Arquitectura y Design Direction en Milán. Actualmente es gerente social de la empresa consultora goodbrands® y profesor de Conceptos de Diseño en la Köln International School of Design. Tumminelli ha trabajado como crítico de diseño para Domus y Form; en este momento escribe para la publicación de economía Handelsblatt. En 2004 publicó "Car Design".

... ha studiato Architettura al Politecnico di Milano e Design Direction ala Domus Academy. Oggi è professore alla KISD, L'Istituto di Design del Politecnico di Colonia e CEO di goodbrands®, una società di consulenza nel settore del branding. Avendo collaborato per anni alla rivista domus, Tumminelli scrive ora per Handelsblatt, il quotidiano economico-finanziario tedesco. Nel 2004 ha pubblicato il libro "Car Design".

thanks

The boating industry being a rather extravagant business, plagued by many historical ups and downs and marked by often inconsistent marketing, compiling this book was quite an adventure. To gather correct information and original images with the proper quality has been hard if not, at times, impossible. I was lucky to find a few supporting companies and to meet many individuals who, often over the Internet, have helped finding out enough to make us—and hopefully you too—happy. Thank you all!

Die Bootsindustrie ist ein eher extravagantes Geschäftsfeld, das sich durch viele Höhen und Tiefen und häufig inkonsistentes Marketing auszeichnet. Die Erstellung des Buches war deshalb ein ziemliches Abenteuer. Korrekte Informationen und Originalbilder von guter Qualität zu bekommen war schwierig, manchmal auch unmöglich. Zum Glück gab es einige unterstützungswille Firmen und viele Leute, die – oftmals über das Internet – genug herausfanden, um uns und hoffentlich auch Sie zufrieden zu stellen. Vielen Dank an alle!

L'industrie nautique est un domaine commercial plutôt extravagant qui se définit par des hauts et des bas nombreux et souvent par un marketing inconsistant. C'est pourquoi la réalisation de cet ouvrage fut très aventureuse. Il fut difficile et parfois impossible d'obtenir des informations correctes et des photos originales de haute qualité. Par chance nous avons rencontré quelques sociétés très serviables et de nombreuses personnes – souvent sur Internet – qui ont recueilli suffisamment de documents, pour notre grande satisfaction et j'espère pour la leur. Un grand merci à tous !

La industria de embarcaciones es un campo de negocios más bien extravagante, que se caracteriza por muchos altos y bajos y frecuentemente con un marketing inconsistente, cuando no hasta inexistente. Por esta razón, la confección del libro ha sido una verdadera aventura. Fue difícil, a veces hasta imposible, conseguir informaciones correctas y fotografías originales de alta calidad. Por suerte hubo algunas empresas y mucha gente con voluntad de brindar soporte, que –frecuentemente a través de Internet– han encontrado lo suficiente como para satisfacernos a nosotros y esperamos que a ustedes también. ¡Muchas gracias a todos!

A discapito dell'indubbio prestigio di molti brands, l'industria nautica è un business che vive in un mondo a parte, spesso fatto di realtà molto piccole che hanno vissuto i loro alti e bassi. La ricerca per questo libro è stata una bella avventura, ottenere informazioni ed immagini a volte difficile se non impossibile. È doveroso ricordare alcune aziende e persone particolarmente collaborative che – spesso grazie ad Internet – ne hanno infine permesso la realizzazione. Grazie a tutti!

Special thanks to/ein besonders herzlicher Dank an/nos remerciements particulières à/un cordial agradecimiento especial a/un ringraziamento speciale a:

Mario Amati, **Arch. Giorgio Barilani**, **Klaus Boesch**, **Arch. Paolo Caliari**, **Eric Cashion** (Hatteras), **Marilyn DeMartini** (Cigarette Racing Team), **Dr. Norberto Ferretti** + **Fulvia Venturi** (Ferretti Group), **Sara Gioanola** (Perini Navi), **David Kain** (Hurrikain Marine Products), **Chris Kochmann**, **Claudia Jew** (The Mariners' Museum), **Stephen Julius** +**Meghan Stout** (Chris Craft), **Giuseppe Meroni** + **Fabio Generoso** (Cantieri Riva), **Dr. Gianpiero Moretti**, **Edoardo Ratto** (Cantieri Baglietto), **Ing. Carlo Riva**, **Karla Rodriquez** (Bertram Yacht), **Arch. Silvia Suardi**, **Kathrin Theodoli** (Magnum Marine), **Mario Vazquez** (Donzi Marine), **Stéphanie Vignau** (Cantieri di Pisa), **Bengt Wåhlin** (Coronet Yacht Club).